~The Best of~

BROCHURE DESIGN⁵

ROCKPORT

CORPORATE PRODUCT SERVICE INSTITUTIONAL&ORGANIZATIONAL SELF-PRO

~The Best of~

BROCHURE DESIGN⁵

ONAL

GLOUCESTER MASSACHUSETTS

ROCKPORT PUBLISHERS

FIRST PUBLISHED IN THE UNITED STATES OF AMERICA BY:
Rockport Publishers, Inc.
33 Commercial Street
Gloucester, Massachusetts 01930-5089
Telephone: (978) 282-9590
Facsimile: (978) 283-2742

ISBN 1-56496-780-8

10 9 8 7 6 5 4 3

DESIGNER | Stoltze Design
COVER IMAGE | Nesnadny + Schwartz
 The Progressive Corporation,
 1997 Annual Report (Detail)
 see page 55

Printed in China

業務架構日益完備。從無至有，有

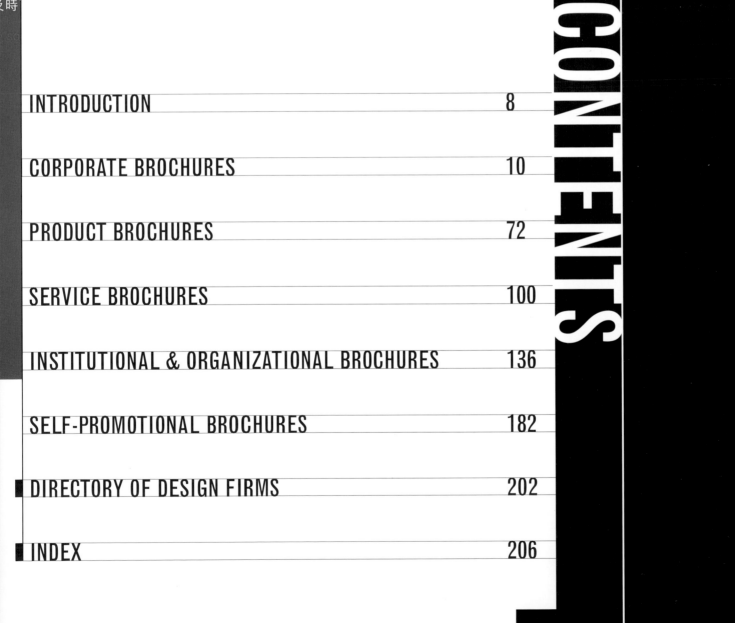

CONTENTS

OPEN OR IGNORE.

"When you receive a **BROCHURE** in the mail, or see one on a store countertop, those are your basic options. And whether you like it or not, the graphic designer who made th brochure has a huge **impact** on that decision.

My senior year of high school, I remember receiving BROCHURES from about a million different colleges, from everywhere on the face of the Earth. They came unsolicited, and having that "future will figure itself out" attitude, I had little interest in looking at them. Even so, there were a few that I just could not resist. They so completely captured my attention that I couldn't help but peruse their large, glossy pages; revealing scenes of a college life that I could only imagine; telling anecdotes of the amazing things that occurred on campus. These brochures were purely seductive, and I found myself browsing through them again and again. With my trusty "yes" pile, I was convinced that I needed to know nothing more than what was in that brochure. And sometimes, the brochure was really all the information I really had with which to make my decision. In those cases, I would carefully read all the text, trying to absorb what that college could offer me. But I read it on another level also. Consciously or subconsciously, the feel of the brochure— the colors, the papers, the fonts—these details were what I used to distill the essence of the college. Was it a conservative place? Were the students there wild? Was the college known for its innovative teaching? I allowed something as basic as the color palette to discern that for me.

INTRODUCTION

And it is that level of the design that makes the graphic designer's job so difficult and so gratifying. Good designers know clever ways to fit enormous amounts of text into a specified format, to work within a tight budget, to appease a difficult client. Don't get me wrong—those are very difficult tasks. But beyond that, the designers only have the use of the tools of the basic elements of design to capture the feeling, the essence of the client. And good designers, with an endless number of ideas, amazing innovations, and a little bit of luck, can really do that.

In the end, my decision on where to attend college was not solely based on the brochure. But truth be known, there sure were a lot of places that I didn't even consider because

their brochure just did not tell me to "open."

—ALDEN ROY, DESIGNER

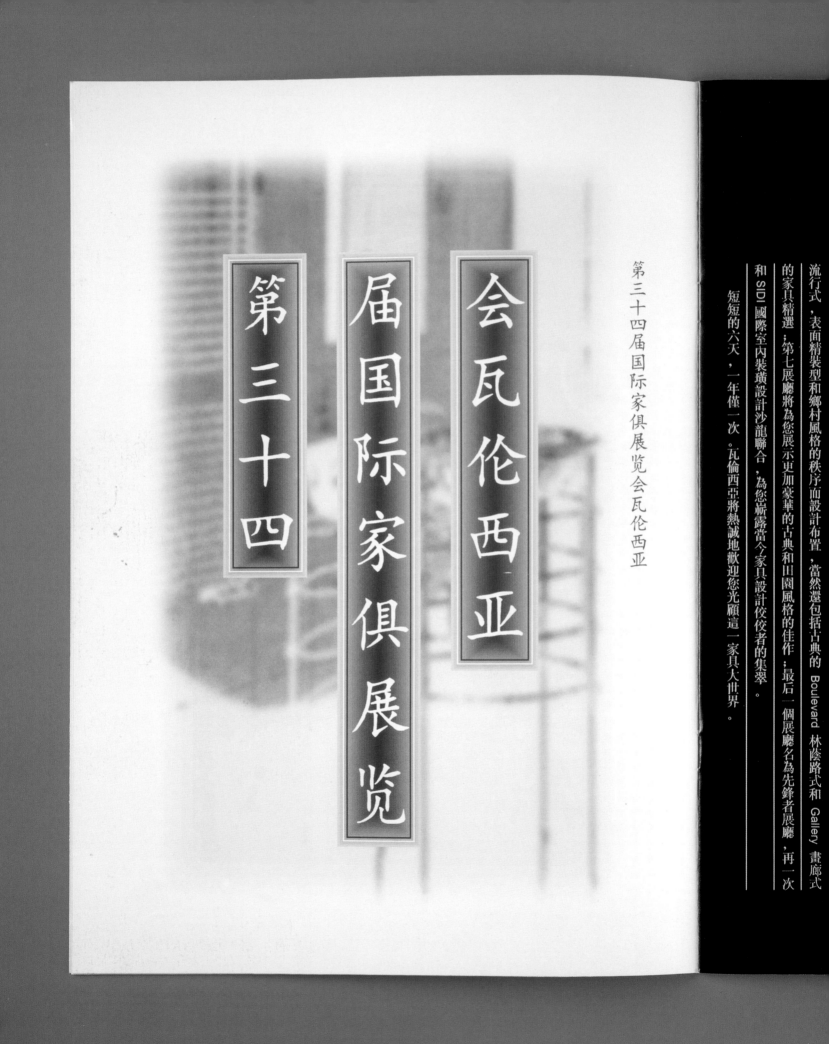

第三十四届国际家俱展览会瓦伦西亚

会瓦伦西亚

届国际家俱展览

第三十四

流行式，表面精裝型和鄉村風格的秩序而設計布置，當然還包括古典的 Boulevard 林陰路式和 Gallery 畫廊式的家具精選；第七展廳將為您展示更加豪華的古典和田園風格的佳作；最后一個展廳名為先鋒者展廳，再一次和 SIDI 國際室內裝璜設計沙龍聯合，為您崭露當今家具設計佼佼者的集翠。

短短的六天，一年僅一次。瓦倫西亞將熱誠地歡迎您光顧這一家具大世界。

CORPORATE BROCHURES

每年一度

時間為六天，來訪者達五萬以上，一千多個參贊公司分別來自歐洲、亞洲和美洲。就在這里，FIM 西班牙‧瓦倫西亞國際家具展覽會將為您展示，當今世界家具的新動態，新產品；為您提供難尋的良機。

每年只有一次，而每次只持續六天。盡管如此，如果您是一位具有鑒賞能力的商人，這六天時間將是無法估量的，它很可能使您在整年之余坐享其成。就在同一地點，您可以飽覽一個壯觀的當今家具世界，可以獲得一個完整的商業視野，您所期望的各種貿易良機隨時有機會出現。

第三十四屆瓦倫西亞國際家具展覽會，于一九九七年九月二十二日至九月二十七日在西班牙，瓦倫西亞市舉行，有一百多個國家和地區前來參加。巨大的展覽館其總面積為180.000 平方米將容納世界家具市場應有盡有的產品，五萬名來自世界各地的商人可以欣賞到歐洲、亞洲和美洲的上千家家具制造廠的杰作。

您將在觀賞優雅的古典式家具的同時，發現為未來二十一世紀開創的新產品：鋁制座椅，精制皮革的三套

DESIGN FIRM | Pepe Gimeno, S.L.
DESIGNER | Pepe Gimeno
CLIENT | Feria Internacional del Mueble de Valencia
TOOLS | Macromedia FreeHand, Adobe Photoshop
PRINTING PROCESS | Offset

This is the program given out at the International Furniture Fair in Valencia. The brochure had to be designed in five different languages.

DESIGN FIRM | Q DESIGN
ART DIRECTORS | Thilo Von Debschitz, Laurenz Nielbock
DESIGNER | Roman Holt
CLIENT | VKE
TOOLS | QuarkXPress, Adobe Photoshop
PAPER | Akylux & Polyart
PRINTING PROCESS | Ultraviolet, four-color Pantone

Annual Report for VKE (association of plastic processing industries). Text and cover is all synthetic paper, therefore UV-printing was used.

Geschäftsbereich

ÖFFENTLICHKEITSARBEIT

Der VKE sucht auch in seiner Öffentlichkeitsarbeit die Zusammenarbeit mit anderen europäischen Verbänden, wo immer sich eine Möglichkeit dazu ergibt. So wurde im vergangenen Jahr auf Initiative des VKE ein gemeinsames, einheitliches europäisches Logo für Kunststoff auf den Weg gebracht. Es soll als Siegel für den innovativen, vielseitigen Werkstoff der Zukunft stehen und für alle Europäer leicht verständlich sein. Gerade im Bereich der Kommunikation macht multinationale Zusammenarbeit besonderen Sinn: Internationaler Handel und ungehinderter, reger Informationsaustausch auf verschiedensten Kommunikationskanälen haben längst auch die Massenkommunikation internationalisiert.

Das gilt im besonderem Maß fürs Internet. Der Datenhighway kennt keine Ländergrenzen.

Seit dem Frühsommer 1997 zeigt auch der VKE mit professionell gestalteten, eigenen Seiten im Internet Flagge. Unter „www.vke.de" finden sich Basisinformationen rund um Kunststoff und die Kunststoff-Industrie ebenso wie aktuelle News aus der Welt der Polymere – selbstverständlich auf deutsch und auf englisch. Zahlreiche Links, also per Mausklick herstellbare, direkte Verbindungen, runden das Angebot ab. Von der VKE-Homepage gelangt man problemlos zu den Mitgliedsfirmen, zu Organisationen und anderen Kunststoff-Verbänden, auch im europäischen Ausland und sogar in Übersee. Und die Nutzungsstatistik zeigt, daß gerade die europäischen Nachbarn eifrige Websurfer sind. Nur etwas über die Hälfte der Homepage-Besucher kam aus Deutschland.

Ein Highlight auf den Webseiten war im vergangenen Jahr die europäische Online-Regatta, ein gemeinsam mit den europäischen Kunststoff-Erzeugern entwickeltes Spiel im Internet. Die User konnten von der VKE-Seite zu verschiedenen großen Kunststoff-Anwendern surfen, Fragen zu Kunststoff beantworten und damit attraktive Preise gewinnen. Hauptgewinn war ein Segeltörn mit Wibke Bülle und Nicola Birkner, den Seglerinnen der 470er Olympia-Crew, die unter dem Motto „Innovation in Kunststoff" an den Start gehen.

Sponsoring:
Sport und Kultur

Denn auch das 1996 begonnene Sponsoring der Seglerinnen der 470er Klasse und des deutschen Frauen-Nationalachters wird fortgesetzt. Die Partnerschaft

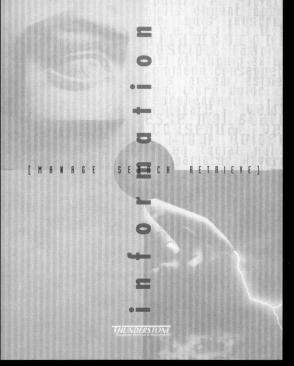

information

[M A N A G E S E A R C H R E T R I E V E]

THUNDERSTONE

DESIGN FIRM | Zylstra Design and Denise Kemper Design
(collaboration)

ART DIRECTORS | Melinda Zylstra, Denise Kemper

DESIGNERS | Melinda Zylstra, Denise Kemper

PHOTOGRAPHER | Stock

COPYWRITER | Thunderstone

CLIENT | Thunderstone

TOOLS | QuarkXPress

PAPER | Neenah Environment Mesa White,
UV Ultra II Columns

PRINTING PROCESS | Three-color offset lithography

The design firm's goal was to create a unique
brochure that stands out from the crowd and
reflects the client's non-traditional outlook.
With this goal in mind, they designed the project
using unusual page layout, paper stock, and
photographic images.

THUNDERSTONE?

Thunderstone is an independent R&D company that provides high-end software to manage, retrieve, filter and electronically publish information content consisting of text and multimedia. Over the last 17 years Thunderstone has sold more than 400,000 end-user licenses to corporations, software developers, content providers and government entities. Privately held, Thunderstone maintains a constant commitment to excellence and innovation within diverse areas of information management and retrieval. Its focus on constant technical advancement provides its customers with the ability to specifically address the demands of their user base without compromise.

THE THUNDERSTONE DIFFERENCE

Large organizations generally have specific information retrieval and management needs that can only be met by a combination of several unrelated products, but this type of integration is time consuming and error prone. Other retrieval vendors just index text and provide the ubiquitous list of answers. Thunderstone will realize and implement the entirety of the application exactly as envisioned; rapidly and maintainably. Our Texis RDBMS is fully capable of managing text and multimedia objects out of the box without the need to resort to loosely coupled "Data-Blade" programs. The Thunderstone infrastructure can meet the diverse and unique needs for almost any internet application.

The marketplace for internetworked information management/retrieval systems is rapidly expanding. Texis represents a crucial part of the information requirement by symmetrically merging objects, relational data, and full text retrieval. Thunderstone has been a pioneer since 1984 with the first concept based retrieval product on the market. No other product can make this claim, and no integration of other products can easily replicate Texis' functionality.

www.thunderstone.com
[S E A R C H C L A S S I F Y D I S S E M I N A T E]

DESIGN FIRM | Stoltze Design

ART DIRECTOR | Clifford Stoltze

DESIGNERS | Clifford Stoltze, Dina Radeka

PHOTOGRAPHER | William Huber

CLIENT | New England Investment Company

PAPER | Mohawk 50/10, Champion Benefit Oyster
80 lb. text, Gilclear Medium 28 lb.

PRINTING PROCESS | Cover: 4 PMS plus varnish; front
section: 5 PMS plus varnish;
financials: 1 PMS

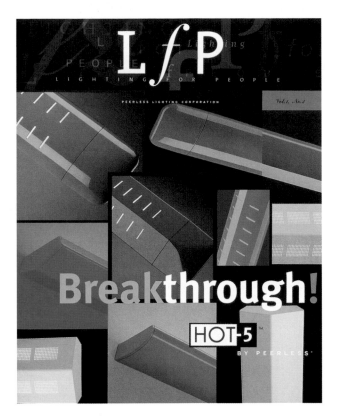

DESIGN FIRM | JD Thomas Company
DESIGNER | Clive Piercey
PHOTOGRAPHERS | Various/Stock
COPYWRITER | Jim Thomas
CLIENT | Peerless Lighting Corporation
TOOLS | QuarkXPress, Adobe Photoshop
PAPER | French-Construction 100 lb. cover
PRINTING PROCESS | Four-color offset

This quarterly publication was created to
announce new technologies and products.
The distinctive design is meant to appeal to
interior designers and architects.

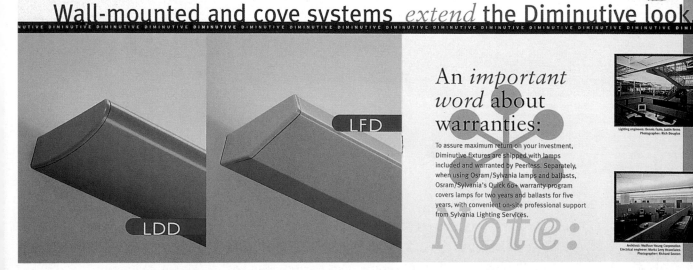

WALL & COVE

LIGHTDUCT™ and LIGHTFIN™ WALL-MOUNTED FIXTURES use the same advanced HOT-5™ technology and optical system to project soft, uniform light on the wall above and across the ceiling in corridors, small offices, rooms with low ceilings, and in general use areas.

Compared with similar T8 and T5 systems, the performance is extraordinary. Single-lamp Diminutive wall-mounted fixtures project nearly as much light as 2-lamp conventional fixtures, allowing you to decrease the number of lamps while also reducing ongoing maintenance and energy costs.

The sleek housings match Lightfin and Lightduct pendant-mounted designs, and feature the same high quality materials, finish and construction.

DIMINUTIVE COVE LIGHTING can transform a ceiling into a glowing surface that provides pure, diffuse light virtually free of hot spots, glare and shadow. Combining HOT-5™ technology and the same sophisticated optics, the system projects continuous levels of illumination from fewer lamps, and is scaled down to install easily into smaller architectural spaces.

6'x 2' Diminutive Cove lighting features a patented optical system inside a compact, easy-to-install housing that fits into smaller architectural cavities.

A Diminutive indirect lighting scheme offers exceptional space design versatility. In addition to pendant-mounted fixture arrangements, you can extend the sleek new look into small offices and conference rooms, corridors and waiting areas using matching wall-mounted fixtures (shown here at Peerless Design & Technology Center). You can also add dramatic cove lighting in selected special use spaces.

Wall-mounted and cove systems *extend* the Diminutive look.

DIMINUTIVE DIMINUTIVE DIMINUTIVE DIMINUTIVE DIMINUTIVE DIMINUTIVE DIMINUTIVE DIMINUTIVE DIMINUTIVE DIMINUTIVE DIMINUTIVE DIMINUTIVE DIMINUTIVE DIMINUTIVE DIMINUTIVE DIMINUTIVE DIMINUTIVE DIM

LFD

LDD

An *important word* about warranties:

To assure maximum return on your investment, Diminutive fixtures are shipped with lamps included and warranted by Peerless. Separately, when using Osram/Sylvania lamps and ballasts, Osram/Sylvania's Quick 60+ warranty program covers lamps for two years and ballasts for five years, with convenient on-site professional support from Sylvania Lighting Services.

Note:

The computer-intense environment of ECHOSTAR Corporation's headquarters in Littleton, Colorado was among the first to be lit by Peerless Lightfin HOT-5 fixtures. The firm and its architect, burkettdesign, Denver, are happy with how the small-scaled fixtures add an attractive design element without intruding into the space. The engineers, ABS Consultants, like how Lightfin meets the challenge of extraordinarily high ceilings with fewer fixtures and lamps than the conventional 3-lamp T8 alternative. RP1 criteria, lighting levels, and ceiling uniformity standards were easily satisfied.

Lighting engineers: Dennis Fazio, Justin Kerns
Photographers: Rich Douglas

To Finish Line, Inc. image was vital in the design of its corporate headquarters in Indianapolis. Parabolic lighting was thus considered inappropriate, yet conventional T-8 indirect lighting appeared bulky because of 8'-10' ceiling heights. Lightduct™ answered with diminutive fixtures spaced 10' on center, delivering over 50 initial fc with 7-to-1 ceiling uniformity ratio. 20% fewer fixtures were required, and energy, lamping and installation costs were significant reduced.

Architect: Walhton-Young Corporation
Electrical engineer: Marks Levy Associates
Photographers: Richard Sexton

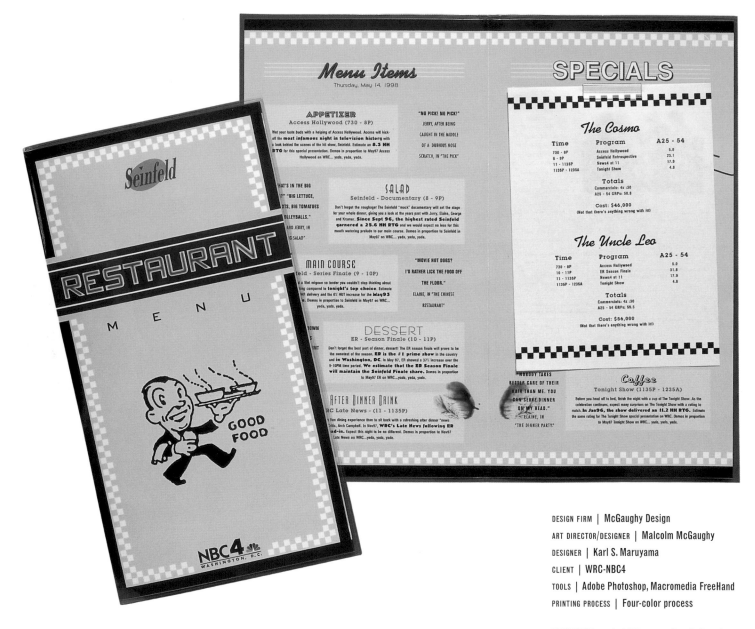

DESIGN FIRM | McGaughy Design

ART DIRECTOR/DESIGNER | Malcolm McGaughy

DESIGNER | Karl S. Maruyama

CLIENT | WRC-NBC4

TOOLS | Adobe Photoshop, Macromedia FreeHand

PRINTING PROCESS | Four-color process

WRC-NBC4 wanted this promotional piece to be something their clients could save as a collector's item.

DESIGN FIRM | Morgan Design Studio, Inc.

ART DIRECTOR/DESIGNER | Michael Morgan

PHOTOGRAPHER | Dan Weiss

COPYWRITER | Jennifer Jiles

CLIENT | 100 Black Men of America Inc.

TOOLS | QuarkXPress

PAPER | Proterra/Georgia-Pacific Natural

PRINTING PROCESS | Four-color plus metallic, satin varnish

The client wished to convey how "Four for the Future" helps to mentor inner-city children. Editorial shots highlight the support, the power, and the elements of the mentoring program. Successful design techniques included intricate folding and color usage. The organization is non-profit, so the brochure was designed to be printed as a work-in-turn, which allowed Morgan Design to stay within their limited budget.

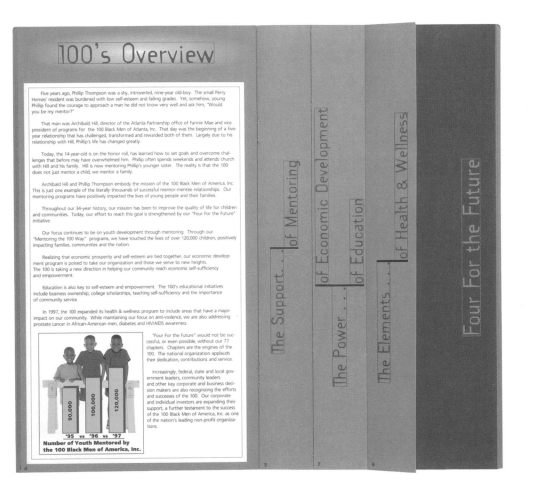

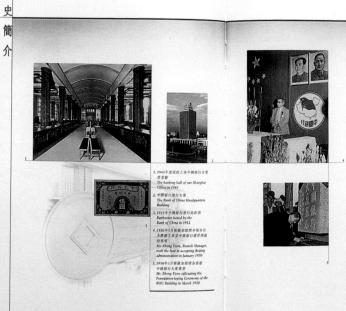

總行

● 中國銀行的前身是一九零五年清朝政府成立的戶部銀行，一九零八年改組為大清銀行。一九一二年一月，奉孫中山臨時大總統諭，改組為中國銀行，同年二月在上海開業。一九四九年十一月，中國銀行總管理處遷往北京。一九五三年中央人民政府指定中國銀行為國家特許的外匯專業銀行。一九七九年國務院批准中國銀行為國務院直屬機構，專門行使國家外匯外貿專業銀行的職能。

● 隨著國家經濟體制改革及對外開放政策的持續深入，中國銀行進入了新的歷史發展時期，並以其雄厚的實力、卓著的信譽、穩健的經營，躋入了世界大銀行的前列，並逐步朝向國有商業銀行轉化。

根據英國《銀行家》雜誌一九九七年公佈的全球一千家大銀行中，以核心資本計，中國銀行列世界第十五位，國內第一位；以總資產列世界第二十四位。世界著名雜誌《歐洲貨幣》連續三年評中國銀行為最佳國內銀行。

1. 1943年建成的上海中國銀行大廈營業廳
 The banking hall of our Shanghai Office in 1943
2. 中國銀行總行大廈
 The Bank of China Headquarters Building
3. 1912年中國銀行發行的鈔票
 Banknotes issued by the Bank of China in 1912
4. 1930年1月鄭鐵如率領本行分公會體職工及歡迎中國銀行總管理處的照片
 Mr. Zheng Tieru, Branch Manager, took the lead in accepting Beijing administration in January 1930
5. 1930年3月鄭鐵如經理為香港中國銀行大廈奠基
 Mr. Zheng Tieru officiating the Foundation-laying Ceremony of the BOC Building in March 1930

ORIGIN OF BANK OF CHINA

HEAD OFFICE

● Bank of China's predecessor in the Qing Dynasty was the Treasury Bank, which was established by the government in 1905 and subsequently renamed as the Bank of Great Qing in 1908. In January 1912, under the sanction of Dr. Sun Yat-sen, the Interim President, Bank of Great Qing was reorganized with its name changed to Bank of China. The Bank commenced its business in Shanghai in February, 1912. In November 1949, the Head Office of Bank of China was relocated to Beijing. In 1953, the Central People's Government issued a decree designating Bank of China as the state's foreign exchange bank. In 1979, the State Council decided that the Bank should be under its direct jurisdiction with specific functions of a state bank specializing in foreign exchange and foreign trade.

● China's reform and open policy has directed the Bank of China to a new historical era. With its solid foundation, fine reputation and prudent operation, the Bank has become one of the leading banks in the world, and is gradually being transformed into a state-owned commercial bank.

According to "The Banker" of July 1997, Bank of China was ranked 15th among the world's 1,000 largest banks in terms of core capital, and the first in China. With respect to total assets, the Bank was the 24th in the world. "Euromoney" also selected Bank of China as the best domestic bank in China for three consecutive years.

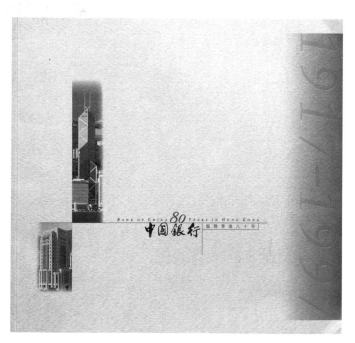

DESIGN FIRM | Kan & Lau Design Consultants
ART DIRECTORS | Kan Tai-Keung, Lau Sin Hong
DESIGNER | Cheung Lai Sheung
CLIENT | Bank of China, Hong Kong
PAPER | Cover: Hiap Moh F961-304 320 gsm;
text: 151 gsm Artpaper and
Heiwa Ultrafelt 118 gsm

The contrast between the new and old buildings of the Bank of China expresses the bank's progress over its eighty-year history.

DESIGN FIRM | The Creative Response Company, Inc.
ART DIRECTOR/ILLUSTRATOR | Sandy Salurio
DESIGNERS | Sandy Salurio, Arne Sarmiento
COPYWRITER | Fides Bernardo
CLIENT | Fil-Estate Group of Companies
TOOLS | Adobe Photoshop and PageMaker, Macromedia
FreeHand
PAPER | C2S 220 lb.
PRINTING PROCESS | Offset

This interactive sales kit includes a movable wheel that shows the titles of the four districts within the park. Bright, playful colors in solid blocks readily create a feeling of outdoor fun and excitement, clearly establishing that life in Southwoods Ecocentrum is an everyday adventure.

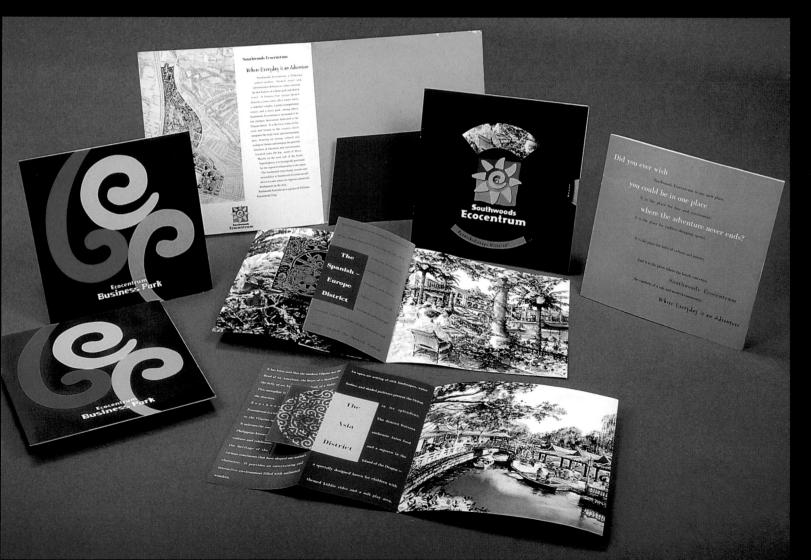

Caring for and managing our land

Land was at the heart of the congressional discussions about the Alaska Native Claims Settlement Act when it was passed in 1971.

Land also provides an incredibly strong tie to our heritage for those of us who live in Southeast Alaska and for those of us who left but who still trace our ancestry to the region.

For such reasons, our maturing corporation is devoting considerable time and attention to how we care for and manage our land.

Sealaska is structuring its resource management program to perpetuate our cultural identity and subsistence...

New policies at work
In 1982, Sealaska took an important step toward its stewardship mission, with the implementation of its first environmental policy. Ultimately, changing times and new laws called for a positive step ahead, resulting in even stronger policies and programs that were adopted by the corporation late last year.

Sealaska's new environmental policies require the corporation to aggressively assume responsibility for our environment...

Sealaska is responsible for balancing conservation and environmental considerations with shareho...

DESIGN FIRM | Hornall Anderson Design Works, Inc.
ART DIRECTORS | Jack Anderson, Katha Dalton
DESIGNERS | Katha Dalton, Heidi Favour, Nicole Bloss, Michael Brugman
ILLUSTRATOR | Sealaska archive
COPYWRITER | Michael E. Dederer
CLIENT | Sealaska Corporation
TOOLS | Adobe PageMaker, QuarkXPress
PAPER | Quest Green, Cougar Natural, Speckletone Barn Red, Cougar Opaque, Quest Moss, Gilbert Voice Rye

The client needed a piece that would serve not only as an annual report, but would also celebrate the company's 25th anniversary. The Hornall Anderson team created a clean design, incorporating earthy colors and native art references. Their biggest challenge was printing the Pantone colors on uncoated, colored paper stock, which required multiple drawdowns.

CAMP JOHN HAY

DESIGN FIRM | The Creative Response Company, Inc.
ART DIRECTOR/DESIGNER | Arne Sarmiento
PHOTOGRAPHER | Francis Abraham
COPYWRITER | Pia Gutierrez
CLIENT | CJH Development Corporation
TOOLS | Adobe Photoshop and PageMaker,
 Macromedia FreeHand
PAPER | C2S 229 lb., Matte 100 lb.
PRINTING PROCESS | Offset

To distinguish Camp John Hay from among other land developments, a fictional character was created whose poignant diary entries show the personal significance of living in Baguio, the summer capital of the Philippines.

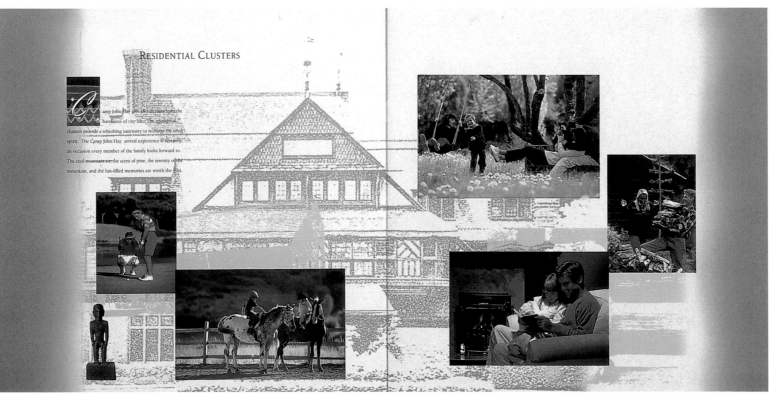

RESIDENTIAL CLUSTERS

Camp John Hay provides a retreat from the harshness of city life. The residential clusters provide a refreshing sanctuary to recharge the tired spirit. The Camp John Hay arrival experience is certainly an occasion every member of the family looks forward to. The cool mountain air, the scent of pine, the serenity of the mountain, and the fun-filled memories are worth the visit.

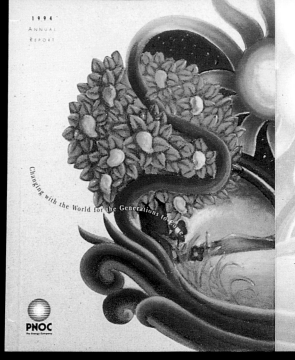

VISION STATEMENT

To be a Group of world-class people
guided by **managerial excellence**.
To use our resources wisely, responsibly.
To explore, develop, and manage existi...
and potential energy sources,
whenever, wherever.
All these that the country woul...
better place to live in...
And that prosperity would br...
envelop the lar...
This is, this shall, fore...
The Philippine Natio...
Going boldly where...
has ever ...

DESIGN FIRM | The Creative Response Company, Inc.

ALL DESIGN | Sanady Salurio

PHOTOGRAPHER | Francis Abraham

COPYWRITER | Creative Copy Team

CLIENT | Philippine National Oil Company (PNOC)

TOOLS | Adobe Photoshop and PageMaker,
 Macromedia FreeHand

PAPER | C2S 220, Matte 80 lb.

PRINTING PROCESS | Offset

The challenge for PNOC's 1995–1996 annual report
was to create a divergent approach to the usual tech-
nical presentation common to petroleum companies,
while conveying their adaptation and responsiveness
to ever-changing environments. The strategy of using
oil pastel renditions successfully met this challenge
and strengthened the company's position as a
responsible leader in the petroleum industry.

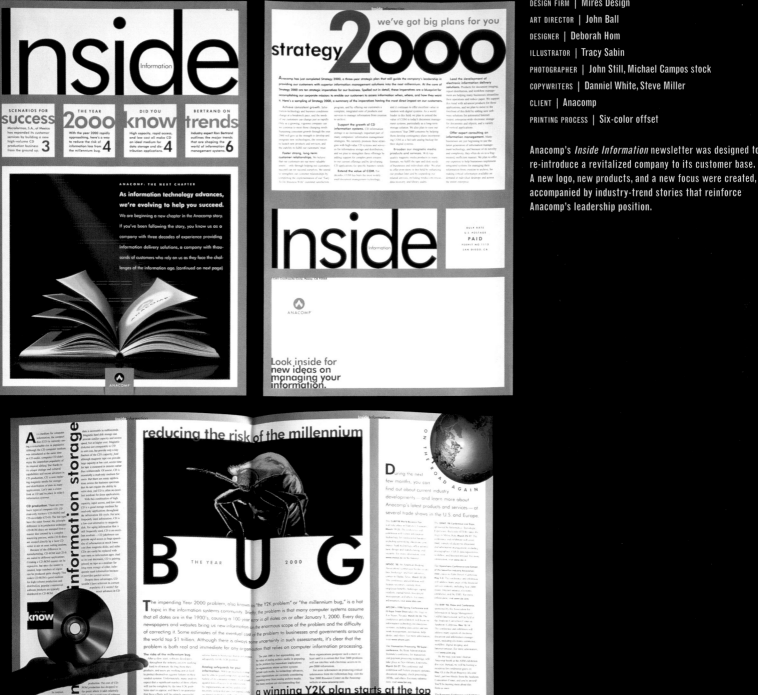

DESIGN FIRM | Mires Design

ART DIRECTOR | John Ball

DESIGNER | Deborah Hom

ILLUSTRATOR | Tracy Sabin

PHOTOGRAPHER | John Still, Michael Campos stock

COPYWRITERS | Danniel White, Steve Miller

CLIENT | Anacomp

PRINTING PROCESS | Six-color offset

Anacomp's *Inside Information* newsletter was designed to re-introduce a revitalized company to its customer base. A new logo, new products, and a new focus were created, accompanied by industry-trend stories that reinforce Anacomp's leadership position.

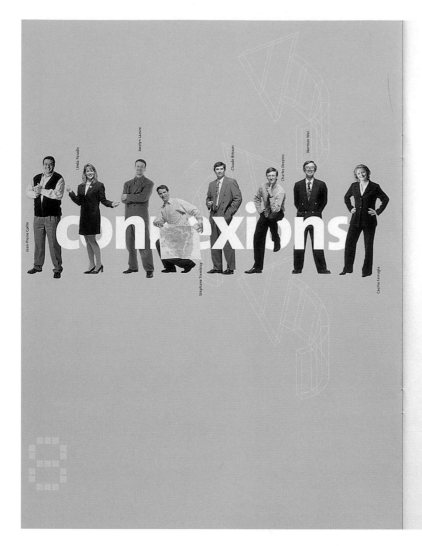

With a national 30 MHz licence to operate PCS in the 1.9 GHz range, Microcell Connexions is the only Canadian company to deploy, operate and market an open wireless telecommunications network based on the GSM standard. In addition, Connexions wholesales its network, making it available to service providers and entrepreneurs who wish to enter the wireless market and offer their own services.

Microcell's GSM network serves five regions, and currently offers digital coverage to nearly 40% of the Canadian population, and by the end of 1998, it will cover the majority of the population. Roaming on AMPS networks increases coverage to 94% of the Canadian population.

The approach is simple:

| Adopt a well-proven technology that is on the leading edge in terms of costs and product development and is a world standard.

| Build out a cost-effective network to support the economics of a mass-market approach: build in densely populated areas where people live, work and spend their leisure time; offer roaming on the cellular analog network between cities and in remote areas; offer worldwide coverage through roaming on the networks of its GSM counterparts.

| Design an open network and offer it to other providers on a wholesale basis, to quickly leverage the network investment, and capitalize on the opportunities created by additional niche and full-service operators entering this market.

In the first half of 1998, Microcell expects that the network will be rolled out progressively to an additional 3.7 million Canadians, rapidly increasing the overall population coverage. Networks will be launched in areas such as Victoria, Edmonton, Calgary and Barrie. Microcell is also working towards additional roaming services in other centres in the U.S. and overseas.

THE GSM ADVANTAGE

| GSM (GLOBAL SYSTEM FOR MOBILE COMMUNICATIONS) IS THE WORLD'S LEADING WIRELESS DIGITAL TECHNOLOGY, WITH NETWORKS OPERATING IN 109 COUNTRIES, SERVING 66 MILLION SUBSCRIBERS AT THE END OF 1997. TWO MILLION NEW GSM CUSTOMERS ARE ADDED EVERY MONTH WORLDWIDE. GSM NOW ACCOUNTS FOR 31% OF THE WORLD'S TOTAL WIRELESS MARKET. ONLY GSM HANDSETS USE A SMART CARD, CONTAINING THE CUSTOMER'S INDIVIDUAL AUTHENTICATION KEY, PERSONAL IDENTIFICATION AND SERVICE PROFILE INFORMATION. GSM OFFERS SUPERIOR VOICE QUALITY, CALL PRIVACY AND THE ADVANTAGES OF NATIONAL AND INTERNATIONAL ROAMING.

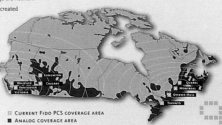

☐ CURRENT FIDO PCS COVERAGE AREA
■ ANALOG COVERAGE AREA

DESIGN FIRM | Goodhue & Associés Design Communication
CREATIVE DIRECTOR | Lise Charbonneau
ART DIRECTOR | Paulo Correia
DESIGNERS | Josée Barsalo, Aube Savard
ILLUSTRATOR | Daniel Huot
PHOTOGRAPHER | Jean-Francois Berube
COPYWRITER | Microcell Solutions Language Services
CLIENT | Microcell Telecommunications Inc.
TOOLS | QuarkXPress, Macromedia FreeHand, Infini D
PRINTING PROCESS | Offset

During 1997, the client revolutionized personal communications and experienced outstanding growth. They wished to emphasize the personnel responsible, hence the use of vibrant-yellow, human figures on the cover, and staff photos inside.

The Beresford process starts with an examination of your existing applications and architecture—your departments, users' requirements, software requirements and the like—and compares them against the Beresford Model. From here, Beresford cost-effectively provides Design, Project

MODELS CREATE THE ULTIMATE SOLUTION

Management, and Professional Skills to a successful implementation. Although implementation may differ from customer to customer, the Beresford approach will tailor the system exactly to meet your needs, while maintaining a package. You may require a phased implementation, for example, leaving some legacy systems in place while replacing others. – Beresford is a powerful system that enables you to see your loan, lease and credit card business while it is in process. The movement and flow of information can be managed throughout the day, at any moment and from any location, regardless of where it originates. —

In 1927, Charles Lindbergh made the idea of aviation technology less intimidating by being the first to fly alone and non-stop across the Atlantic Ocean from New York to Paris in a high-wing monoplane, "The Spirit of St. Louis."

MODELS IN FLIGHT

BERESFORD

DESIGN FIRM | ZGraphics, Ltd.
ART DIRECTOR | Joe Zeller
DESIGNER | Renee Clark
ILLUSTRATOR | Paul Turnbaugh
CLIENT | Beresford

Beresford has created a comprehensive loan, lease, and credit-card system adaptable every part of any finance company. They achieve this adaptability by producing models that are customized to the target business. The concept of airplane model-building helps to convey Beresford's strategy while focusing on their theme: models in flight.

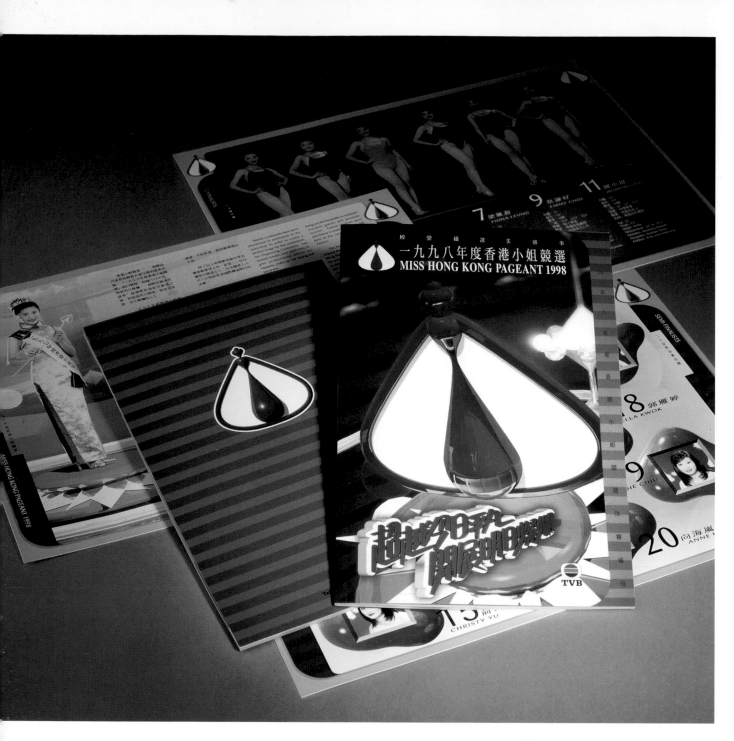

DESIGN FIRM | Television Broadcasts Limited

ART DIRECTOR | Alice Yuen-wan Wong

PRINCIPAL DESIGNER | Andrew Pong-yee Chen

DESIGNER | Tom Shu-wai Cheung

CLIENT | Miss Hong Kong Pageant 1998

TOOLS | Adobe Illustrator and Photoshop,
Macromedia FreeHand

PAPER | 150 gsm art paper

PRINTING PROCESS | Four-color plus one Pantone on cover;
four-color inside

To convey the pageant is "as glamorous as a crystal palace,"
the designers created a three-dimensional environment and
gave the pageant's logo a magical appearance.

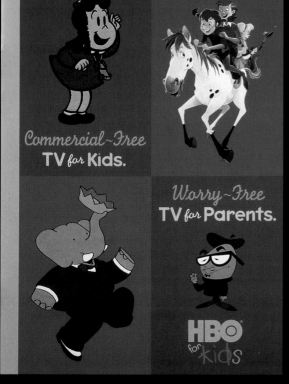

Commercial~Free
TV *for* **Kids.**

Worry~Free
TV *for* **Parents.**

HBO
for
kids

DESIGN FIRM | SJI Associates Inc.
ART DIRECTOR | Susan Seers
DESIGNER | Karen Lemke
COPYWRITER | Jessy Vendley
CLIENT | HBO, Cindy Matero
TOOLS | QuarkXPress, Adobe Photoshop and Illustrator
PRINTING PROCESS | Offset

HBO wanted a brochure design that would promote their line-up of children's programming and give each program the space to show its own personality. The use of patterned backgrounds gave each spread its own identity, while tying the brochure together.

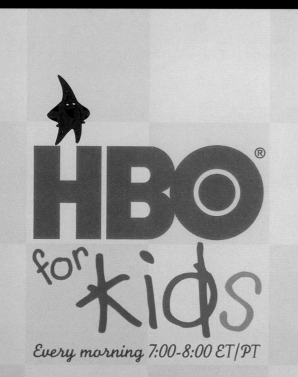

HBO®
for kids

Every morning 7:00-8:00 ET/PT

More than ever, parents are concerned about what their kids are exposed to on television. Which is why we created HBO for Kids—a fun, enriching alternative to commercially driven children's programming. We don't answer to advertisers; we answer to parents. Which means HBO for Kids airs only programs that parents can feel good about. Intelligent shows that are as educational as they are entertaining, and scheduled at sensible times so that kids of all ages can enjoy them.

...so much fun, kids don't even notice it's good for them!

DESIGN FIRM | AWG Graphics Communicação, Ltda.
ART DIRECTOR | Renata Claudia de Cristofaro
DESIGNERS | Dennys Lima, Marcello Gava
CLIENT | Reifenhäuser Ind. Maq. Ltda.
TOOLS | Adobe Photoshop, CorelDraw, PC
PAPER | Couchê 180 gsm
PRINTING PROCESS | Offset

This brochure was designed to sell plastic extrusion machinery by artistically showing the final product and its applications. To achieve this objective, the designers mixed products obtained by the machinery with the machinery itself.

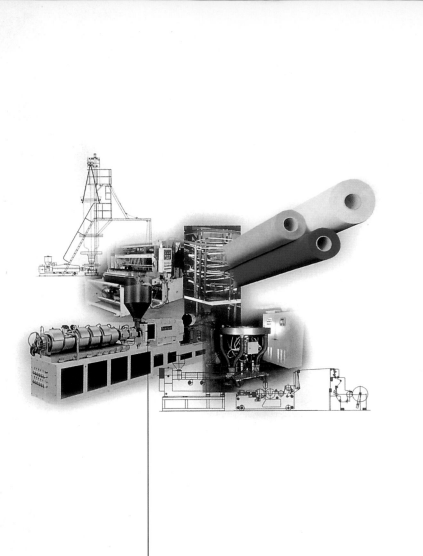

Reifenhäuser
Extrusão com Perfeição

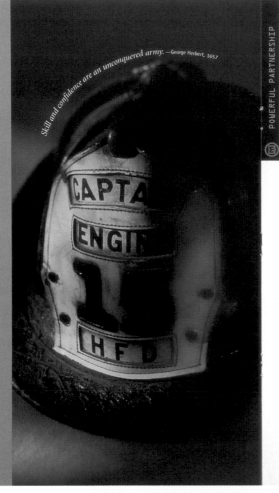

Moonlight Media puts the power and potential of online media at your service.

Skill and confidence are an unconquered army. —George Herbert, 1657

Our experienced, imaginative staff is ready to serve as your technology partner, helping you achieve your business goals with speed and efficiency. And Moonlight Media's commitment to you is ongoing. Once we design your Internet or Intranet site, we consult with you on developing

your strategy and targeting your audience. And our technology experts keep you aware of emerging tools and opportunities that will prove valuable to you and the success of your business.

You see, Moonlight Media takes a handcrafted approach to handling your Internet, Intranet, and Web-based needs. And if you think "handcrafted" is an inappropriate term to describe an outfit whose stock in trade is leading-edge online technology, please keep this in mind:

Our company is not about technology. Our company is about using technology to help your company do business more successfully.

James M. Vardaman & Company

For this forestry consulting firm, Moonlight Media developed a web site that provides critical timber market information for investors, along with a private archive of timber publications that may be reviewed by authenticated site members. We also constructed a JAVA-based software tool that allows site visitors to demo the company's PTAEDA2V+ECONVR software that predicts timber yields and their associated financial returns.

Stuart C. Irby Company

Moonlight Media constructed a territory planning and reporting tool for Irby that allows outside salesmen to plan and track their weekly sales activity. Salesmen use custom Active X controls, developed by Moonlight Media, to enter their plans into the parent Call Planner database. Once entered, these plans are tracked and later married to mainframe data to generate performance reports. Managers also have the capability to log on and review the call planning activity.

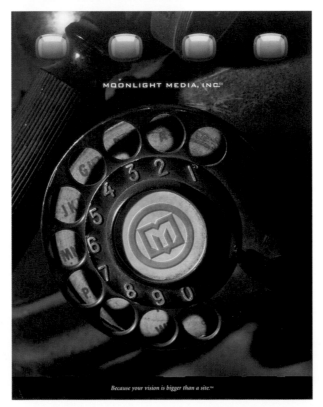

MOONLIGHT MEDIA, INC.℠

Because your vision is bigger than a site.℠

DESIGN FIRM | Communication Arts Company

ART DIRECTOR/DESIGNER | Hilda Stauss Owen

PHOTOGRAPHER | Photodisc: Design Photo Image

COPYWRITER | David Adcock

CLIENT | Moonlight Media, Inc.

TOOLS | Macromedia FreeHand

PAPER | Stock Karma

PRINTING PROCESS | Four-color offset lithography

In contrast to the youthful client's high-tech enterprise of Web design and services, the designers chose a striking collection of nostalgic images that suggest tried-and-true reliability and strength.

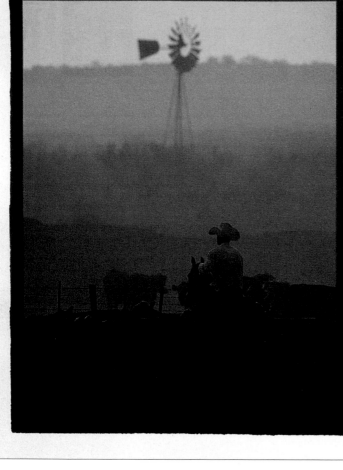

Successful discoveries last year on the Pitchfork Ranch have resulted in daily production of 350 barrels of oil, and additional acreage is scheduled for 3D seismic surveys in 1998.

the history behind PITCHFORK RANCH

The circus partnership of Barnum & Bailey was not the only important alliance formed in 1881. Eugene Williams and Dan Gardner, boyhood friends in Mississippi before the Civil War, joined forces that year to start a cattle business on the South Wichita River near Lubbock, Texas. The last quarter of the 19th century was a rough-and-tumble time for the growing cattle industry. Surviving drought, severe winters, unstable prices and occasional rustlers, the Pitchfork Ranch held title to 97,000 acres and had increased its herd to more than 12,000 cattle by 1900.

The present-day operation, an outstanding example of perseverance, loyalty and respect for the cowboy way of life, has incorporated the modern world of helicopters and cellular phones with traditions of the past, including the historic chuckwagon, seasonal roundups and a brand that has been around since 1843. The 165,000-acre ranch in central West Texas has endured over 100 years of assorted political and economical difficulties that defeated many large cattle syndicates from ranching's Golden Era.

The descendants of Eugene Williams have been directly involved in the Pitchfork Land and Cattle Company since it was incorporated in 1883. With a century of consolidation and acquisitions, the ranch is actually larger today than at any other time in its history. Louis Dreyfus Natural Gas and Pitchfork, sharing a belief in traditional standards of trust and honesty, work together for results that are mutually beneficial to both companies.

continued from page 17 | OFFSHORE This acreage position was acquired after evaluating seismic data information compiled by the Company that indicates multiple targets at depths ranging from 8,000 to 12,000 feet. Of the total $25 million budgeted for offshore drilling, $18 million, or 72 percent, is slated for exploration activities in 1998. To counter an industry shortage of offshore drilling rigs, the Company has entered into a six-month drilling rig contract with an option to extend the contract for another six months. Louis Dreyfus Natural Gas plans to drill at least five exploratory wells and has identified 11 additional prospects.

exploration.WESTERN The Permian Basin of southeast New Mexico and West Texas is another region in which Louis Dreyfus Natural Gas has committed to important exploration projects. The Company's leasehold inventory of over 1.2 million acres will yield approximately 15 exploration wells in 1998 with a focus on projects in the Midland, Val Verde and the Delaware Basins of New Mexico. Typical exploration targets are the Strawn, Morrow and Atoka, with depths ranging from 7,000 to 13,000 feet. Forty percent of the total drilling budget for the Western region will go to exploration projects.

Pitchfork Ranch continues to be a successful and promising project; the Company has exclusive exploration rights and a 78 percent working interest in 140,000 gross acres. Louis Dreyfus Natural Gas negotiated with the landowners of this working ranch in West Texas to be one of the first companies to shoot a large 3D seismic project. Following a 30-square-mile survey and four successful Tannehill discoveries last year, there are plans for at least four more exploratory wells in 1998. Knowledge gained from this shoot and from current drilling is being used to identify similar anomalies in the ranch area. The Company has plans for a new 50-square-mile 3D survey; after evaluation of this data, additional drilling is expected to begin by the fourth quarter.

exploration.MID-CONTINENT Louis Dreyfus Natural Gas properties in Oklahoma, Kansas and the Texas Panhandle represent some of its most established production. And despite the extensive amount of development in this area, exploration teams have successfully identified numerous targets, each of which has the potential for daily production levels exceeding one million cubic feet. Almost one-fourth of the $40 million total drilling budget will focus on exploratory targets, including the Watonga-Chickasha Trend which produces from the Morrow/Springer formation.

18 19

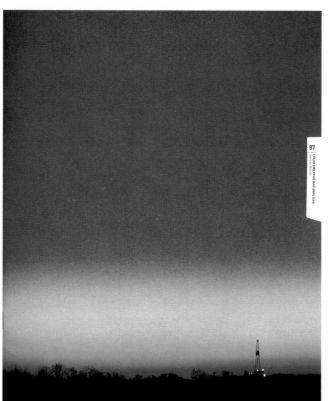

97

DESIGN FIRM | Wood Design

ART DIRECTOR | Tom Wood

DESIGNERS | Tom Wood, Alyssa Weinstein

PHOTOGRAPHER | Chris Shinn

COPYWRITER | Maryanne Costello

CLIENT | Louis Dreyfus Natural Gas

TOOLS | QuarkXPress, Adobe Illustrator

PAPER | Mohawk Navaho

PRINTING PROCESS | Six-color, die-cut

The annual report parallels the exploration and production activities of the company and the lives of the cowboys and ranchers working on the properties. The design contrasts editorial and technical attitudes through typography, journalistic photography, feature stories, color, and sequence.

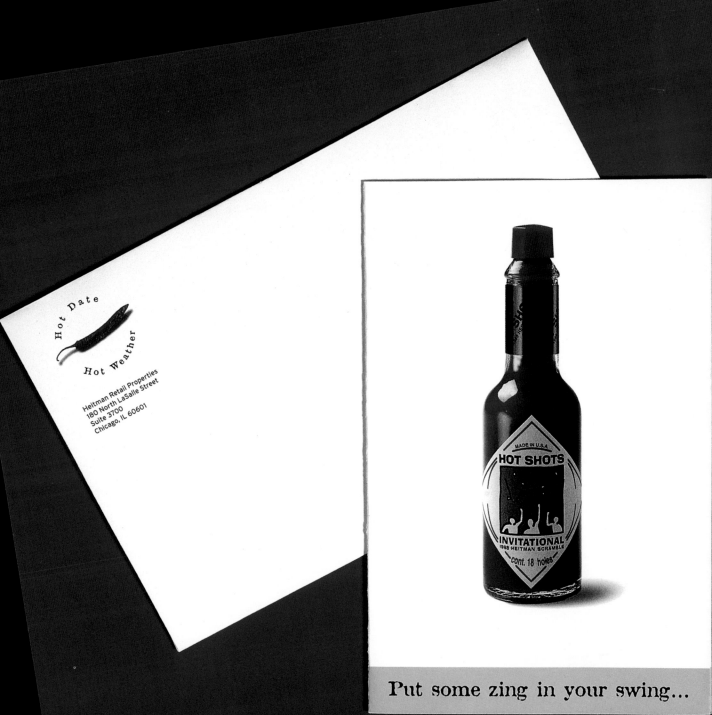

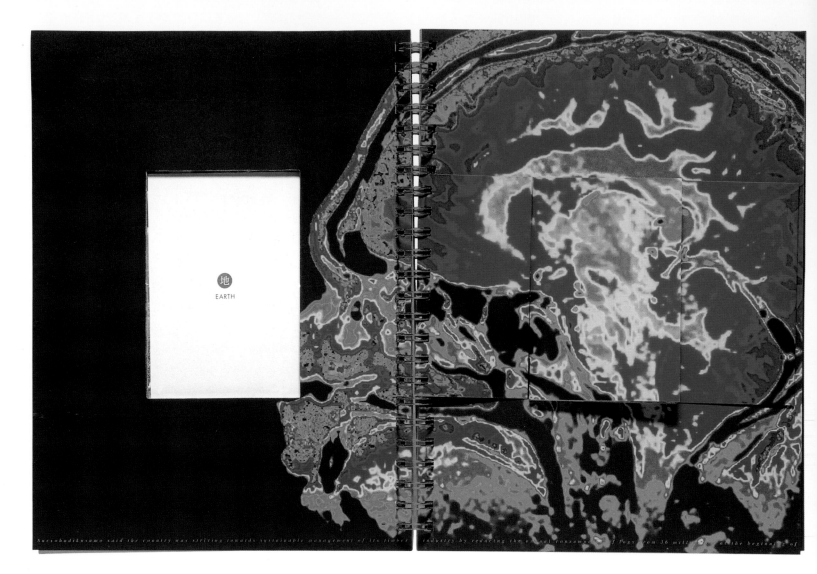

地

EARTH

Suryohadikusumo said the country was striving towards sustainable management of its timber industry by reducing the annual consumption of logs from 36 million at the beginning of

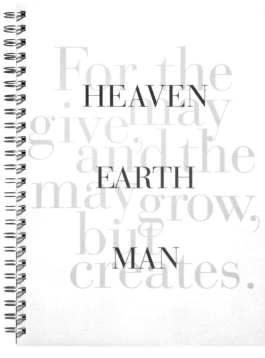

HEAVEN

EARTH

MAN

For the give may and the may grow, but creates.

DESIGN FIRM | Alan Chan Design Company

ART DIRECTOR | Alan Chan

DESIGNERS | Alan Chan, Peter Lo, Pamela Low

COPYWRITERS | Margaret Tsui, Todd Waldson, Ann Williams

CLIENT | Swank Shop

The Chinese philosophy of heaven, earth, and man was adopted as the metaphor in this environmentally themed brochure. Heaven and earth easily translated to the sections for the Swank Shop and A Swank Inspiration, respectively. The concept behind the Man section for the Swank Studio, however, depicts the evolution of humankind and the influence of technology.

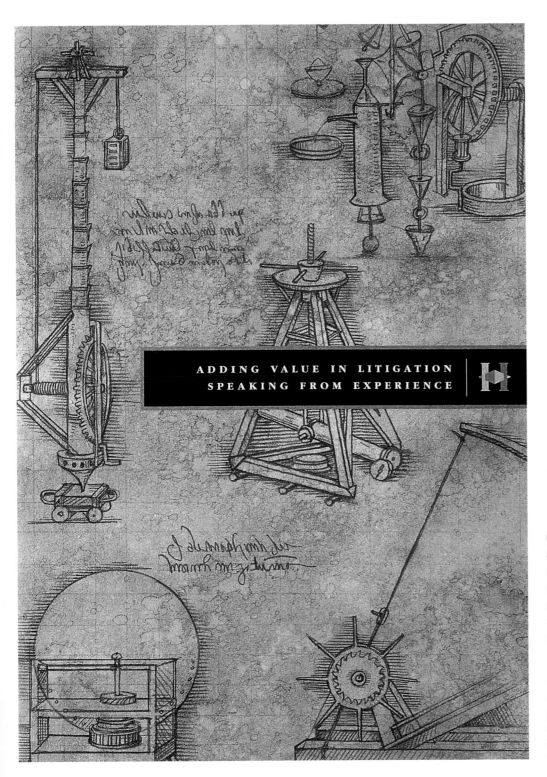

ADDING VALUE IN LITIGATION
SPEAKING FROM EXPERIENCE

DESIGN FIRM | Julia Tam Design

ART DIRECTOR/DESIGNER | Julia Chong Tam

ILLUSTRATOR | Kirk Caldwell

COPYWRITER | Dennis Moore

CLIENT | Houlihan Howard Lokey and Zukin

TOOLS | QuarkXPress, Adobe Photoshop

PAPER | 80 lb. Superfine cover, Mohawk eggshell soft
white smooth

The client wanted an Leonardo da Vinci—type drawing
to show class and simplicity, so the designers scanned in
paper with an aged patina to simulate old-time paper. The
client also needed pockets to hold cards, but wanted to be
sure that the cards did not fall out. The designers decided
on a glued-in flap and stepped slits for a strong display.

DESIGN FIRM | Jeff Fisher Logo Motives
CREATIVE DIRECTOR | Sara Perrin, Seattle Seahawks
DESIGNER/ILLUSTRATOR | Jeff Fisher
PHOTOGRAPHERS | Various
COPYWRITER | Sara Perrin
CLIENT | Seattle Seahawks
TOOLS | Macromedia FreeHand, Macintosh
PRINTING PROCESS | Six-color process

This multi-element package of materials for the Seattle
Seahawks promotes their 1998–1999 season. Various
pieces can be used to target potential corporate sponsors,
season-ticket holders, and the general public.

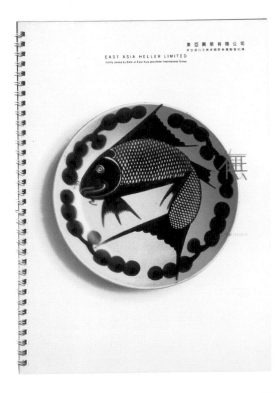

DESIGN FIRM | Alan Chan Design Company
ART DIRECTOR | Alan Chan
DESIGNERS | Alan Chan, Jiao Ping
CLIENT | East Asia Heller Ltd.

The fish visual was adopted to symbolize the proficient and Chinese-focused services the client provides. Four Chinese idioms, each containing a word-play on fish, were used to highlight four successful business stories. The cover is a familiar Chinese-style dish with an acetate overlay of a fish; this layout allows the fish to transfer over the empty plate—a metaphor for prosperity and abundance.

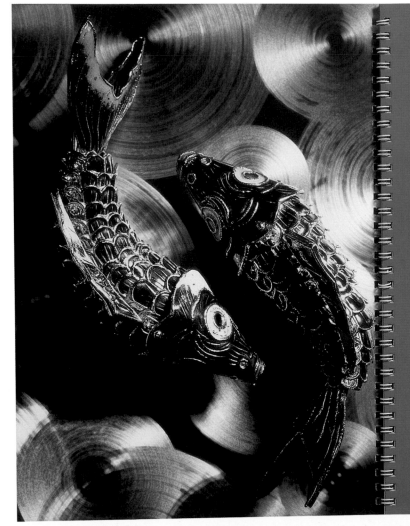

東亞興萊勇於打破傳統的融資方式，為高雅線圈提供發票貼現與機器租賃服務；信貸額緊隨銷售額遞增，緊密配合高雅線圈急速擴展的業務，令公司業務架構日益完備。從無至有，有賴融資及時而充足，如魚得水。

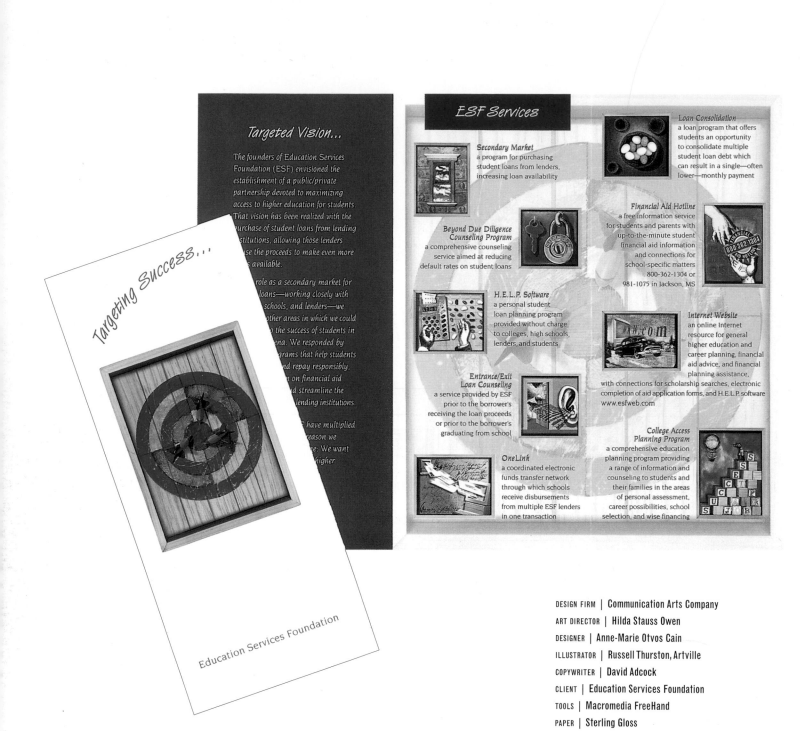

Targeted Vision...

The founders of Education Services Foundation (ESF) envisioned the establishment of a public/private partnership devoted to maximizing access to higher education for students. That vision has been realized with the purchase of student loans from lending institutions, allowing those lenders [to u]se the proceeds to make even more [loan]s available.

[In our] role as a secondary market for [student] loans—working closely with [students,] schools, and lenders—we [saw] other areas in which we could [add to] the success of students in [this are]na. We responded by [developing prog]rams that help students [borrow a]nd repay responsibly, [educate them] on financial aid [options, an]d streamline the [process for] lending institutions.

[The results of ES]F have multiplied [... the r]eason we [... our nam]e: We want [... toward] higher

Targeting Success...

Education Services Foundation

ESF Services

Secondary Market
a program for purchasing student loans from lenders, increasing loan availability

Beyond Due Diligence Counseling Program
a comprehensive counseling service aimed at reducing default rates on student loans

H.E.L.P. Software
a personal student loan planning program provided without charge to colleges, high schools, lenders, and students

Entrance/Exit Loan Counseling
a service provided by ESF prior to the borrower's receiving the loan proceeds or prior to the borrower's graduating from school

OneLink
a coordinated electronic funds transfer network through which schools receive disbursements from multiple ESF lenders in one transaction

Loan Consolidation
a loan program that offers students an opportunity to consolidate multiple student loan debt which can result in a single—often lower—monthly payment

Financial Aid Hotline
a free information service for students and parents with up-to-the-minute student financial aid information and connections for school-specific matters 800-362-1304 or 981-1075 in Jackson, MS

Internet Website
an online Internet resource for general higher education and career planning, financial aid advice, and financial planning assistance, with connections for scholarship searches, electronic completion of aid application forms, and H.E.L.P. software www.esfweb.com

College Access Planning Program
a comprehensive education planning program providing a range of information and counseling to students and their families in the areas of personal assessment, career possibilities, school selection, and wise financing

DESIGN FIRM | Communication Arts Company
ART DIRECTOR | Hilda Stauss Owen
DESIGNER | Anne-Marie Otvos Cain
ILLUSTRATOR | Russell Thurston, Artville
COPYWRITER | David Adcock
CLIENT | Education Services Foundation
TOOLS | Macromedia FreeHand
PAPER | Sterling Gloss
PRINTING PROCESS | Four-color, offset lithography

As an extension of an existing corporate publication, this pamphlet highlights the specific services with playfully abstract collage illustrations.

DESIGN FIRM | Television Broadcasts Limited

ART DIRECTOR | Alice Yuen-wan Wong

Who Is UIS?

DESIGN FIRM | Tom Fowler, Inc.

ART DIRECTOR | Thomas G. Fowler

DESIGNER | Karl S. Maruyama

PHOTOGRAPHER | Tod Bryant/Shooter, Inc.

COPYWRITER | Brad Elliot

CLIENT | UIS, Inc.

TOOLS | QuarkXPress, Adobe Illustrator and Photoshop

PAPER | Neenah Classic Columns, Zanders Ikono Gloss

PRINTING PROCESS | Offset and foil stamping

UIS needed a brochure to send to brokers and prospective sellers describing who they are, what kind of business they buy, and the kinds of products their subsidiaries produce.

U I S

Dom Antonellis joined New England Confectionery as an engineer. His first assignment: Modernize the company's outdated production lines. That success led to others, and in 1978 he became president, a position he holds today. "We've built an organization in which companies can thrive" he says. "There is no corporate bureaucracy to deal with, and by bringing so many great brands together we open the way to more effective marketing and stronger year-round sales."

More than eight billion Sweetheart Conversation Hearts are sold annually, and together with NECCO's Sweet Talk line they make the company the leading manufacturer of these products. Contempo-rary slogans keep this classic brand fresh and product popularity high.

Masterpieces is an extension of the famous Candy Cupboard line of boxed chocolates. Marketed exclusively through more than 2,000 K-Mart stores across the country, the brand was created to further strengthen the entire company's position in the mass merchandiser marketplace.

U I S

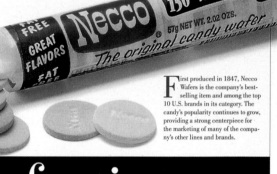

First produced in 1847, Necco Wafers is the company's best-selling item and among the top 10 U.S. brands in its category. The candy's popularity continues to grow, providing a strong centerpiece for the marketing of many of the company's other lines and brands.

Confectionery

The New England Confectionery Company is the oldest multi-line candy company in the United States. UIS acquired it in 1963. Today, with its two divisions, Stark Candy Company and Haviland Candy, Company, the $100-million company is steadily expanding through a highly aggressive brand development strategy, year-round product marketing programs and strategic acquisitions.

Haviland Thin Mints became the top-selling brand in its category after UIS acquired the company. Today it is one of the backbones of the company's comprehensive product line.

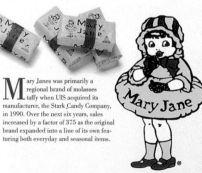

Mary Janes was primarily a regional brand of molasses taffy when UIS acquired its manufacturer, the Stark Candy Company, in 1990. Over the next six years, sales increased by a factor of 375 as the original brand expanded into a line of its own featuring both everyday and seasonal items.

PAGE 7

every day in America **8** firefighters
will suffer a respiratory injury,
of those, **1** out of **24** will die.

over **56,000** deaths and injuries
were related to Carbon Monoxide
over a period of **10** years.
no other poisonous agent has
ever been implicated in
so many deaths.

about **250** people die,
and thousands more are injured each year from accidental Carbon Monoxide poisoning.

On a Tuesday, in one of our plants that is environmentally controlled, with stringent, comprehensive Electrostatic Discharge (ESD) systems in place, where Die Attachment, Calibration, Wire Bonding and highly sensitive, proprietary operations are performed in a class 1000 clean room - hazardous gas detection equipment is manufactured by hand specifically for, among others, the challenging tasks of today's Firefighter.

At the same time dashing from a hazardous response truck, a Firefighter responds to the urgent need to assess the threat of a grimy railcar-derailment, spilling Chlorine gas, or perhaps to a lethal domestic Carbon Monoxide leak from a household furnace some half a hemisphere away. In an instant, two worlds meet over a gas-safety device which in either case will serve to protect and save human life - an AIM Safety gas detector.

AiM Safety gas detection products have always brought people and safety together. The relationships we've formed over gas safety are significant and deep. Friendships with our nations fire departments... with industrial corporations, utilities and select marketing partners... with our customers and within communities - these are the relationships that help define us as a company, set us apart, and are responsible for our growth and success.

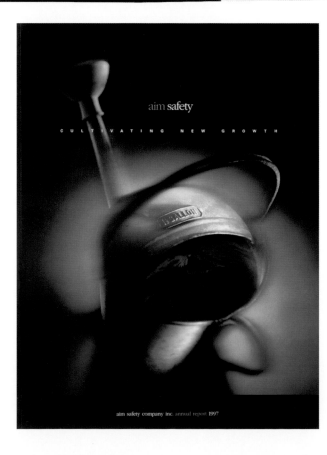

aim **safety**

CULTIVATING NEW GROWTH

aim safety company inc. annual report 1997

DESIGN FIRM | Big Eye Creative, Inc.

ART DIRECTOR/DESIGNER | Perry Chua

ILLUSTRATOR | Stephen Dittberner

PHOTOGRAPHERS | Grant Waddell, Dann Ilicic

COPYWRITER | Craig Holm

CLIENT | Aim Safety Company, Inc.

TOOLS | Adobe Illustrator and Photoshop, QuarkXPress

PAPER | Cover and text: Utopia;
financial section: Potlatch Karma Natural

PRINTING PROCESS | Six colors: four process, spot metallic,
spot varnish

The watering can is a universal symbol of careful nurturing, growth, and rejuvenation of life, and here it represents the seeds of the future carefully planted by management. The concept also relates nicely with Aim's main business—saving lives with their gas-detection equipment.

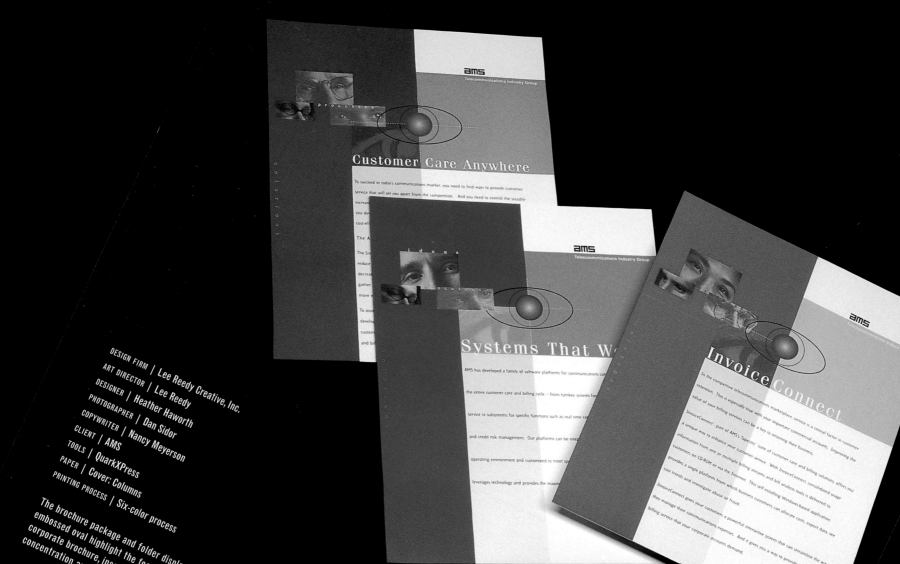

DESIGN FIRM | Lee Reedy Creative, Inc.

ART DIRECTOR | Lee Reedy

DESIGNER | Heather Haworth

PHOTOGRAPHER | Dan Sidor

COPYWRITER | Nancy Meyerson

CLIENT | AMS

TOOLS | QuarkXPress

PAPER | Cover: Columns

PRINTING PROCESS | Six-color process

The brochure package and folder display
embossed oval highlight the foc...
corporate brochure, ins...
concentration a...

1996 ANNUAL REPORT

Linn Area Credit Union

DESIGN FIRM | Marketing & Communication Strategies Inc.

DESIGNER | Lloyd Keels

PHOTOGRAPHER | Marketing & Communication Strategies Inc.

CLIENT | Linn Area Credit Union

TOOLS | QuarkXPress, Adobe Illustrator and Photoshop

PAPER | Neenah Classic Laid cover; Olympian 80 lb. coated text

PRINTING PROCESS | Two color offset

The client wished to have an annual report that was modern and classy without a lot of printing extras. A two-color design with ornate icons and interesting page headers and footers created a piece that conveyed the personality of the growing credit union.

AUDIT COMMITTEE REPORT

The Audit Committee is responsible for monitoring and evaluating credit union activities. The committee reviews credit union procedures to ensure that the highest degree of integrity is maintained in operations and that the Credit Union adheres to all federal and state laws and regulations.

This year, the Audit Committee retained the auditing firm of Petersen & Associates of Omaha, Nebraska, to assist in carrying out its responsibilities. This firm conducted a comprehensive audit and performed a full examination of the Credit Union's financial statements for the calendar year 1996. The audit and examination revealed no areas of concern and confirmed the soundness of the Credit Union. A letter from the firm's latest audit is included in this report.

Each year, Petersen & Associates performs a verification of member account balances and requests that members notify them of any discrepancies. No significant discrepancies have been reported. The Audit Committee also works with the firm to evaluate the internal controls that are used in the operation of the Credit Union to be sure that all areas of risk are adequately controlled.

In addition to this independent assessment, our Internal Auditor randomly monitors operations through a continuous program of random loan reviews, member account verifications, and other audit procedures to ensure the safety and soundness of your credit union.

Linn Area Credit Union is also examined, on an annual basis, by the Credit Union Division of the State of Iowa. This examination assessed the Credit Union's lending practices and financial operations for compliance with applicable laws and regulations. Linn Area Credit Union was given a favorable report.

As a result of the independent audits, examinations and the observations of the committee, it is our belief that the enclosed financial statements fairly and accurately reflect the financial condition of Linn Area Credit Union as of December 31, 1996.

DONALD WARREN
AUDIT COMMITTEE CHAIRMAN

LLOYD BAIRD

VERYL SIEVERS

CREDIT COMMITTEE REPORT

RAY VANDERWIEL
CREDIT COMMITTEE CHAIRMAN

KENT BAKER

R. MICHAEL GILLEN

The Credit Committee establishes guidelines for the Credit Union's lending programs. The committee has empowered a staff of professional loan officers to meet the borrowing needs of our members and provide knowledgeable solutions and advice. Members are offered a wide range of personal and real estate loans at competitive rates and terms.

Loan demand continued to be active in 1996. Loans granted to members increased 17.3% over the prior year. The Credit Committee is especially pleased to report that the quality of the loan portfolio is outstanding. Throughout the year we maintained very minimal delinquency. At year end only 17 credit cards totaling $57,499.68 were delinquent, and just 7 consumer loans for $47,019.54 and one $195,653.88 mortgage were past due more than 60 days. Out of 5,690 loans this is an incredibly low number and reflects the high moral standards of our members and the fine work of our lending staff.

The mortgage department was busy with first mortgage, construction loan, and refinancing activity throughout the year due to rates maintaining historically low levels. Credit Union members were granted 220 first mortgage loans totaling $16.8 million. This included 23 construction loans, a 69% increase over the prior year. With projections that the current interest rate environment will remain steady, it looks like 1997 will be a very active year as well.

Our MASTERCARD, VISA Classic and VISA Gold programs continue to increase in numbers and attract new members. With all three cards at very competitive interest rates and terms, we were able to increase credit card outstandings to $4,917,817, up from $3,968,248 in December of 1995. The total number of cards has increased from 2,723 to 3,150 reflecting the favorable rates that the Credit Union has to offer.

We congratulate and thank our loan staff for their exceptional efforts over the past year. We also thank you for utilizing the Credit Union for all of your borrowing needs and we look forward to serving you in the future.

DESIGN FIRM | Belyea Design Alliance
ART DIRECTOR | Patricia Belyea
DESIGNER | Ron Lars Hansen
PHOTOGRAPHER | Jim Linna
COPYWRITER | Toby Todd
CLIENT | Pacific Market International
PAPER | Strobe, Classic Columns
PRINTING PROCESS | Hexachrome

This brochure gives an overview of PMI's philosophy,
capabilities, and services. The bold product shots are
designed to show the company's focus on detail and
the active-lifestyle market they target.

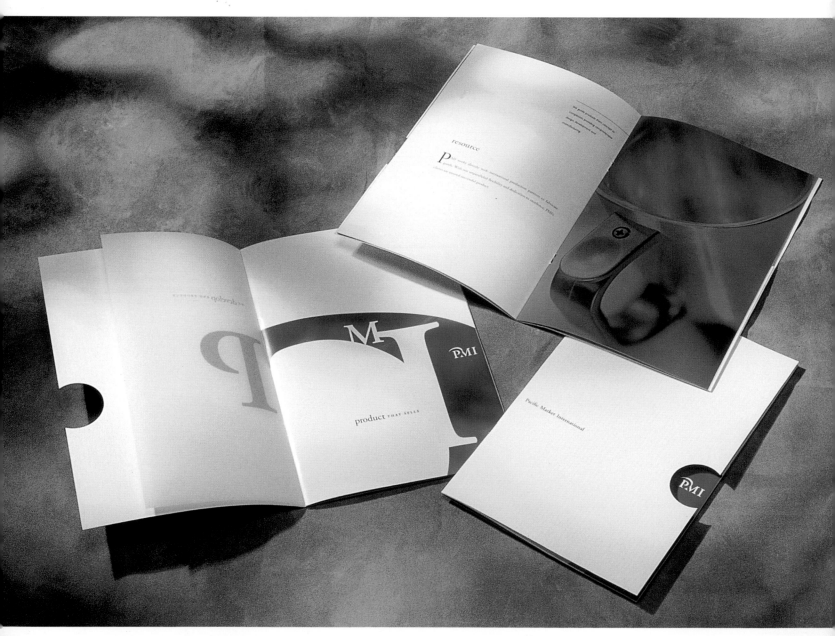

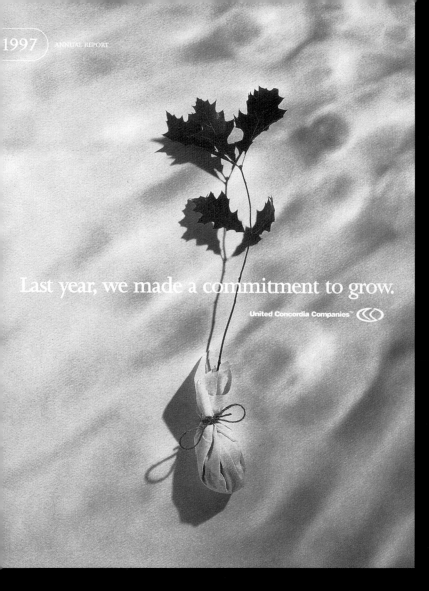

1997 ANNUAL REPORT

Last year, we made a commitment to grow.

United Concordia Companies™

DESIGN FIRM | BrabenderCox
ART DIRECTOR/DESIGNER | Kevin Rayman
PHOTOGRAPHER | Stock, Pat Leeson
COPYWRITERS | Kevin Rayman, Sarah Starr
CLIENT | United Concordia
TOOLS | QuarkXPress, Adobe Illustrator and Photoshop
PAPER | Fox River Sundance, Strathmore Elements
PRINTING PROCESS | Black plus PMS Warm Gray, duotone photos

The client wanted to relate their success in the past year along with a down-to-earth feeling. Because of the small amount of information used in this piece, the designers felt it was important to let the delivery of the information communicate its importance, thus the fold-out pocket folder with inserts.

DESIGN FIRM | Ramona Hutko Design
ALL DESIGN | Ramona Hutko
CLIENT | Computer Sciences Corporation
TOOLS | Adobe Illustrator, QuarkXPress, Macintosh
PAPER | Mohawk Superfine
PRINTING PROCESS | Offset

Since the building interior was incomplete, type was
used as illustration depicting the main messages

Briefing Center Executive

Computer Sciences Corporation

CSC

DESIGN FIRM | Vaughn Wedeen Creative
ART DIRECTOR | Steve Wedeen
COPYWRITER | Foster Hurley
CLIENT | US West

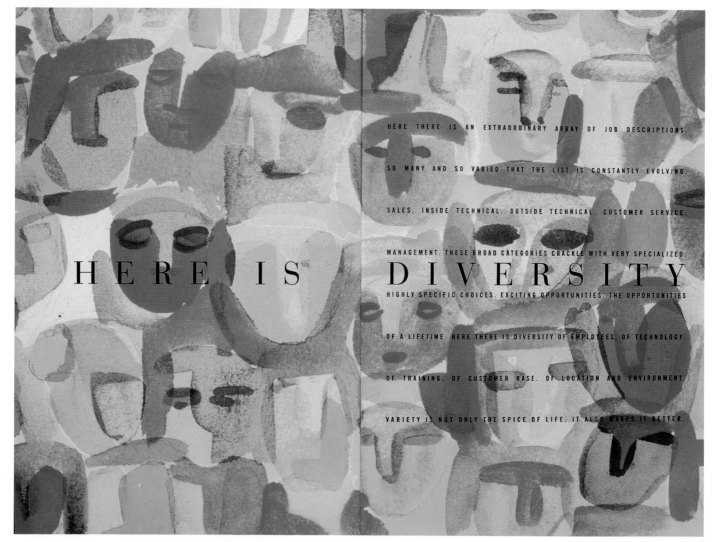

HERE IS DIVERSITY

HERE THERE IS AN EXTRAORDINARY ARRAY OF JOB DESCRIPTIONS.

SO MANY AND SO VARIED THAT THE LIST IS CONSTANTLY EVOLVING.

SALES. INSIDE TECHNICAL. OUTSIDE TECHNICAL. CUSTOMER SERVICE.

MANAGEMENT. THESE BROAD CATEGORIES CRACKLE WITH VERY SPECIALIZED,

HIGHLY SPECIFIC CHOICES. EXCITING OPPORTUNITIES. THE OPPORTUNITIES

OF A LIFETIME. HERE THERE IS DIVERSITY OF EMPLOYEES, OF TECHNOLOGY,

OF TRAINING, OF CUSTOMER BASE, OF LOCATION AND ENVIRONMENT.

VARIETY IS NOT ONLY THE SPICE OF LIFE. IT ALSO MAKES IT BETTER.

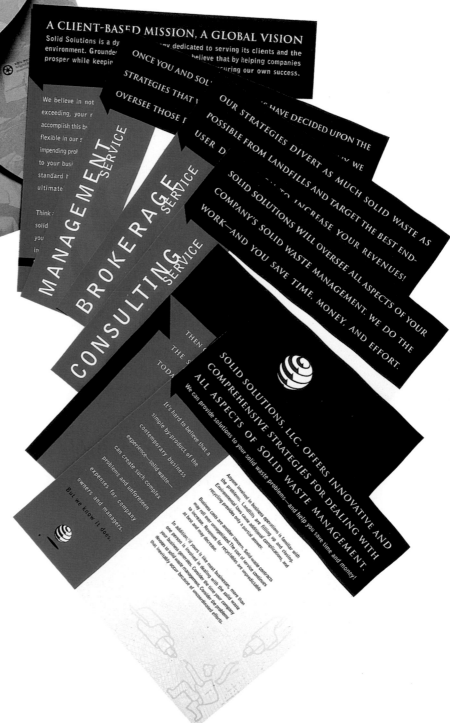

DESIGN FIRM | Insight Design Communications
ART DIRECTORS/DESIGNERS | Tracy and Sherrie Holdeman
CLIENT | Solid Solutions
TOOLS | Macromedia FreeHand

By emphasizing the actual recycling efforts of the
company, the designers chose a practical way to
illustrate the company mission.

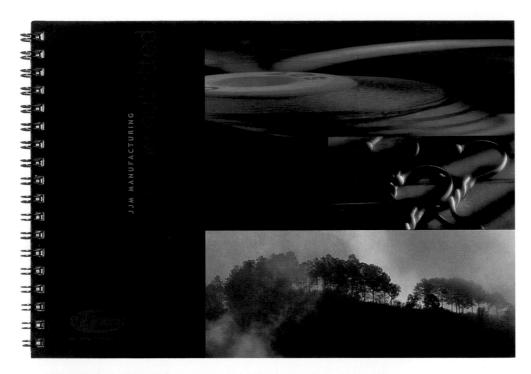

DESIGN FIRM | The Riordon Design Group, Inc.
ART DIRECTOR | Ric Riordon
DESIGNERS | Dan Wheaton, Shirley Riordon, Greer Hutchison, Sharon Pece
PHOTOGRAPHER | Robert Lear
COPYWRITERS | Shirley Riordon, Dan Wheaton, Greer Hutchison
CLIENT | JJM Manufacturing
TOOLS | QuarkXPress, Adobe Photoshop and Illustrator
PAPER | Supreme Gloss Cover, Glama Vellum
PRINTING PROCESS | Four-color stochastic (Somerset Graphics)

Inspired by the client's commission to create a public-relations piece specifically aimed at the high-end corporate market, the designers used soft, textural images and natural colors to visually imply the qualities of the sportswear.

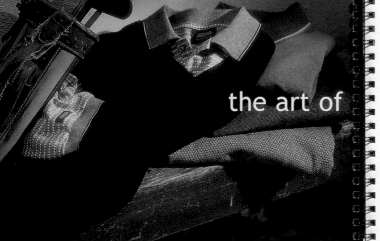

GOLF • The JJM Tour Line goes the distance with soft, 100% cotton lightweight fabrics, subtle patterns and rich hues. The Tour Line embodies a refined style and easy comfort that won't leave you in the rough.

the art of looking good.

It's all about style and quality – it's about being noticed. We're in the business of dressing up your corporate image. More specifically, we design, manufacture and customize garments for companies worldwide.

Our garments are created with careful attention to the smallest detail. Choose from a discerning two-button placket or make a statement with a stylish zippered closure. Our golf shirts will bring you in under par, with labels strategically placed on the right sleeve, to help prevent hooks or slices.

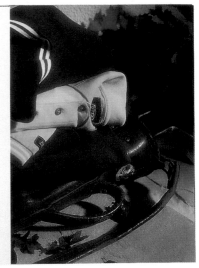

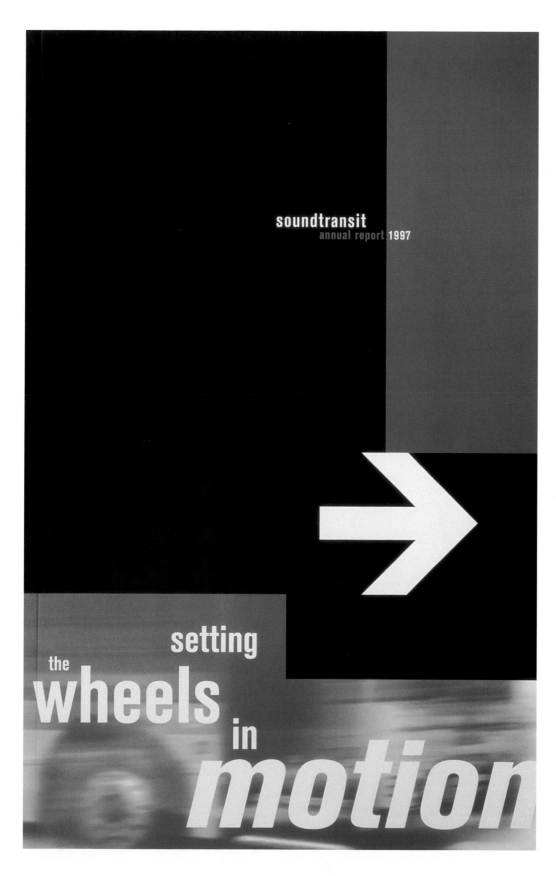

setting the wheels in motion

soundtransit
annual report 1997

DESIGN FIRM | Sound Transit
ART DIRECTOR/DESIGNER | Anthony Secolo
COPYWRITER | Evelyn Eldridge, Tim Healy
CLIENT | Sound Transit
TOOLS | Adobe PageMaker, Macromedia FreeHand
PAPER | Matrix Coronado
PRINTING PROCESS | Two-color plus varnish

Successful elements include metallic ink for the image in metallic monotone and the radius diecut. The client response to this report was ecstatic.

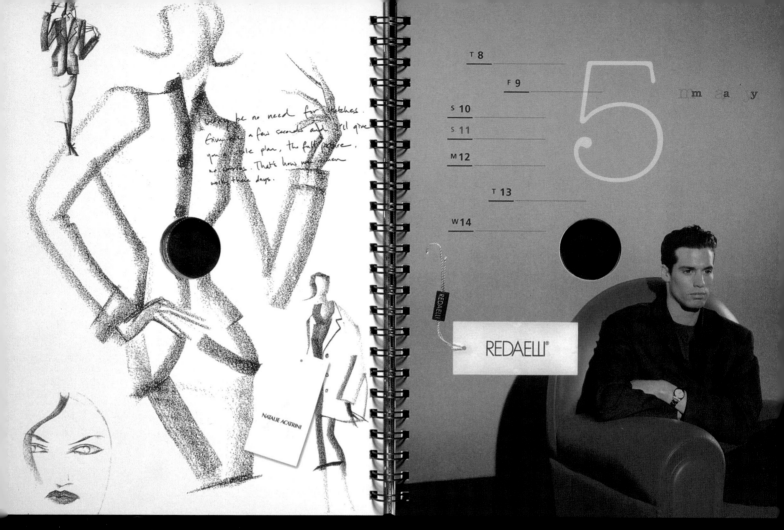

Natalie Acatrini

REDAELLI

THE LEGEND

THE MISSION

THE FASHION

DESIGN FIRM | Alan Chan Design Company
ART DIRECTOR | Alan Chan
DESIGNERS | Alan Chan, Miu Choy, Pamela Low
COPYWRITER | Lam Ping Ting
CLIENT | Swank Shop

The spring/summer fashion catalogue portrays the
evolutionary process of Hong Kong and its fashion scene
during rule by the British. The legend of Nu Wo repairing
the hole in the sky is also included in the design.

DESIGN FIRM | Mervil Paylor Design

ART DIRECTOR/DESIGNER | Mervil M. Paylor

PHOTOGRAPHER | Stock, Kelly Culpepper

COPYWRITER | Melissa Stone

CLIENT | The Close Family

TOOLS | Adobe Photoshop and PageMaker

PAPER | Strathmore Grande

The client is the majority stockholder in Springs Industries, manufacturer of select Ultrasuede.® The branch attached to the cover comes from one of the 6,000 Fort Mill, South Carolina, peach trees grown by client's family since the mid-1800s.

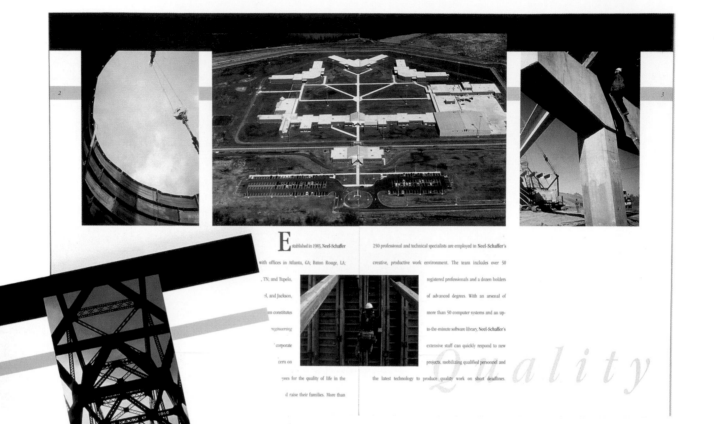

Established in 1983, Neel-Schaffer with offices in Atlanta, GA; Baton Rouge, LA; TN; and Tupelo, l, and Jackson, m constitutes engineering corporate cern on yees for the quality of life in the d raise their families. More than

250 professional and technical specialists are employed in Neel-Schaffer's creative, productive work environment. The team includes over 50 registered professionals and a dozen holders of advanced degrees. With an arsenal of more than 50 computer systems and an up-to-the-minute software library, Neel-Schaffer's extensive staff can quickly respond to new projects, mobilizing qualified personnel and the latest technology to produce quality work on short deadlines.

Quality

NEEL-SCHAFFER, INC.
ENGINEERS • PLANNERS • LANDSCAPE ARCHITECTS

DESIGN FIRM | Communication Arts Company
ART DIRECTOR | Hap Owen
DESIGNER | Anne-Marie Otvos Cain
COPYWRITER | David Adcock
CLIENT | Neel-Schaffer, Inc.
TOOLS | Macromedia FreeHand, Adobe Photoshop
PAPER | Potlatch Karma, Neenah classic laid, Kromekote
PRINTING PROCESS | Five-color, offset lithography

The purpose of this booklet was to highlight the client's vast capabilities. Their large-scale projects called for large-scale photographs. The challenge was to keep rhythm and symmetry throughout using a variety of photographs and subjects.

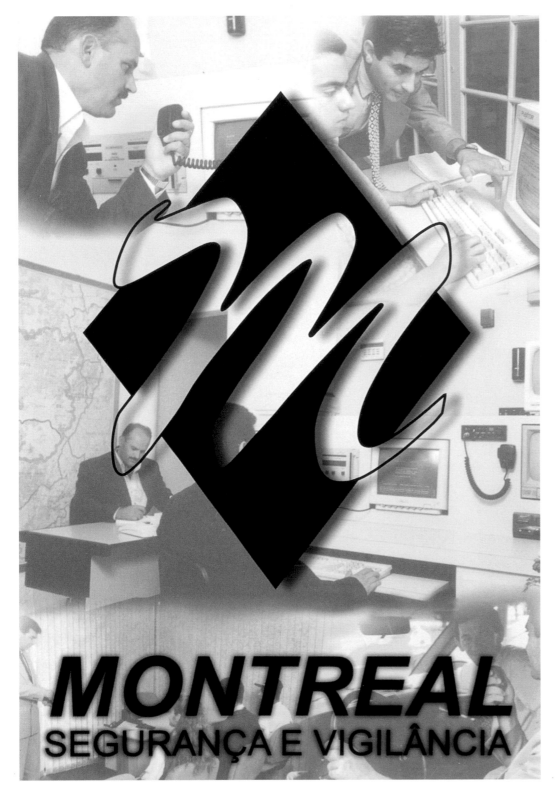

MONTREAL
SEGURANÇA E VIGILÂNCIA

DESIGN FIRM | AWG Graphics Communicação, Ltda.
ART DIRECTOR | Renata Claudia de Cristofaro
DESIGNER | Luciana Vieira
PHOTOGRAPHER | Fabio Rubinato
CLIENT | Montreal Segurança
TOOLS | Adobe Photoshop, CorelDraw, PC
PAPER | Couchê 150 gsm
PRINTING PROCESS | Offset

The creative concept shows the company and its employees right on the cover, so prospective clients will see immediately what Montreal services deliver. The fusion of images reinforces the creative concept.

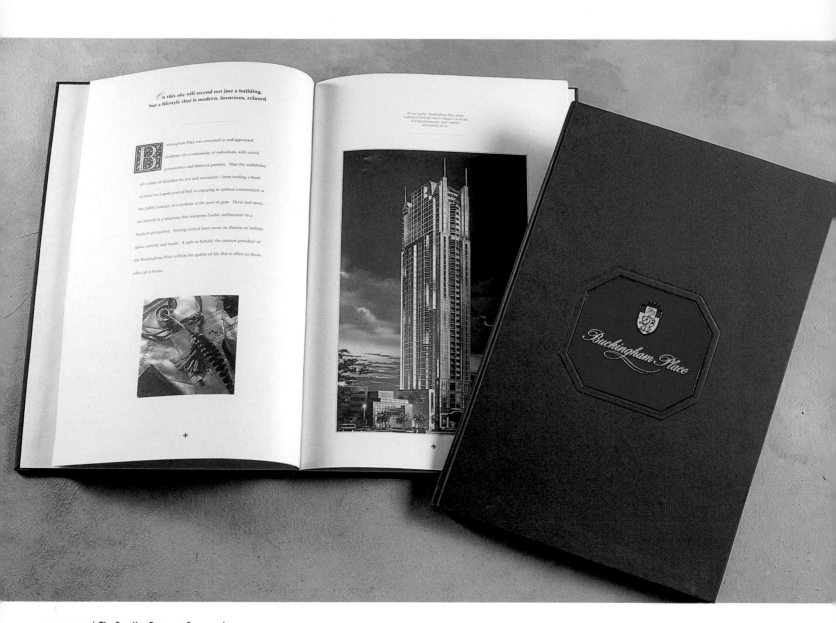

DESIGN FIRM | The Creative Response Company, Inc.

ART DIRECTOR/DESIGNERS | Creative Team

COPYWRITERS | Creative Copy Team

CLIENT | Sun City Marketing

TOOLS | Adobe Photoshop and PageMaker,
 Macromedia FreeHand

PRINTING PROCESS | Offset

The objective of this brochure was to position
Buckingham Palace as a first-class residential
condominium, fit for a king with the most
discriminating taste. To achieve this objective, the
creative team used an oversized trim, cut with
elegant fonts and handsome photos printed on
special paper to emphasize grandeur. A hard-bound
cover was used with foil stamping to complete the
nobility image the client desired.

DESIGN FIRM | Melissa Passehl Design
ART DIRECTOR | Melissa Passehl
DESIGNERS | Melissa Passehl, Charlotte Lambrechts
PROJECT MANAGER/WRITER | Caroline Ocampo
PHOTOGRAPHER | Geoffrey Nelson
COPYWRITER | Susan Sharpe
CLIENT | Girls Scouts Annual Report 1995–1996: Girl Power
TOOLS | QuarkXPress, Adobe Illustrator and Photoshop
PAPER | Gilclear and Lustro Gloss
PRINTING PROCESS | Two-color lithography

This annual report defines girl power as it relates
to a day-in-the-life of a Girl Scout. The designers used
a tall, thin format with bold type, graphic color, and a
photojournalistic approach to show how Girl Scouts
promote programs that enable the development of
character, courage, respect, honor, strength, and wisdom.

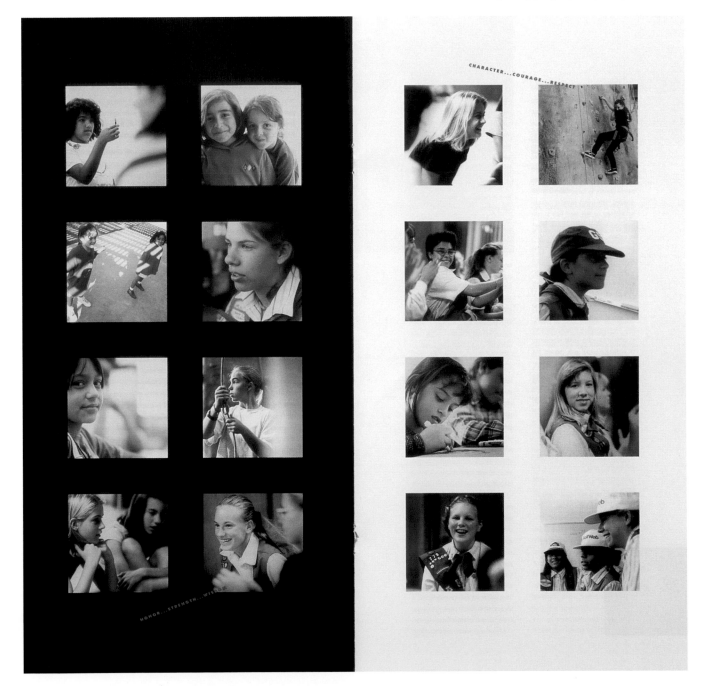

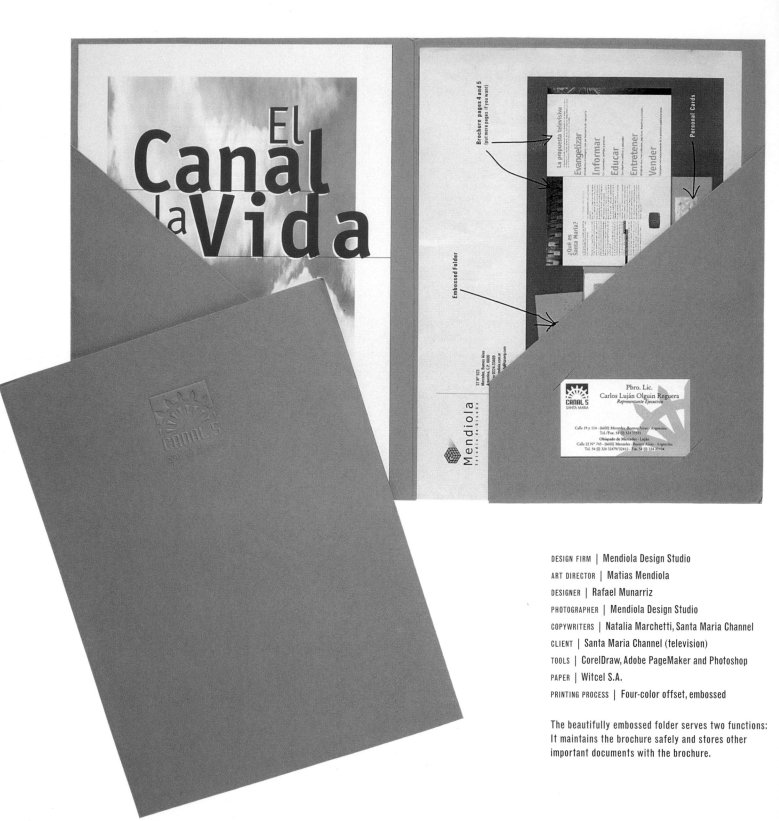

DESIGN FIRM | Mendiola Design Studio

ART DIRECTOR | Matias Mendiola

DESIGNER | Rafael Munarriz

PHOTOGRAPHER | Mendiola Design Studio

COPYWRITERS | Natalia Marchetti, Santa Maria Channel

CLIENT | Santa Maria Channel (television)

TOOLS | CorelDraw, Adobe PageMaker and Photoshop

PAPER | Witcel S.A.

PRINTING PROCESS | Four-color offset, embossed

The beautifully embossed folder serves two functions:
It maintains the brochure safely and stores other
important documents with the brochure.

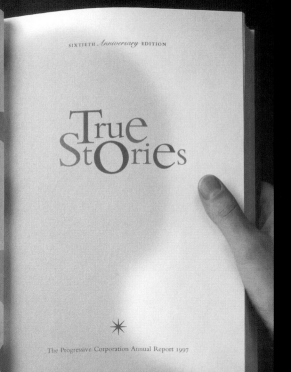

DESIGN FIRM | Nesnadny & Schwartz

ART DIRECTORS | Mark Schwartz, Joyce Nesnadny

DESIGNERS | Joyce Nesnadny, Michelle Moehler

PHOTOGRAPHERS | Ron Baxter Smith, cover;
Design Photography, artwork

COPYWRITER | Peter B. Lewis, The Progressive Corporation

CLIENT | The Progressive Corporation

TOOLS | Trade Gothic, QuarkXPress

PAPER | French Construction Whitewash 100 lb. cover;
French Parchtone White 60 lb. text, uncoated fly;
SD Warren Strobe Gloss 100 lb. coated text;
French Frostone Flurry 70 lb. uncoated text

PRINTING PROCESS | Outside cover: four-color process plus dull
aqueous coating; inside cover: three match
colors plus dull aqueous coating;
five special match colors, uncoated fly;
four-color process plus gloss varnish,
coated text; six special match colors,
uncoated text

In a free-association test recently administered to 1,153 college students, the word "insurance" prompted the response "romance" in 82.8% of cases…Alright, we admit it—we're only kidding. Still, for our claim representatives (at our more than 350 claim offices), romance isn't an unknown continent. On a recent Saturday evening, Chandra Haines, a Progressive claim representative in Savannah, Georgia came to the rescue of a young couple involved in a fender bender. She helped them contact their families, and, despite the late hour, arranged to have their car repaired immediately. The couple, who had just been married, were heading to Florida for their honeymoon and had thought for certain their trip was ruined. But they weren't counting on the efficiency of Progressive's Immediate Response® claims service. In a romantic cause, our claim representatives stand ready to slay any dragon.

the
rOmance
of
immediate respOnse

no. 4

Marty Ackley, mixed media on canvas, 1997

12

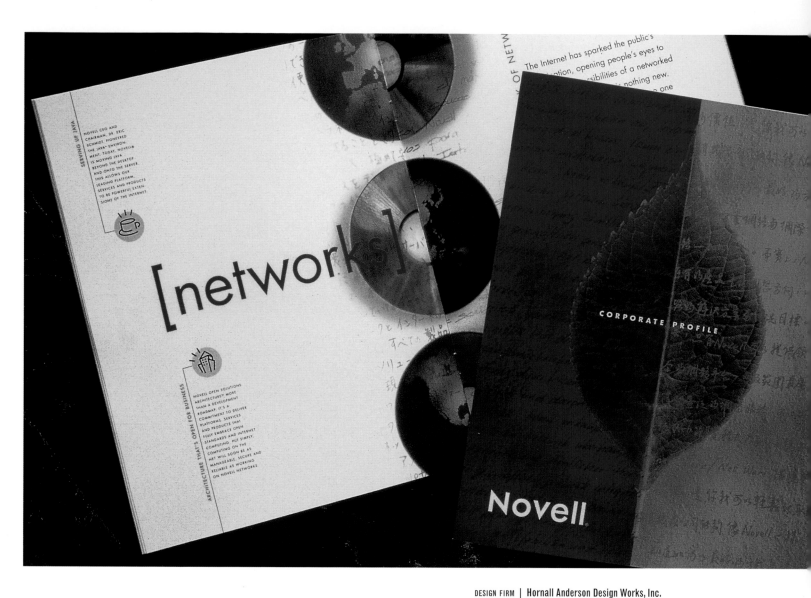

DESIGN FIRM | Hornall Anderson Design Works, Inc.

ART DIRECTOR | Jack Anderson

DESIGNERS | Jack Anderson, Lisa Cerveny, Heidi Favour,
Jana Wilson Esser

ILLUSTRATOR | Hornall Anderson Design Works, Inc.

PHOTOGRAPHER | Tom Collicott

COPYWRITER | Scott Ford

CLIENT | Novell, Inc.

TOOLS | QuarkXPress

PAPER | Signature dull, UV Ultra

This corporate profile displays the company's vast
networking experience. It was important to create
a brochure that emphasized business-to-business
communication, and had a straightforward, easy-
to-read approach to its technical information.

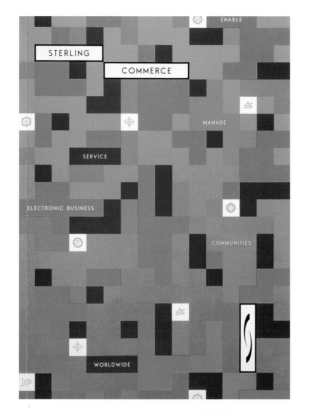

DESIGN FIRM | Pinkhaus Design

ART DIRECTOR | Kristin Johnson

DESIGNER/ILLUSTRATOR | Raelene Mercer

PHOTOGRAPHER | John Running

COPYWRITER | Frank Cunningham

CLIENT | Sterling Commerce

TOOLS | QuarkXPress, Adobe Illustrator and Photoshop

PAPER | Potlatch McCoy Velour

PRINTING PROCESS | Offset 8/8, four-color process plus two
Pantone plus two varnishes (dull and gloss)

Sterling requested their story be told through the voice of
their customers. The creative inspiration was driven by
the graphic image the designers established for Sterling
Commerce during this past year.

Nobody can tell our story better than our clients. We asked twelve of
them, each representative of a different industry, to share their experience.
The fact is, we have 40,000 other clients, each with a similar story to tell.
But that's a bigger brochure than we wanted to tackle.

ASK AND THEY'LL TELL YOU

10

11

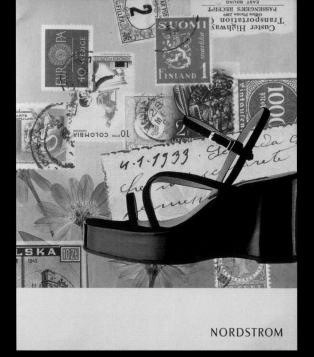

NORDSTROM

DESIGN FIRM | The Leonhardt Group
DESIGNERS | Greg Morgan, Janee Kreinheder
ILLUSTRATOR | Greg Morgan
PHOTOGRAPHER | Europe: John Rees; shoes:Don Mason
COPYWRITER | Renee Sullivan, Jodi Eschom
CLIENT | Nordstrom
PAPER | Cougar Opaque

Nordstrom wanted their shoe catalog to go beyond
the traditional, to be artistic and tactile, yet main-
tain the feel and look of Nordstrom. The message is
conveyed by the your-feet-take-you-places theme,
while the designed-in-Europe message is subtly
expressed by the destination imagery and exotic
foreign postage stamps.

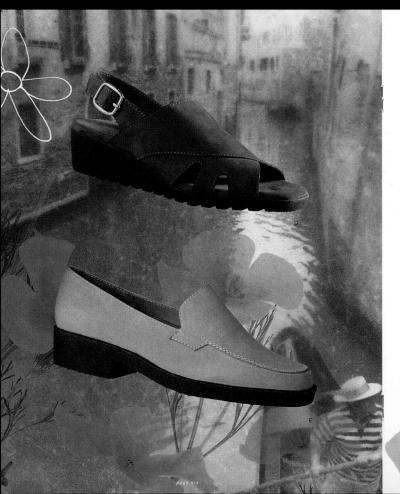

opposite and this page, D: **Nordstrom 'Dayton'** sandal. When it comes to comfort, this is a global
classic. Camel, red or black; 59.95. E: **Nordstrom 'Darcy'** loafer. As easy as a lazy gondola ride.
Beige or black; 59.95. Both styles feature an unlined nubuck upper and latex rubber sole, in sizes
7–11n; 4–12,13m; 6–10w. In Women's Shoes.

DESIGN FIRM | Michael Courtney Design
ART DIRECTOR | Michael Courtney
DESIGNERS | Michael Courtney, Michelle Rieb, Bill Strong
PHOTOGRAPHER | Pete Eckert, Eckert & Eckert
COPYWRITER | Leslie Brown, In Other Words
CLIENT | Mahlum Architects
TOOLS | Adobe PageMaker and Photoshop

Mahlum wanted to create a one-of-a-kind invitation
that would draw past, current, and prospective
clients to their new office space, and that could be
used also for their long-term marketing objectives.

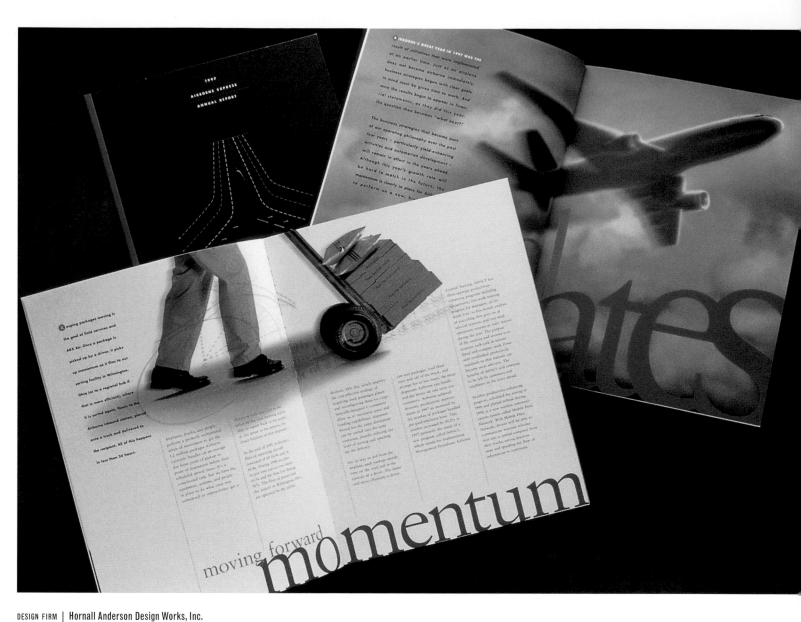

DESIGN FIRM | Hornall Anderson Design Works, Inc.

ART DIRECTORS | John Hornall, Lisa Cerveny

DESIGNERS | John Hornall, Lisa Cerveny, Heidi Favour,
Bruce Branson-Meyer

PHOTOGRAPHER | Robin Bartholick

COPYWRITER | Elaine Floyd

CLIENT | Airborne Express

TOOLS | QuarkXPress, Macromedia FreeHand, Adobe Photoshop

PAPER | Mohawk Superfine

Large, bold type and photographic images stress the
company's inherent goals: acceleration, frequency,
momentum, consistency, and potential. Each photo reflects
movement, which emphasizes the client's business of
swift international air-courier services.

EDUCATIONAL DESIGN

CDFL

COOKE DOUGLASS FARR LEMONS / LTD

DESIGN FIRM | Communication Arts Company

ART DIRECTOR | Hilda Stauss Owen

DESIGNER | Anne-Marie Otvos Cain

COPYWRITER | David Adcock

CLIENT | Cooke Douglass Farr Lemons, Ltd.

TOOLS | Macromedia FreeHand, Adobe Photoshop

PAPER | Patina matte

PRINTING PROCESS | 5/5, offset lithography

The second in a series of booklets, this piece focuses on the firm's educational design work. Although the booklets had to be produced at three different points during the year, they were designed simultaneously to keep the look consistent throughout the series.

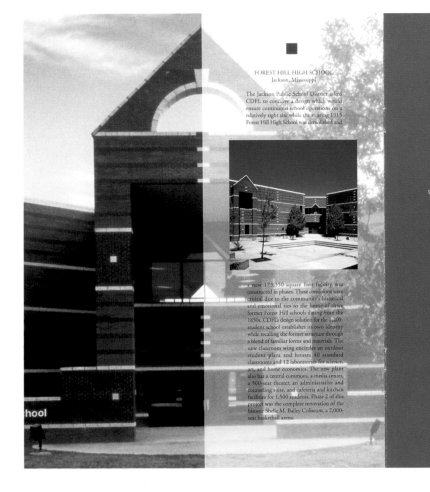

FOREST HILL HIGH SCHOOL
Jackson, Mississippi

The Jackson Public School District asked CDFL to conceive a design which would ensure continuous school operations on a relatively tight site while the existing 1915 Forest Hill High School was demolished and a new 173,350-square foot facility was constructed in phases. These conditions were critical due to the community's historical and emotional ties to the home of three former Forest Hill schools dating from the 1850s. CDFL's design solution for the 1,200-student school establishes its own identity while recalling the former structure through a blend of familiar forms and materials. The new classroom wing encircles an outdoor student plaza and houses 40 standard classrooms and 12 laboratories for science, art, and home economics. The new plant also has a central commons, a media center, a 500-seat theater, an administrative and counseling suite, and cafeteria and kitchen facilities for 1,500 students. Phase 2 of this project was the complete renovation of the historic Shelie M. Bailey Coliseum, a 2,000-seat basketball arena.

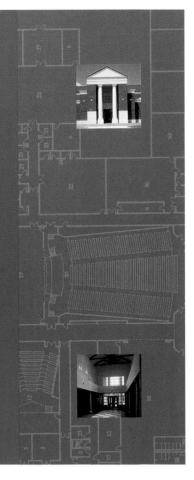

CDFL Selected Clients:

HIGHER EDUCATION
Alcorn State University
Auburn University
Baylor University
Belhaven College
Hinds Community College
Indiana State University
Jackson State University
Mississippi State University
Mississippi University for Women
University of Arkansas
University of Mississippi
University of Mississippi Medical Center

PUBLIC & PRIVATE
SCHOOL SYSTEMS
Claiborne County School District
Clinton Public School District
First Presbyterian Day School
Hazlehurst Public School District
Hillcrest Christian School
Hinds County Public Schools
Jackson Public School District
Jackson Preparatory School
Montgomery County School District
Quitman County School District
Rankin County School District
Pearl Public School District
Sharkey-Issaquena Line
Consolidated School District
Simpson County School District
Winona Public School District
Vicksburg-Warren School District

GOVERNMENTAL
Mississippi Bureau of Buildings
Mississippi Department of Education
United States Department of Labor

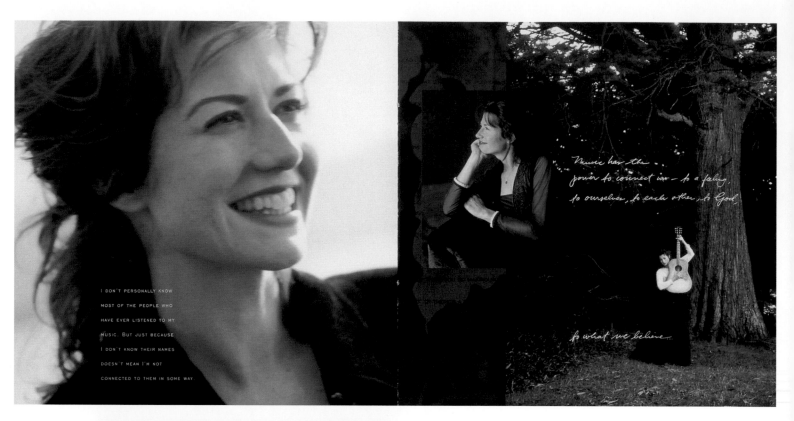

I DON'T PERSONALLY KNOW
MOST OF THE PEOPLE WHO
HAVE EVER LISTENED TO MY
MUSIC. BUT JUST BECAUSE
I DON'T KNOW THEIR NAMES
DOESN'T MEAN I'M NOT
CONNECTED TO THEM IN SOME WAY.

DESIGN FIRM | Anderson Thomas Design, Inc.

ART DIRECTOR/DESIGNER | Susan Browne

ILLUSTRATOR | Kristi Carter (hand lettering)

PHOTOGRAPHERS | Kurt Markus, Just Loomis

COPYWRITER | Amy Grant

CLIENT | Amy Grant Productions/Blanton Harrell
Entertainment

TOOLS | QuarkXPress, Adobe Photoshop

PAPER | Gilbert Voice, Sandpiper, Warren Lustro Dull

PRINTING PROCESS | Four-color process plus dry-trap
gloss plus dull varnishes

The client requested a clean, understated,
sophisticated design, specifically not Photoshop
layered. The album title lent itself to the image of
Amy Grant looking directly at the camera; the design
unfolded aournd this. There was a tight deadline
for this project; after photography, the concept and
design/engraving/printing were completed in about
four weeks.

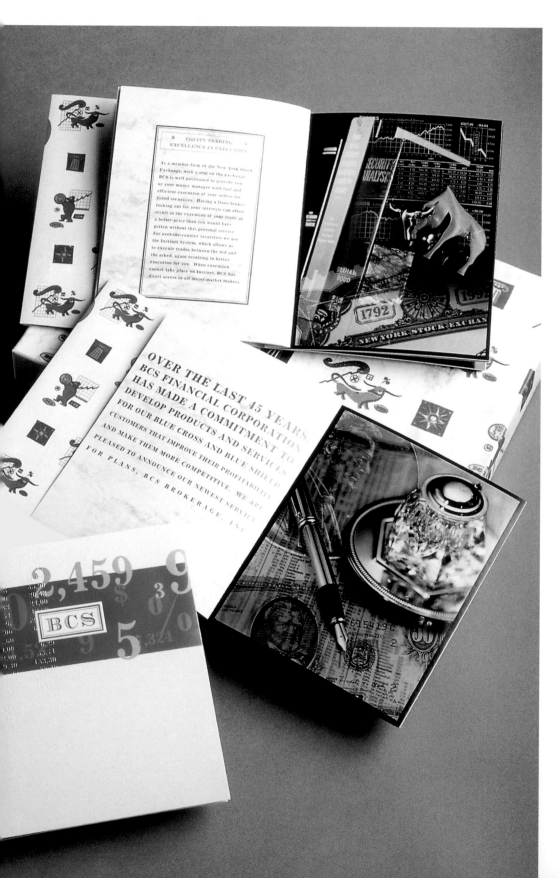

DESIGN FIRM | Sayles Graphic Design
ALL DESIGN | John Sayles
PHOTOGRAPHER | Bill Nellans
COPYWRITER | Jill Schroeder
CLIENT | BCS Insurance Company
PAPER | Terracoat cream
PRINTING PROCESS | Offset

Targeted to BCS affiliates with investment interests, the announcement arrives in an elegant presentation box. The hinged lid is printed with a pattern of illustrations: bulls, bears, and currency symbols printed in copper, silver, and gold metallic inks on a marbled paper stock. Inside, a fitted tray holds a brochure filled with dramatic four-color photo collages, bold illustrations, and copy printed on alternating cast-coated and marbleized pages, along with a special gift: a glass paperweight etched with a bull.

DESIGN FIRM | Vardimon Design
ART DIRECTOR | Yarom Vardimon
DESIGNERS | Yarom Vardimon, D. Goldberg, G. Ron
PHOTOGRAPHER | Avi Ganor
COPYWRITER | Copirite Y. Fachler
CLIENT | Elite Industries Ltd.
PRINTING PROCESS | Offset

The photographer tried to show the cut-outs imaginatively, in three dimensions, to emphasize the company's A-brands.

SNACALKTYS

TAKING THE MARKET BY STORM

IN JUST 5 YEARS, ELITE HAS ACHIEVED A DOMINANT SHARE OF THE SALTY SNACK MARKET, VASTLY INCREASING TOTAL SALES VOLUME IN THIS EXPANDING MARKET. ELITE NOW ACCOUNTS FOR MORE THAN 50% OF THE POTATO CHIP MARKET AND 25% OF THE PUFFED CORN SNACKS MARKET.

UNDER A LICENSING AGREEMENT WITH "FRITO-LAY", PART OF "PEPSICO FOODS INTERNATIONAL", ELITE PRODUCES "RUFFLES", THE WORLD'S NUMBER ONE POTATO CHIP SNACK; "CHEETOS", THE POPULAR CHEESE-FLAVORED SNACK; AND "DORITOS", THE CORN CHIPS FAVORITE. OTHER LOCALLY DEVELOPED AND MANUFACTURED PRODUCTS SUCH AS "SHOOSH" ARE WELL ESTABLISHED IN THE DOMESTIC MARKET, AND ENJOYED BY A WIDE CROSS-SECTION OF THE CONSUMER PUBLIC.

ELITE'S ENTRY INTO THE SALTY SNACK MARKET HAS PROVED A RESOUNDING SUCCESS. THE WIDE VARIETY OF DIFFERENT PRODUCTS NOW AVAILABLE HAS INCREASED DEMAND AND RAISED THE QUALITY OF SNACKS ON THE MARKET BY OFFERING HEALTHY AND VITAMIN-ENRICHED PRODUCTS WITH WIDE CONSUMER APPEAL.

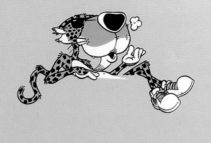

WITHIN 5 YEARS OF ENTERING THE MARKET, ELITE ACHIEVED A DOMINANT SHARE OF THE SALTY SNACK MARKET. DORITOS (THE CORN CHIPS WITH THE LOUDEST TASTE ON EARTH), HAVE ALREADY BECOME A FIRM FAVORITE.

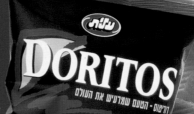

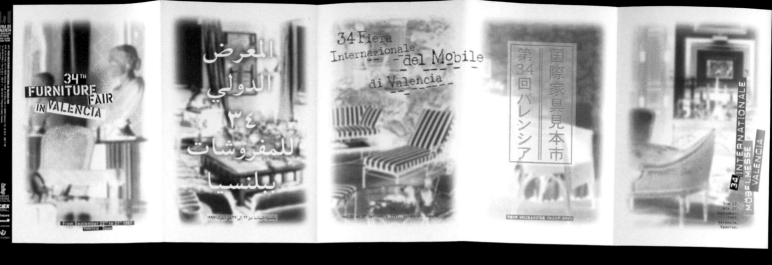

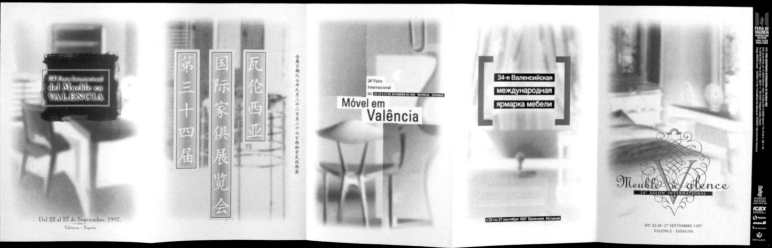

DESIGN FIRM | Pepe Gimeno, S.L.

DESIGNER | Pepe Gimeno

General Motors
Pontiac GMC Division

Pontiac's Rageous, *with its aggressive exterior cloaking a multifunctional interior, redefines the traditional sports coupe concept. Pontiac styling cues like the twin nostril V-shaped fascia and Ram Air hood intakes are combined with bulging wheel flares and a sinuous hourglass waistline to emphasize its fun-to-drive nature. In*

response to the target market's active life-styles, the Rageous includes some very functional features not readily visible. A pair of rear hinged access panels immediately behind the primary front doors make entry and exit easy for the rear seat passengers. At the back, a fold-down tailgate and rear hatch open to accommodate 4' x 8' sheets of plywood.

ALL DESIGN | Barry Hutzel

COPYWRITER | Roger Quinlan

CLIENT | IDSA Michigan Chapter

TOOLS | Adobe PageMaker and Photoshop

PAPER | Neenah Classic Columns 80 lb. cover;
Romaine #1 house stock gloss 80 lb. text

PRINTING PROCESS | Two color

This yearly publication is a showcase for Michigan Industrial Designers' products. The budget was kept down by producing a two-color piece that took full advantage of the colored cover stock.

Eddy

Office Explorations won a Gold IDEA Award in the design explorations category.

Haworth
Holland

Designed to support the ways people really work, not just how they say they do, **Flo and Eddy** *(left, above and below) are two of the latest in Haworth's ongoing research and exploration process. Created as "icons," these prototypes also function as thought starters, initiating dialogue between Haworth and their customers. Flo's curved fiberglass work-surface supports a stepped mesh screen for work-in-progress and incorporates a freestanding sound baffle with built-in speakers to create individualized white noise. Eddy uses larger contoured fiberglass wings to support work above the worksurface with various flexible arms for displaying high visibility items.*

Flo

DESIGN FIRM | Goodhue & Associés Design Communication

CREATIVE DIRECTOR | Lise Charbonneau

ART DIRECTOR | Paulo Correia

DESIGNERS | Josée Barsalo, Dany DeGrâce

ILLUSTRATOR | Caroline Merola

PHOTOGRAPHER | Jean Vachon

COPYWRITER | Ivanhoe, Communications and Public Affairs

CLIENT | Ivanhoe Inc.

TOOLS | QuarkXPress, Macromedia FreeHand,
Adobe Photoshop

PRINTING PROCESS | Offset

The client, a real-estate giant specializing in shopping
centers, sought to show prospective investors its
sound expertise and flair for innovation. Outsized
images and classical serif type draw the reader in.

STRENGTH

IVANHOE IS WITHOUT DOUBT A FORCE
IN THE CANADIAN REAL ESTATE INDUSTRY

Ivanhoe is one of Canada's most respected property
management, development and investment companies,
specializing in quality shopping centers in urban areas. ■ As
soon as the Company appeared on the scene early in the
1950s, it began carving out a place for itself in the real
estate sector. Today it is active across the country, primarily
in Quebec and Ontario, but also in Western Canada through
investments in Cambridge. For several years it has
been investing in the United States, forming major
financial partnerships with a number of U.S. real estate
giants. When Ivanhoe was created, it capitalized on the
opportunities for rapid growth offered by the marketplace
and the economic conditions of the fifties. It was, therefore,
well prepared for the economic downturn and the recession
of the 1990s and was able to go on investing in a careful
and patient manner while continuing to skilfully manage
its assets. ■ To meet new challenges, Ivanhoe knows that it can count on dedicated,
competent human resources. It has invaluable tools that enable it to adapt to industry
change: diversification into foreign markets, strategic alliances, sustained research
and development, and a comprehensive marketing program. All these measures are
based on a new definition of the shopping center and on the quality of service
offered to tenants and consumers. ■ A healthy financial situation and dynamic
management of its real estate portfolio and organizational resources have enabled
the Company to gradually become a leader. Combining management expertise with
solid development and investment capacity, Ivanhoe is without doubt a major force in
the real estate industry.

The Company manages
a full range of quality
shopping centers in Canada
and the United States,
from neighborhood centers
to regional supercenters.

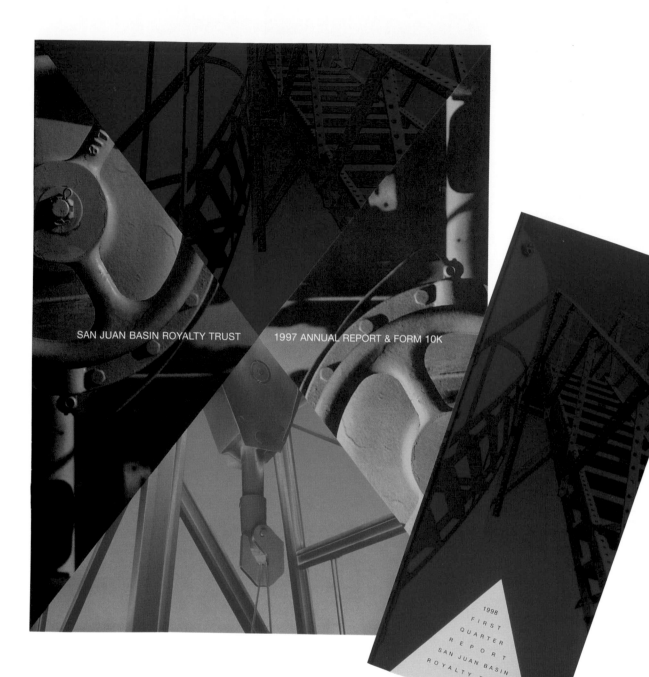

SAN JUAN BASIN ROYALTY TRUST 1997 ANNUAL REPORT & FORM 10K

1998
FIRST
QUARTER
REPORT
SAN JUAN BASIN
ROYALTY TRUST

DESIGN FIRM | Witherspoon Advertising

ART DIRECTOR/DESIGNER | Rishi Seth

CLIENT | San Juan Basin Royalty Trust

TOOLS | QuarkXPress, Macintosh

PAPER | Signature Gloss

PRINTING PROCESS | Offset

Although an oil and gas trust, San Juan Basin Royalty
does not produce or distribute oil and gas. Witherspoon
decided to spice up the dry financial information with
a series of pictures of tools and large equipment used
in oil and gas fields.

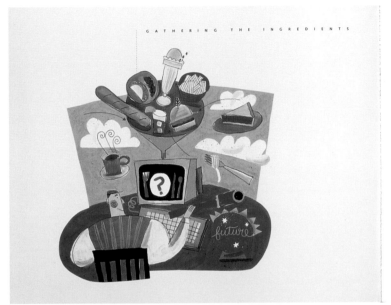

The successful outcome of a recipe is dependent on two things: the skill of the cook and the quality of the materials. Half-measures and substitutes are not acceptable, for a wise cook works with only the best ingredients.

Brinker's own recipe for success also calls for the best. We hire the best people, and we ask the best of them. In order to ensure optimum results from their efforts, Brinker utilizes cutting-edge information systems. Years ago, when we learned there was no software available that addressed our needs, we decided that compromise on an issue this important was simply not an option. As a result, we created a proprietary system that not only fits our unique requirements but also offers the capacity to grow and change along with our business.

The technologies we use allow Brinker to efficiently acquire and analyze data. Equally important, they enable us to format information so it can be easily understood and implemented. Our sales-tracking system is an excellent case in point. Since Brinker concepts are always in the process of refining their menus, this system enables us to accurately assess customer response to all menu items on a daily, weekly, and monthly basis. Using the sales-tracking system, Brinker can determine which items are succeeding with the public and see the impact they're having on a concept's profit picture. Conversely, we discover which items should be retired or reconfigured to pique customer interest. We also use sales-tracking to spot customer trends well before they become evident in the marketplace.

29

Good cooking demands the best ingredients. That's why Brinker International has created a customized information system that allows us to capture, analyze, and easily implement store-generated data. Our leading-edge system also streamlines operations, cuts costs, tracks customer trends, and allows us to whip up such tasty creations as Chili's highly successful Frequent Diner Program.

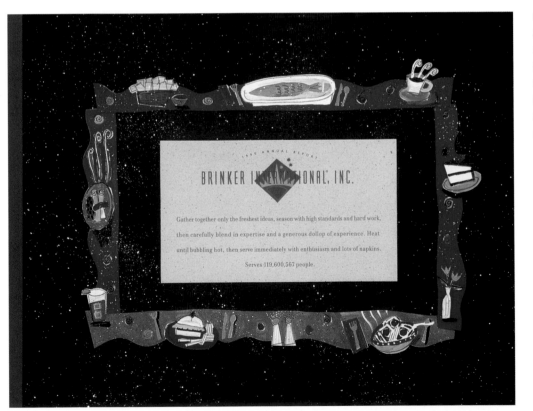

DESIGN FIRM | Joseph Rattan Design
ART DIRECTOR/DESIGNER | Joe Rattan
ILLUSTRATOR | Linda Hilton
PHOTOGRAPHER | Stuart Cohen
COPYWRITER | Mary Langridge
CLIENT | Brinker International
TOOLS | Macintosh
PRINTING PROCESS | Offset

"AND WHEN I LOOK INTO THE EYES OF MY CHILD, SO INNOCENT, THERE'S EVIDENCE OF YOUR LOVE, EVIDENCE OF YOU"

TALK TO ME

John Elefante and Dino Elefante

SOMETIMES WE SEE GOD AS OMINOUS AND UNAPPROACHABLE. BUT I BELIEVE THAT GOD LOVES WHEN WE CAN HAVE A SIMPLE CONVERSATION WITH HIM, JUST AS WE WOULD A CLOSE FRIEND. HE'S BEEN WHERE WE ARE. THERE IS NO FEELING OR EMOTION WE HAVE THAT HE DOESN'T UNDERSTAND.

I recall a time in my life when I was scared to
share my heart with anyone
Afraid of who I really was I'd hide behind a wall
where no one could see
Then the stones that formed the wall began to
crumble
And your whisper knocked me off my feet and
took me to my knees

When you said, talk to me, let's have a
conversation
I hear more than just words, I can hear down in
your soul
So talk to me, I'll do more than listen
I stood where you're standing and I know just
how you feel
Talk to me, talk to me

Aimless I'd go searching for a twisted play on
words, that made me feel that I was alright
Striving for perfection when the only perfect
thing I had was weakness
Then strength began to build in me
All it took was Your words to get me to
my knees,
And you said...

Talk to Me, let's have a conversation
I hear more than just words, I can hear down in
your soul
Won't you talk to Me, I'll do more than listen
I stood where you're standing and I know just
how you feel
Talk to me, I've been right where you are
I know every breath you take, every feeling in
your heart
Talk to me, tell me what you're feeling
Know I'm always here for you, whenever you
need me

And the stones that formed the wall began to
crumble
All it took was Your words to get me to my
knees

© 1997 Uncle Pitts Music/BMI

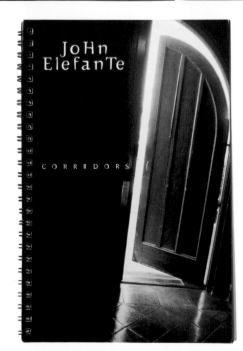

DESIGN FIRM | Anderson Thomas Design, Inc.

ART DIRECTOR/DESIGNER | Jay Smith

PHOTOGRAPHER | Russ Harrington

COPYWRITER | Shari McDonald

CLIENT | Pamplin Music

TOOLS | QuarkXPress, Adobe Photoshop

PAPER | Potlatch, Vintage Gloss, Gilclear,
French Construction, Factory Green

PRINTING PROCESS | Four-color, spot Pantone color,
and black

The client's request was that this piece tell the story of John Elefante; the man, the musician, the ministry, and the music, so his audience would know more about the man behind the voice.

DESIGN FIRM | Phillips Design Group
ART DIRECTOR | Steve Phillips
DESIGNER | Alison Goudreault
ILLUSTRATOR | David Tillinghast
PHOTOGRAPHER | Stock
COPYWRITER | Boston Financial
CLIENT | Boston Financial
TOOLS | QuarkXPress

Phillips Design took an unusual approach to promoting financial services by using a contemporary illustration style that focuses on the way the real estate industry looks at risk-management and insurance.

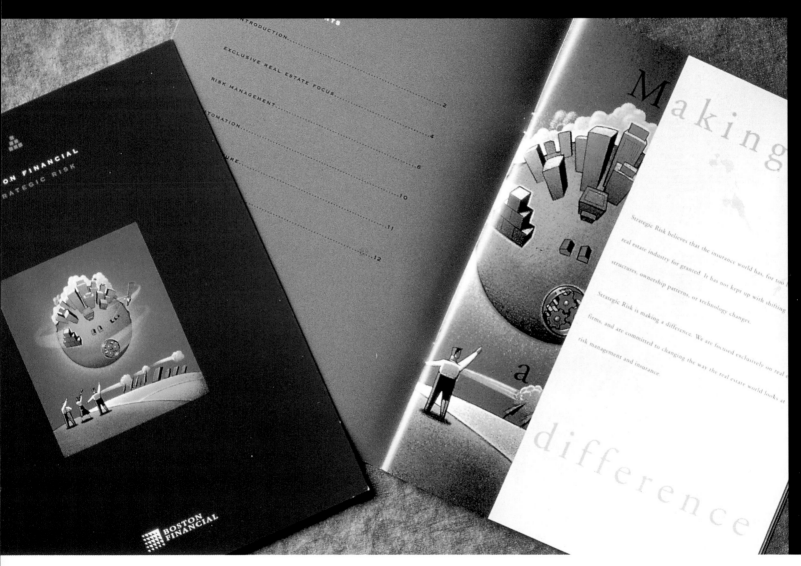

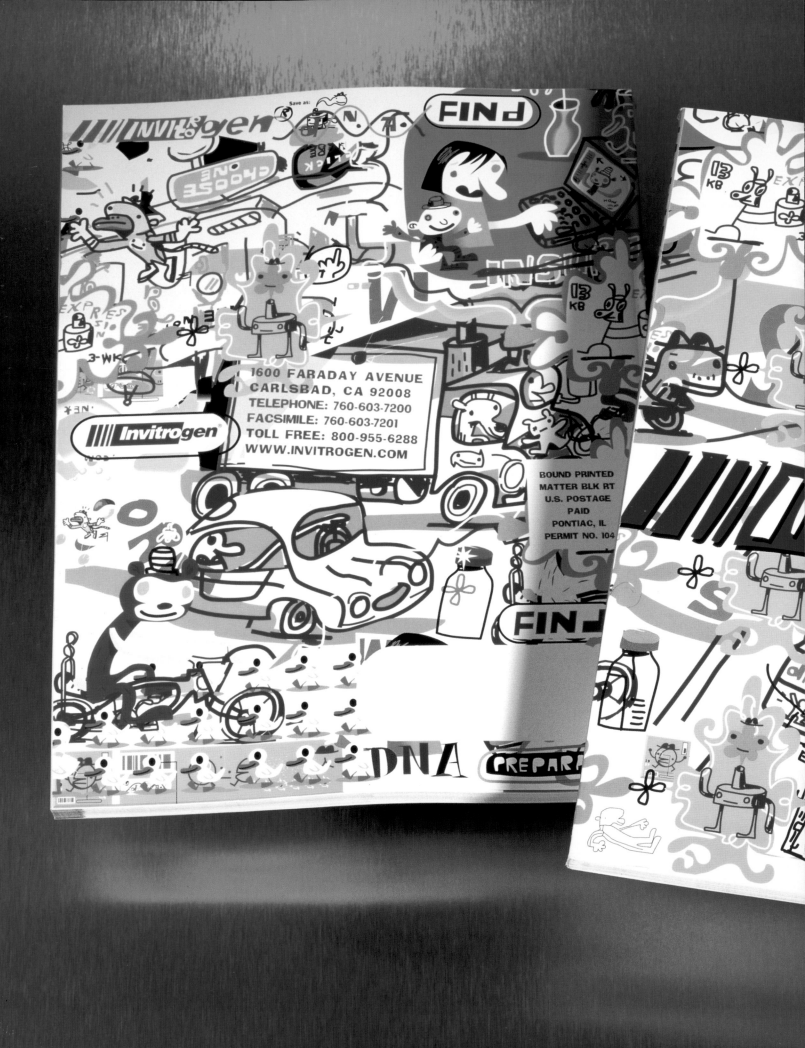

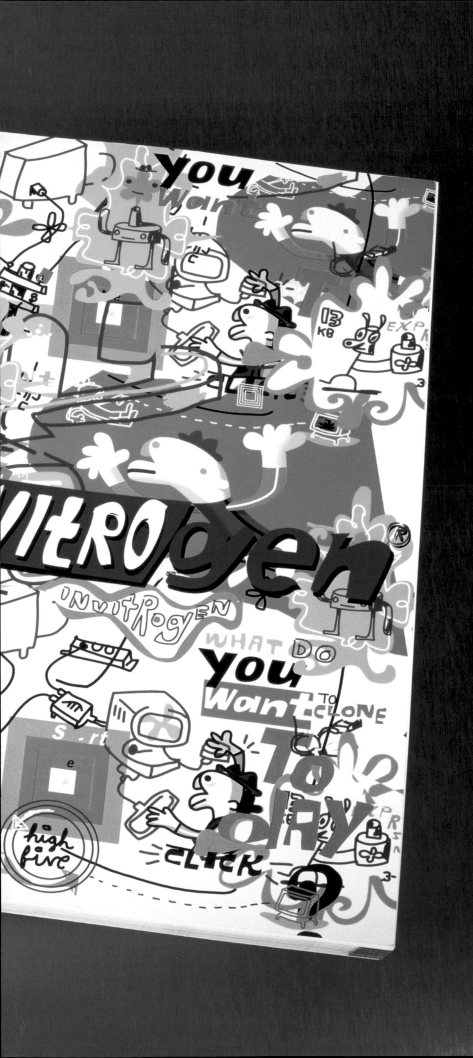

DESIGN FIRM | Mires Design
ART DIRECTOR | Jose A. Serrano
DESIGNER | Mary Pritchard
ILLUSTRATOR | J. Otto
CLIENT | Invitrogen Corporation
TOOLS | Adobe Illustrator
PAPER | White gloss cover weight
PRINTING PROCESS | Four-color process

The design team created a cover for this catalog that had a fresh look without appearing too high tech.

DESIGN FIRM | Tom Fowler, Inc.
ART DIRECTORS | Thomas G. Fowler, Karl S. Maruyama
DESIGNERS | Thomas G. Fowler, Karl S. Maruyama,
Brien O'Reilly
COPYWRITER | Karl S. Maruyama
CLIENT | Canson-Talens, Inc.
TOOLS | QuarkXPress, Adobe Illustrator
PAPER | Utopia Premium Blue White 110 lb. cover,
Canson Satin (various weights)
PRINTING PROCESS | Offset, stamping, embossing,
and die-cutting

The goal of this brochure is to make the user aware
of all the unique possibilities of translucent paper, and
among translucent sheets, the superiority of Canson Satin.

DESIGN FIRM | Kan & Lau Design Consultants
ART DIRECTOR | Kan Tai-Keung
DESIGNERS | Kan Tai-Keung, Yu Chi Kong, Leung Dai Yin
CHINESE INK ILLUSTRATOR | Kan Tai-Keung
PHOTOGRAPHER | C. K. Wong
CHINESE ILLUSTRATORS | Kwun Tin Yau, Leung Wai Yin,
Tam Mo Fa
CLIENT | Tokushu Paper Manufacturing Co. Ltd.
TOOLS | Macromedia FreeHand, Adobe Photoshop,
Live Picture
PAPER | Bornfree recycled paper

The idea of using Bornfree recycled paper derived
from a philosophy of Buddhism: economize to protect
the Chinese market. Inspired from this philosophy,
elements of calligraphy were applied to demonstrate
the printing aspects of the paper series.

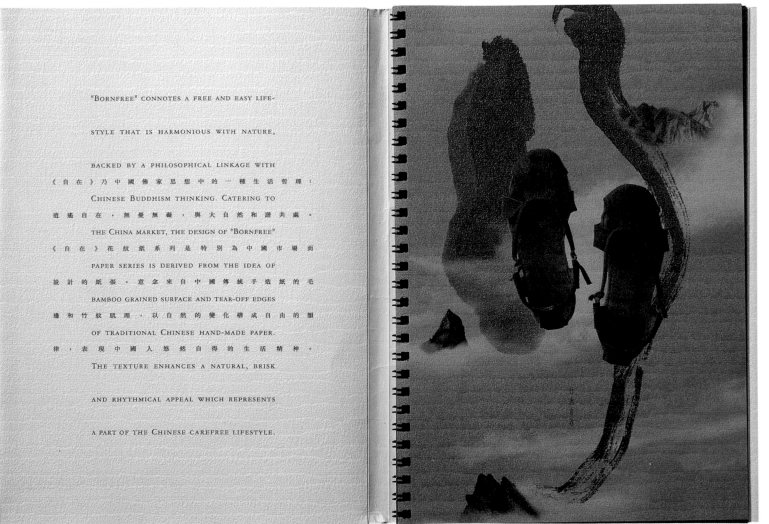

"BORNFREE" CONNOTES A FREE AND EASY LIFE-

STYLE THAT IS HARMONIOUS WITH NATURE,

BACKED BY A PHILOSOPHICAL LINKAGE WITH
《自在》乃中國佛家思想中的一種生活哲理：
CHINESE BUDDHISM THINKING. CATERING TO
逍遙自在，無憂無礙，與大自然和諧共處。
THE CHINA MARKET, THE DESIGN OF "BORNFREE"
《自在》花紋紙系列是特別為中國市場而
PAPER SERIES IS DERIVED FROM THE IDEA OF
設計的紙張。意念來自中國傳統手造紙的毛
BAMBOO GRAINED SURFACE AND TEAR-OFF EDGES
邊和竹紋肌理，以自然的變化構成自由的韻
OF TRADITIONAL CHINESE HAND-MADE PAPER.
律，表現中國人悠然自得的生活精神。
THE TEXTURE ENHANCES A NATURAL, BRISK

AND RHYTHMICAL APPEAL WHICH REPRESENTS

A PART OF THE CHINESE CAREFREE LIFESTYLE.

DESIGN FIRM | Lee Reedy Creative, Inc.

ALL DESIGN | Lee Reedy

PHOTOGRAPHER | Martin Crabbe

CLIENT | National Ski Patrol

TOOLS | QuarkXPress

PRINTING PROCESS | Web

The strong illustration on the cover invites ski patrollers to review the new merchandise offered and breaks the predictable photographic visual solutions often seen in the ski industry.

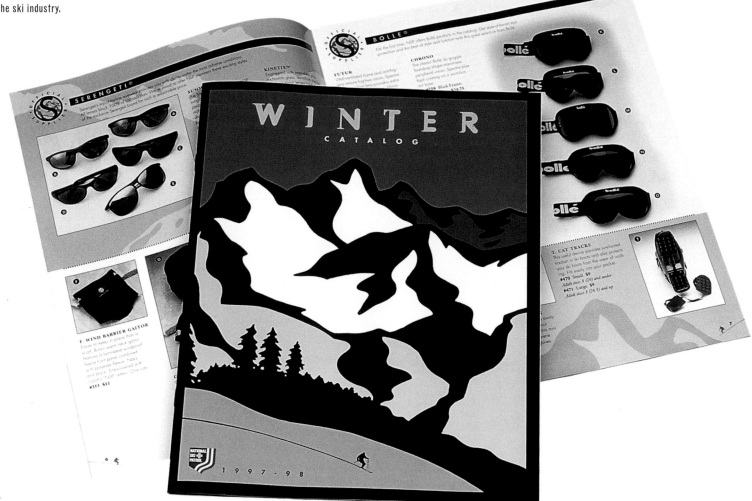

A | Not every day is sunny, which is why the SLK has a retractable hardtop and why you should have our power dome print **mini-umbrella**. It's made of Teflon-treated nylon and folds to 9 inches, perfect for your tote or glove box. A950 999 0404 **$29.50**

B | Our **keyring** opens and closes with the precision of a Swiss watch. Sumptuous calfskin leather with nickel-finished hardware. Exclusively ours, by Bally. A950 999 5903 **$48.50**

C | Our **zippered wallet** of buttersoft "Tartufo" calfskin has a coin compartment and holds three credit cards. No need to worry about spilling your change, as the zippered closure securely holds everything in place. 4¾ x 3½ inches A950 999 1104 **$188**

D | The SLK was designed with one eye on the past and one on the future. Our **SLK square scarf** in 100% silk mimics the power dome shapes in a subtle pattern, surrounded by a black border. Imported from Italy. 43 inches square. B6 799 7501 **$78**

E | **Power dome SLK clip earrings** in sterling silver with gold plating. Matte-sanded surface offsets the gleaming silver power domes. B6 600 7802 **$96**

30

F | Our **Bally calfskin agenda** is sleeker and less bulky than most agendas, yet it holds eight credit cards and your year-at-a-glance. Two inside pockets and a secure snap closure (pen sold separately). 8 x 5¼ x 1½ inches D9701 7500 **$195**

G | The perfect gift, our **sterling silver medallion fob** is formed from solid silver bar stock. Gift-boxed. A950 999 5901 **$18.50**

H | Our stunning **handbag** is an exclusive design, with custom hardware and all the perfection of detail you'd expect from Bally. Made in Italy. Black calfskin 8 x 7½ x 3¾ inches A950 999 6603 **$450**

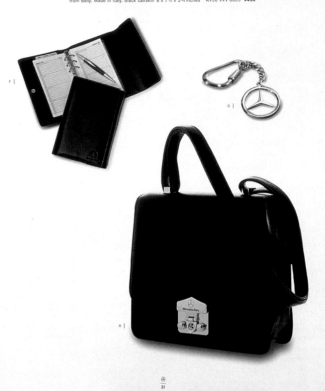

31

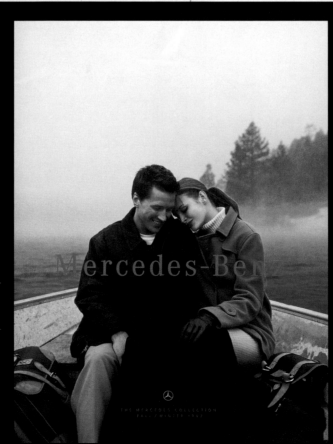

DESIGN FIRM | Pinkhaus Design
ART DIRECTOR/DESIGNER | Kristin Johnson
DESIGNER | Caroline Keavy
COPYWRITER | Frank Cunningham
CLIENT | Mercedes-Benz: Personal Accessories
 Fall/Winter '97
TOOLS | QuarkXPress, Adobe Photoshop
PAPER | Cover: Potlatch Northwest Dull: 80 lb.;
 70 lb. text
PRINTING PROCESS | 6/6 four-color process plus one PMS
 plus spot varnish

The client wanted an approachable, friendly catalog full o
Mercedes-Benz products for people on strict budgets. The
designers succeeded by using great photography that
appeals to luxury car owners as well as to the younger
crowd who aspire to be luxury-car owners.

DESIGN FIRM | Hornall Anderson Design Works, Inc.

ART DIRECTORS | Jack Anderson, Larry Anderson

DESIGNERS | Larry Anderson, Mary Hermes, Mike Calkins,
David Bates, Michael Brugman

ILLUSTRATOR | John Fretz, Jack Unruh, Bill Halinann

PHOTOGRAPHER | David Emmite

COPYWRITER | John Frazier

CLIENT | U.S. Cigar

TOOLS | QuarkXPress, Adobe Photoshop,
Macromedia FreeHand

PAPER | Beer Paper, Havana, Cougar Natural, Gilbert Voice

The client needed a brochure and guidelines to
disperse to distributors involved in the cigar trade.
The brochure composite replaces the client's original
glossy, slick program with a more natural and textured
look and feel, reminiscent of tobacco leaves. To
complete the natural feel of the package, an
eco-friendly stock was used.

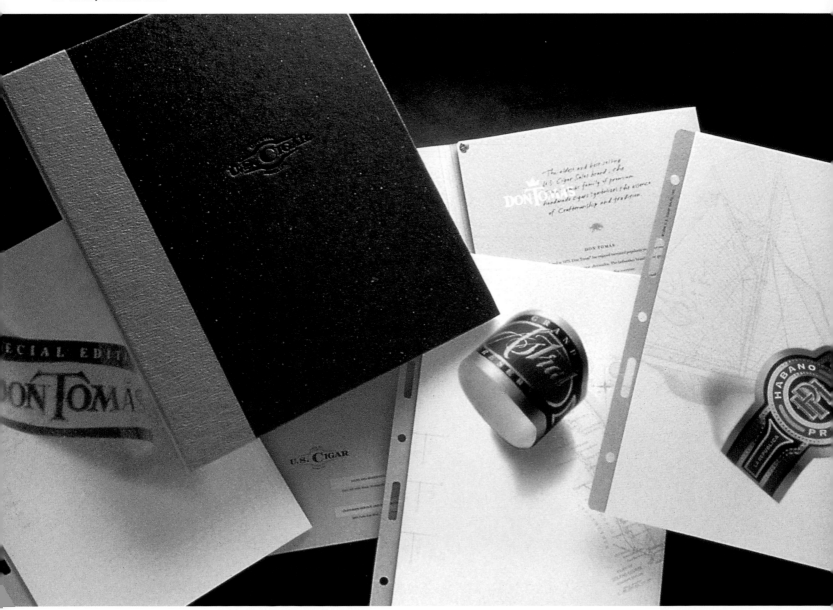

DESIGN FIRM | AWG Graphics Comunicação, Ltda.
ART DIRECTOR | Renata Claudia de Cristofaro
DESIGNERS | Luciana Vieira, Marcelo Gaya
PHOTOGRAPHER | Renata Claudia de Cristofaro
CLIENT | Tresele Ltda.
TOOLS | Adobe Photoshop, PC
PAPER | Triplex 400 gsm
PRINTING PROCESS | Offset

These cover books have been created on one
theme: jeans. The client wanted to illustrate jeans
in a futuristic way by connecting them with letters
and numbers.

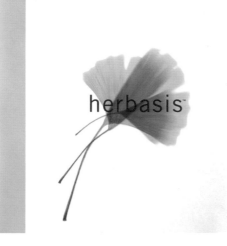

herbasis™

DESIGN FIRM | Design Guys
ART DIRECTOR | Steven Sikora
DESIGNERS | Jay Theige, Amy Kirkpatrick
PHOTOGRAPHERS | Darrell Eager, Michael Crouser
COPYWRITERS | Jay Kaskel, Steven Sikora
CLIENT | Target Stores
PRINTING PROCESS | Offset lithography

Due to the client's limited advertising budget, a great deal of pressure was placed on this product brochure to completely define the brand character of Herbasis to consumers. The creative team kept the design simple and clean, but also used appropriate people and botanicals to add dimension and mystique.

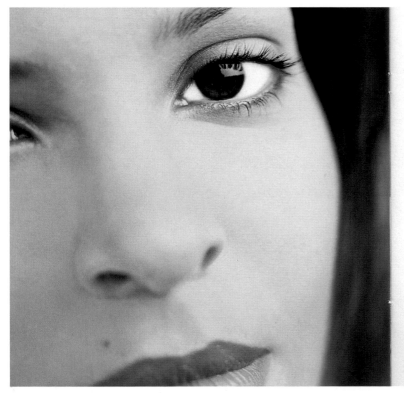

well beyond beauty™

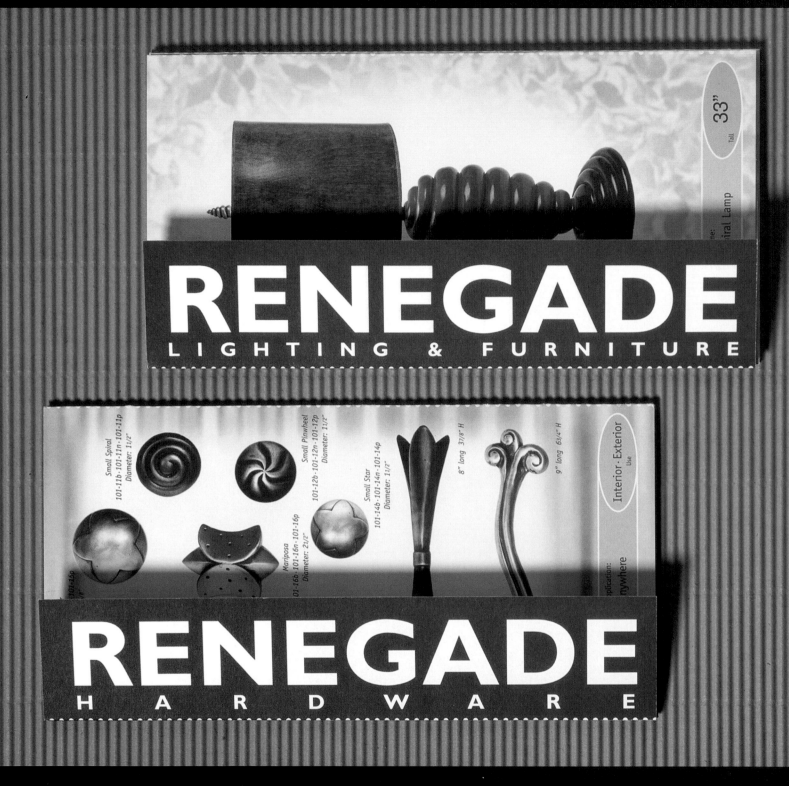

RENEGADE
LIGHTING & FURNITURE

RENEGADE
HARDWARE

DESIGN FIRM | Creative Conspiracy Inc.

ART DIRECTOR | Chris Hickcox

DESIGNER | Neil Hannum

PHOTOGRAPHER | Laurie Dickson

CLIENT | Renegade Artful Objects

TOOLS | QuarkXPress, Adobe Photoshop

PRINTING PROCESS | Four-color process

The design team showcased each item individually to allow the viewer to focus on details. Influences for the design came from colors and textures found in nature.

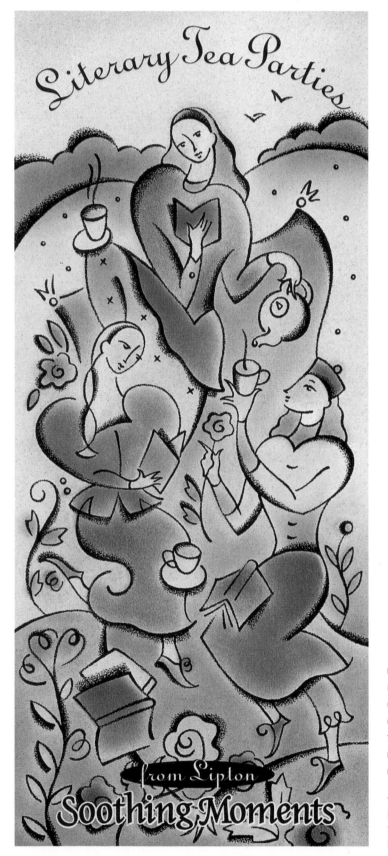

DESIGNER | Janice Aitchison
ILLUSTRATOR | Julia LaPine
COPYWRITER | Sue Balik
CLIENT | Thomas J. Lipton, Inc.
TOOLS | QuarkXPress, Adobe Illustrator
PAPER | Beckett Expressions, Timber
PRINTING PROCESS | Four-color plus one PMS

The target audience for this brochure is consumers
looking for interesting occasions and alternative recipes
to use herbal teas. The designers sought a feminine, yet
literary, feeling for the design.

SCUBAPRO
1998 product line

deep down you want the best

DESIGN FIRM | Visual Marketing Associates, Inc.
ART DIRECTOR | Lynn Sampson
DESIGNERS | Lynn Sampson, Jason Selke
PHOTOGRAPHERS | Jim France, Michael Verdure
CLIENT | JWA/Scubapro
TOOLS | Macromedia FreeHand, Adobe Photoshop
PAPER | Champion Influence Web Gloss
PRINTING PROCESS | Four-color web press

Scubapro wanted to speak to a new generation of divers. By collaging and juxtaposing out-of-water photos with underwater imagery, the designers captured the excitement of scuba diving. Curve elements help to create a flow of information while color-coded sidebars help readers find their place in the catalog.

CLASSIC EXPEDITION

The Expedition is the ultimate expression of SCUBAPRO's stabilizing jacket design. This latest version of the industry standard preserves the Classic's fit and durability while providing new features demanded by today's active divers.

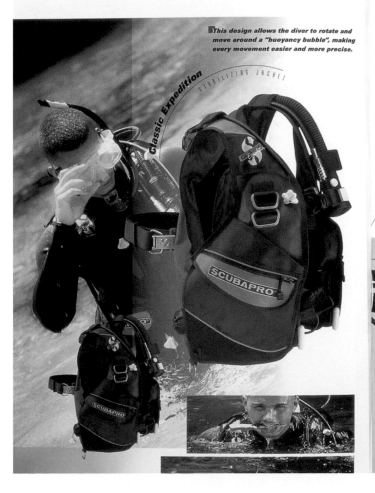

This design allows the diver to rotate and move around a "buoyancy bubble", making every movement easier and more precise.

Classic Expedition

STABILIZING JACKET

Wraparound Air Balance
allows unrestricted air movement and provides unsurpassed stability and control

Integrated Weight System
allows you to carry up to 22 lbs. of fully releasable weights and eliminates the need to use a weight belt in many environments

Hand Glued Finseal Seam Construction
many years of field testing have proven the Finseal seam holds up twice as long as any other seam even when exposed to punishing conditions

Double Neoprene Coated 420 Denier Fabric
for extended life and reduced maintenance

Soft Back Design
with integrated cummerbund for added comfort and stability

Integrated Inflation/Deflation System
for simple one-hand buoyancy control

Standard Rear Pull Dump
for easy air release in a head-down position

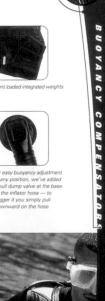

front loaded integrated weights

for easy buoyancy adjustment in any position, we've added a pull dump valve at the base of the inflator hose — to trigger it you simply pull downward on the hose

BUOYANCY COMPENSATORS

All SCUBAPRO BC's accommodate either the A.I.R. 2 or Balanced Inflator for ultimate flexibility.

SCUBAPRO A.I.R. 2
Simplify your hose configuration by using the same hose to supply both the power inflator and the backup regulator.

QUICK RELEASE BALANCED INFLATOR
Featuring ergodynamic styling, the SCUBAPRO Balanced Power Inflator provides push button buoyancy control in a compact, high tech package designed with simplicity of function.

DESIGN FIRM | Shields Design

ART DIRECTORS | Stephanie Wong, Charles Shields

DESIGNER | Charles Shields

PHOTOGRAPHER | Keith Seaman-Camerad

CLIENT | Innerspace Industries

TOOLS | Adobe Illustrator and Photoshop

PRINTING PROCESS | Four-color

The client wanted a series of brochures highlighting different furniture lines. The designers came up with a color-coding system to identify each line. Color-coding also saved money by allowing two-over-four printing.

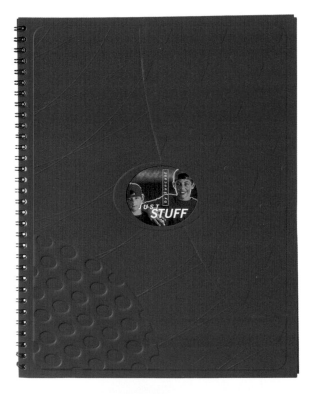

DESIGN FIRM | Visual Marketing Associates, Inc.
ART DIRECTORS | Tracy Meiners, Ken Botts
DESIGNER | Tracy Meiners
ILLUSTRATOR | Cliff Parsons
PHOTOGRAPHER | Jim France, France Photography; stock
COPYWRITER | Pamela Cordery
CLIENT | Suncast Corporation
TOOLS | Macromedia FreeHand, Adobe Photoshop
PAPER | Mead Sig-Nature 80 lb. cover
PRINTING PROCESS | Six-color plus off-line varnish,
dry-trapped, offset lithography

The embossed cover reflects the unique mold pattern
of the Just Stuff product line. Large lifestyle imagery
adds a playful human element, and is Quadtoned, allowing
focus on the product. Kraft paper hints at the product
packaging, while providing a neutral backdrop for
specific information.

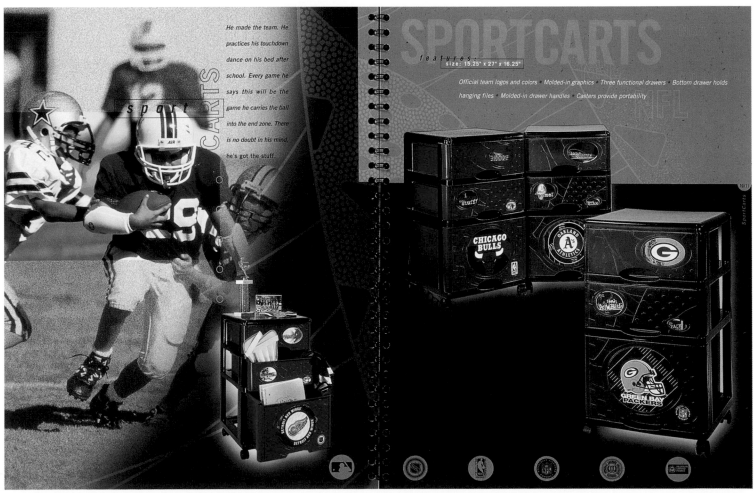

He made the team. He
practices his touchdown
dance on his bed after
school. Every game he
says this will be the
game he carries the ball
into the end zone. There
is no doubt in his mind,
he's got the stuff.

SPORTCARTS

features:
size: 15.25" x 27" x 16.25"

Official team logos and colors • Molded-in graphics • Three functional drawers • Bottom drawer holds
hanging files • Molded-in drawer handles • Casters provide portability

CHAD JACOBS DESIGNS

Born in Cape Girardeau, Missouri, Chad Jacobs' love for art and design began as a youth and was nurtured by his family's love for painting and beautiful objects. Chad holds a degree in architectural studies from the University of Texas. Now living in New York, Chad's designs ranging from furniture to lighting have been featured in the *New York Times*, *House and Garden Magazine* and numerous upscale restaurants. Inspired by nature, Chad's designs are clean, simple and with a timeless quality.

EGG

COCOON

Cocoon
Mouth-blown, sandblasted glass shade nestled in a steel wire-formed stand.

Size: 6"D. × 15" H.
Part#: CJ03830
SRP: $85

Egg
Mouth-blown, sandblasted glass shade nestled in a steel wire-formed stand.

Size: 6"D. × 10" H.
Part#: CJ03840
SRP: $85

Caterpillar
Interlocking system of stacked acrylic discs, styrene diffuser and steel wire-formed frame.

Two sizes avail:
Large: 6.5"D. × 16" H.
Part#: CJ03810
SRP: $125
Small: 5.5"D. × 7" H.
Part#: CJ03820
SRP: $55

CATERPILLAR

4 ORDER TOLL FREE
1-888-461-LUMI (5864)

KEITH WILBER DESIGNS

Los Angeles artist and actor, Keith Wilber became interested in lamp design when he needed a lamp but couldn't find anything really unique. So he decided to make his own! He envisioned creating a lamp that would change the room into something magical when switched on. Since most of his lamp design ideas come either from nature, or the subconscious, the idea of light in motion intrigued him. Thus, the motion lamp was born. His philosophies for lamp design are: 1) it must invoke a response either positive or negative, 2) one must not tire of it too quickly, and 3) the viewer's perspective should change slightly each time you look at it.

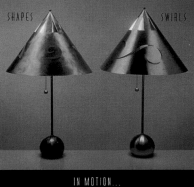

SHAPES SWIRLS

IN MOTION...

MOTION LAMPS

Aluminum Motion Lamps
Shapes Part#: KW0481P
Swirls Part#: KW0481W
Size: 14"D. × 24"H.
SRP: $125

Vinyl Moiré Motion Lamps
Fire Part#: KW0482R
Ice Part#: KW0482W
Liquid Part#: KW0482B
Size: 8"D. × 19.5"H.
SRP: $85

FIRE

LIQUID

ICE

www.lumisource.com **5**

DESIGN FIRM | LumiSource
DESIGNER/ILLUSTRATOR | Jeff Pears
CLIENT | Jeff Pears, Steve Lee: LumiSource
TOOLS | Adobe Illustrator and Photoshop
PRINTING PROCESS | Four-color process

Das komplette Schirmbarkonzept

MEISSL

DESIGN FIRM | Modelhart Grafik-Design DA
ART DIRECTOR | Herbert O. Modelhart
DESIGNER | Kristina Düllmann
PHOTOGRAPHER | Walter Oczlon
COPYWRITER | Herbert Lechner
CLIENT | Schlosserei J. Meissl GmbH
TOOLS | Adobe Illustrator and Photoshop, QuarkXPress
PAPER | Munken Pure Elegance Bordeaux Cover
PRINTING PROCESS | Four-color plus one-color silkscreen print on cover

Since the products are technically complex, they must be communicated in a highly informative style. Meissl's sales process is now more targeted and their salespeople more knowledgeable, thanks to the extensive verbal and visual information transported through this brochure.

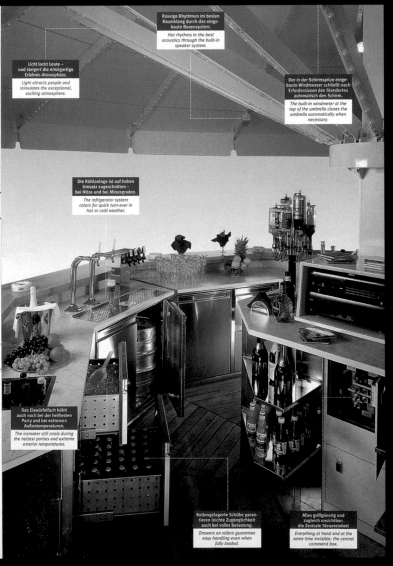

Rassige Rhythmen im besten Raumklang durch das einge-baute Boxensystem.

Hot rhythms in the best acoustics through the built-in speaker system.

Licht lockt Leute – und steigert die einzigartige Erlebnis-Atmosphäre.

Light attracts people and stimulates the exceptional, exciting atmosphere.

Der in der Schirmspitze einge-baute Windmesser schließt nach Erfordernissen des Standortes automatisch den Schirm.

The built-in windmeter at the top of the umbrella closes the umbrella automatically when necessary.

Die Kühlanlage ist auf hohen Umsatz zugeschnitten – bei Hitze und bei Minusgraden.

The refrigerator system caters for quick turn-over in hot or cold weather.

Das Eiswürfelfach kühlt auch noch bei der heißesten Party und bei extremen Außentemperaturen.

The icemaker still cools during the hottest parties and extreme exterior temperatures.

Rollengelagerte Schübe garan-tieren leichte Zugänglichkeit auch bei voller Belastung.

Drawers on rollers guarantee easy handling even when fully loaded.

Alles griffgünstig und zugleich unsichtbar: die Zentrale Steuereinheit

Everything at hand and at the same time invisible: the central command box.

Spitzentechnik für Spitzenrendite

■ Meissl bietet die besten Voraussetzungen fürs perfekte Event-Marketing. Kein Wunder, daß erfolgreiche Gastronomen, Hoteliers und Brau-ereien auf Meissl setzen.

Alle Meissl Schirmbars sind auf höchste Belastung ausgelegt. Nicht nur was Wind und Wetter betrifft, auch die Bar ist auf Höchst-leistung vorbereitet: Stabile, erprobte Konstruk-tionen, widerstandsfähige Materialien, klare Linien und hochwertige technische Gastro-Ausstattung. Denn schließlich soll Ihr Geschäft brummen und nicht die Gäste!

Top Technology for Top Returns

Meissl offers the best conditions for perfect event-marketing. No wonder that successful innkeepers, hoteliers and breweries rely on Meissl.

All Meissl Umbrella Bars meet the highest standards. Not only wind and weather proof, the bar also offers top performance: stable, tested construction, resistant materials, clear lines and high tech gastronomic equipment. As in the end – it is your business that should move and not your guests.

Das passende Zubehör wird mitgeliefert: Hocker und Stehtische setzen die markante Linie fort – und sind ebenso stabil wie die Konstruktion der Schirmbar selbst!

The matching accessories are delivered with the bar: stools and bar tables extend the product line – and are as stable as the construction of the Umbrella Bar itself.

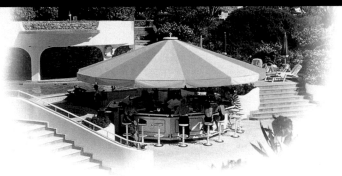

DESIGN FIRM | Big Eye Creative, Inc.

ART DIRECTOR/DESIGNER | Asiza Ilicic

PHOTOGRAPHER | Dann Ilicic

COPYWRITER | Craig Holm

CLIENT | Steel Magnolia

TOOLS | QuarkXPress, Adobe Photoshop

PAPER | Centura Gloss

PRINTING PROCESS | Four-color with spot tint varnish

This catalogue was designed to convey the delicate elegance of Steel Magnolia's custom metal furniture, while balancing the icy strength of the steel they use in all of their creations. Since interior designers are their biggest customers, the catalogue had to be refined, exclusive, and of the finest quality.

The Monarch

 EGAL WITHOUT PRETENSIONS, the MONARCH was designed in collaboration with master archtop luthier Robert Benedetto. It follows in the tradition of the master handing down years of perfected methods and designs to his apprentice. ■ Possessing all the features of the ARTISAN, the MONARCH boasts several attractive additions. Crowning this guitar is a large Benedetto-style headstock with mitred purflings and pinstripe-enhanced binding. The f-holes are fully bound and also trimmed with mitred pinstriped purflings. Only the finest quartersawn seasoned instrument woods are used in its construction, and as with every archtop guitar in the Buscarino lineage the MONARCH is meticulously assembled and tuned. ■ A long list of options and color choices (including the sunburst finish shown opposite), allow the MONARCH to be custom designed as a guitar fit for a king.

Honey Blonde MONARCH

MONARCH *back, showing triple-A wood in a Honey Blonde finish.*

6

THE MONARCH

DESIGN FIRM | Ken Weightman Design
ART DIRECTOR/DESIGNER | Ken Weightman
CLIENT | Buscarino Guitars
TOOLS | QuarkXPress, Adobe Photoshop
PRINTING PROCESS | Offset, die-cut, liquid laminate cover

Liquid laminate on the cover's full-size image suggests the finish of the actual guitars. The F-hole is die-cut. Inside, each of the handcrafted guitar models is presented as fine art.

Drawing from Life

DESIGN FIRM | Pensare Design Group, Ltd.
ART DIRECTOR | Mary Ellen Vehlow
DESIGNERS | Camille Song, Amy Billingham
COPYWRITERS/CLIENT | Devin O'Brien, Adam Attenderfer
TOOLS | Adobe Illustrator and Photoshop, QuarkXPress
PAPER | Monadnock Dulcet, Bier Papier Ale
PRINTING PROCESS | Four-color; silver, white, black on cover

The purpose of this catalog is to showcase the works of the untrained artists of Kenya. The concept was to make readers feel as if they had journeyed into the lives of these children and this is a scrapbook of their adventures.

David Kinywa

David is 19 years old and has been a part of Streetwise since its beginning in January 1994. He was one of the first to get a job painting for a carpentry business. He began working there part-time in April 1995, but they recently refused to make him a permanent employee. He has now returned to Streetwise where he is one of the top designers.

The nomadic Maasai are people of the land. Their survival depends upon the herding of cattle and the harvesting of its milk and blood.

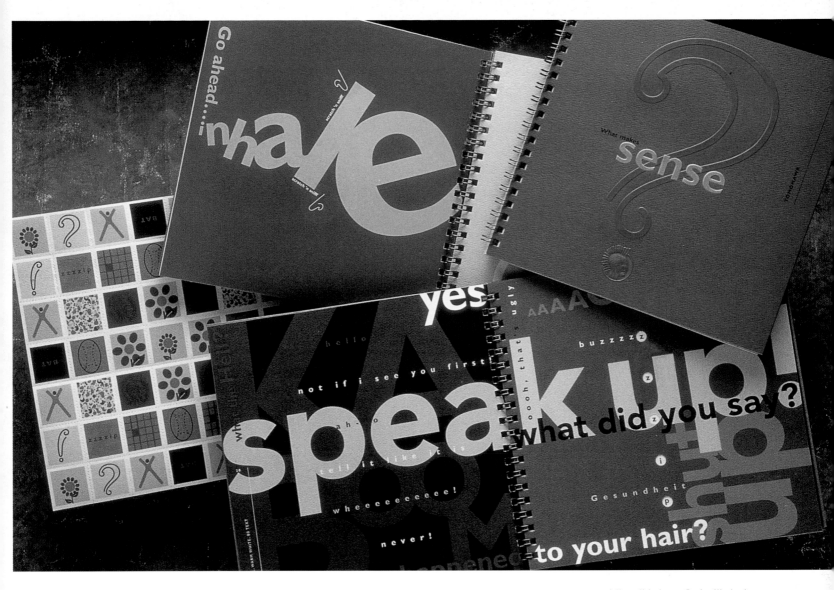

DESIGN FIRM | Hornall Anderson Design Works, Inc.

ART DIRECTORS | Jack Anderson, Lisa Cerveny

DESIGNERS | Jack Anderson, Lisa Cerveny, Mary Hermes,
Jana Nishi, Virginia Le, Jana Wilson Esser

ILLUSTRATOR | Dave Julian

PHOTOGRAPHER | Tom Collicott

COPYWRITER | Suky Hutton

CLIENT | Mohawk Paper Mills

TOOLS | Macromedia FreeHand, Adobe Illustrator,
QuarkXPress

PAPER | Mohawk Tomahawk

The booklet features the best characteristics of the
Tomahawk line by appealing to the reader's senses of
smell, sight, touch, hearing, and taste. Humor was used
to showcase the client's versatile Tomahawk textured
line, including optical illusions, insightful trivia, and
scratch-and-sniff pages.

a new
take on an
old tradition

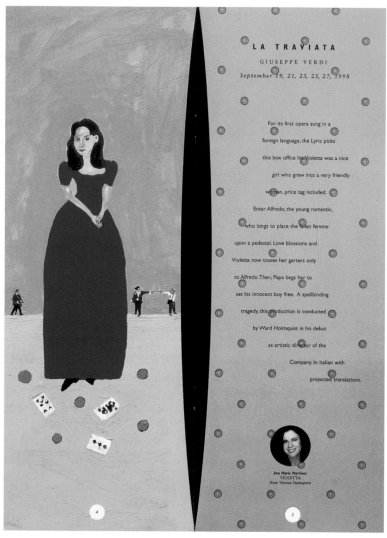

DESIGN FIRM | Muller and Co.
ALL DESIGN | Jeff Miller
COPYWRITERS | Lyric Opera
CLIENT | Lyric Opera
TOOLS | QuarkXPress, Macintosh
PRINTING PROCESS | Four-color offset

The imagery came from taking traditional elements, such as a rose, floral wallpaper, and patterns, then cutting, scratching, reversing, and replacing their original colors with bright, saturated hues.

DESIGN FIRM | DIA
ART DIRECTOR/DESIGNER | Andrew Cook
PHOTOGRAPHER | Vic Paris
COPYWRITER | Robert Davis
CLIENT | AD&D
PAPER | Mohawk
PRINTING PROCESS | Lithography

The catalogue clearly demonstrates the range of products through photographic and graphic styles.

The Classics

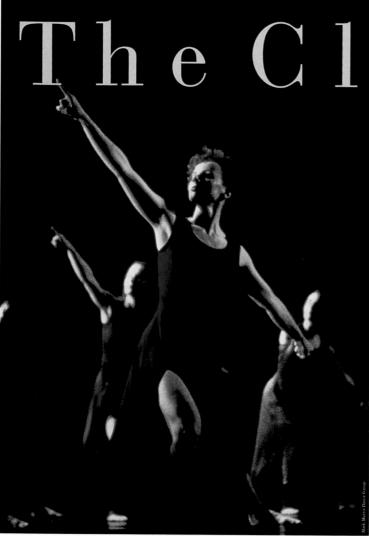

TIMELESS WORKS OF ART

CHANTICLEER

These 12 men comprise an orchestra of voices. The sheer beauty of their sound stems from a seamless blend of carefully matched male voices, ranging from resonant bass to purest countertenor. The ensemble has thrilled audiences worldwide with its brilliance and its repertoire, which includes everything from Renaissance to jazz, gospel to new music. The only full-time classical voice ensemble in this country, Chanticleer has developed a remarkable reputation over an 18-year history for its interpretation of vocal literature. Revel as they do in the pleasure of song.
Sunday, October 6, 7:30pm
$25, $22, $18

MARK MORRIS DANCE GROUP

Here is one of the great choreographers of our time, considered a genius by many. His dance reverberates with wit, humor and lucid musicality. He breaks all the rules, even his own. Irreverent, iconoclastic and yet his work reveals a seriousness and deep understanding of dance. Morris is intensely musical, miraculously turning the classical works of Haydn and Vivaldi into the most contemporary of dances. According to *The Los Angeles Times*, Mark Morris "is deceptively cerebral, insinuatingly sensual, fabulously funky." Now, in the prime of his career, you can see the miracle of Mark Morris.
Sunday–Monday, October 13–14, 7:30pm
$35, $32, $27.50

MOSCOW FESTIVAL BALLET

Combining the best classical elements of two extraordinary companies, the Bolshoi and the Kirov, Artistic Director Sergei Radchenko has forged an exciting new company with some of Russia's leading dancers, including Prima

13

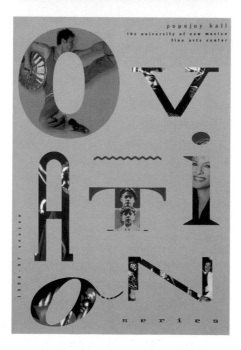

DESIGN FIRM | Vaughn Wedeen Creative
ART DIRECTOR/DESIGNER | Rick Vaughn
PHOTOGRAPHER | UNM Public Events Management
COPYWRITER | UNM Public Events Management
CLIENT | UNM Public Events Management
PAPER | Cougar Opaque White 80 lb. text
PRINTING PROCESS | Four-color process

MONTERRA
PROMISE

DESIGN FIRM | Louisa Sugar Design

ART DIRECTOR | Louisa Sugar

DESIGNERS | Louisa Sugar, Melissa Nery

ILLUSTRATORS | Joey Mantre, Greg Spalenka

COPYWRITER | Lee Nordlund

CLIENT | Monterra Promise Proprietor-Grown Wines

TOOLS | QuarkXPress

PAPER | Teton, Starwhite Vicksburg

PRINTING PROCESS | Letterpress, hot stamping, offset lithography

Research into the place where Monterra Promise wine grapes are grown uncovered a fascinating history, beginning with discovery of the land by the King of Spain' explorers in the 1600s. To communicate these historical roots, this launch brochure was designed to look like a rare book from that era.

MONTERRA PROMISE

GRAPES FROM
THE
BEST VINTAGES ONLY
ARE SELECTED FOR
MONTERRA
PROPRIETOR GROWN WINES.

TOM SMITH
WINEMAKER

BILL PETROVIC
VINEYARD MANAGER

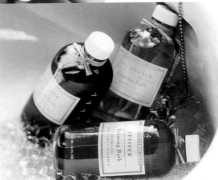

COLOGNE

Wear your own signature statement with these revitalizing colognes. Uniquely formulated with aloe vera, jojoba oil and essential oils, they refresh the skin while adding a layer of fragrance to complement your lifestyle.

75 ML / 2.5 FL OZ

02321 EUCALYPTUS
02322 LAVENDER
02323 VETIVER

FOAMING BATH

Surround yourself with pure herbal fragrances while mounds of bubbles delight your senses. Enriched with jojoba oil, aloe vera and Vitamin E, the copious foam creates a private sanctuary that leaves your skin feeling soft and renewed.

235 ML / 8 FL OZ

02071 EUCALYPTUS
02072 LAVENDER
02073 VETIVER

GLYCERINE SOAP

Pure vegetable glycerine and fragrant essential extracts are the beginning of these beautifully scented jeweltone bars. Enriched with jojoba oil, honey and Vitamins A and E, the gentle lather cleanses thoroughly and then rinses away clean. Perfect for all skin types.

2 SOAPS ~ 85 G / 3 OZ EACH

02091 EUCALYPTUS
02092 LAVENDER
02093 VETIVER

DESIGN FIRM | Design Guys

ART DIRECTORS | Steven Sikora, Lynette Sikora, Gary Patch

DESIGNERS | Jay Theige, Amy Kirkpatrick

PHOTOGRAPHER | Patrick Fox

COPYWRITER | Jana Branch

CLIENT | The Thymes Limited

PRINTING PROCESS | Offset lithography

The inspiration for this catalog was the product packaging. Design Guys styled the brochure similar to the style of each collection, like a travel journal of different places. This entire book was shot in-studio, in natural daylight.

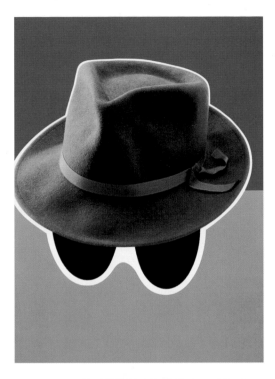

DESIGN FIRM | Factor Design
ART DIRECTOR/ILLUSTRATOR | Paul Neulinger
DESIGNER | Kristina Düllmann
PHOTOGRAPHER | Photodisc
COPYWRITER | Hannah S. Fricke
CLIENT | Römerturn Feinstpapier
TOOLS | Macromedia FreeHand, QuarkXPress, Macintosh
PAPER | Römerturm Kombination
PRINTING PROCESS | Four-color offset

This brochure introduces the new paper line of Römerturm Feinstpapier called Kombination. The big benefit of this new assortment is that it combines different surfaces and shades of white in one line of stock.

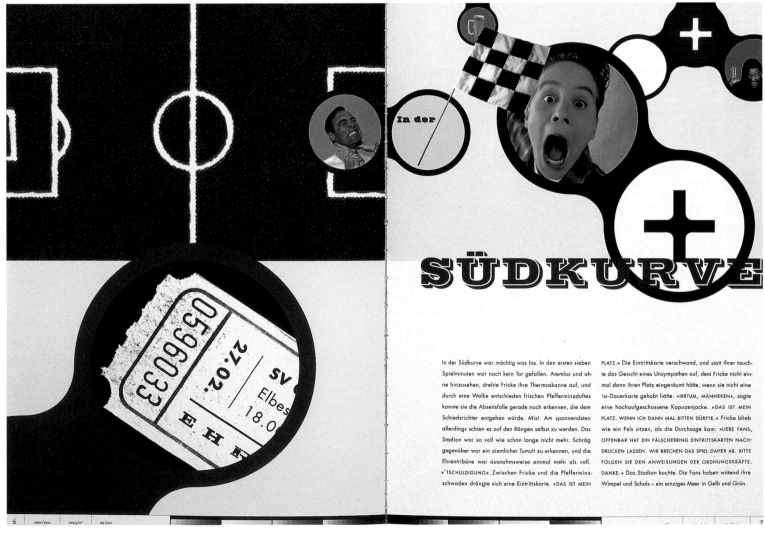

SÜDKURVE

In der Südkurve war mächtig was los. In den ersten sieben Spielminuten war noch kein Tor gefallen. Atemlos und ohne hinzusehen, drehte Fricke ihre Thermoskanne auf, und durch eine Wolke entschieden frischen Pfefferminzduftes konnte sie die Abseitsfalle gerade noch erkennen, die dem Schiedsrichter entgehen würde. Mist. Am spannendsten allerdings schien es auf den Rängen selbst zu werden. Das Stadion war so voll wie schon lange nicht mehr. Schräg gegenüber war ein ziemlicher Tumult zu erkennen, und die Ehrentribüne war ausnahmsweise einmal mehr als voll. »'TSCHULDIGUNG«. Zwischen Fricke und die Pfefferminzschwaden drängte sich eine Eintrittskarte. »DAS IST MEIN PLATZ.« Die Eintrittskarte verschwand, und statt ihrer tauchte das Gesicht eines Unsympathen auf, dem Fricke nicht einmal dann ihren Platz eingeräumt hätte, wenn sie nicht eine 1a-Dauerkarte gehabt hätte. »IRRTUM, MÄNNEKEN«, sagte eine hochaufgeschossene Kapuzenjacke. »DAS IST MEIN PLATZ, WENN ICH DANN MAL BITTEN DÜRFTE.« Fricke blieb wie ein Fels sitzen, als die Durchsage kam: »LIEBE FANS, OFFENBAR HAT EIN FÄLSCHERRING EINTRITTSKARTEN NACHDRUCKEN LASSEN. WIR BRECHEN DAS SPIEL DAHER AB. BITTE FOLGEN SIE DEN ANWEISUNGEN DER ORDNUNGSKRÄFTE. DANKE.« Das Stadion kochte. Die Fans hoben wütend ihre Wimpel und Schals – ein einziges Meer in Gelb und Grün.

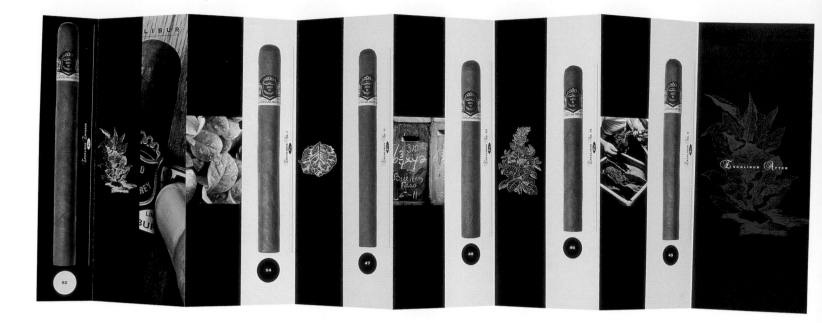

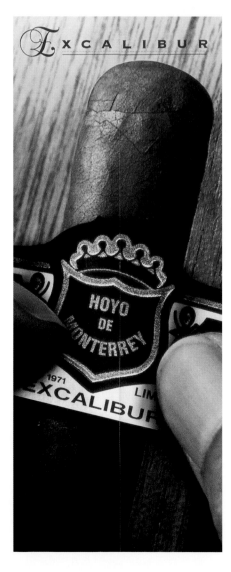

DESIGN FIRM | SJI Associates

DESIGNER | Anthony Cinturatti

PHOTOGRAPHER | Client-supplied photos

COPYWRITERS | Kevin Rayman, Sarah Starr

CLIENT | General Cigar/Villazon

TOOLS | QuarkXPress, Adobe Illustrator and Photoshop

PAPER | Productolith

PRINTING PROCESS | Four-color offset, die-cut and die-scored

The client wanted a brochure that showed all the cigars in the Excalibur line in an exciting, non-traditional format. The use of alternating cream and black panels, duotones, and a short-fold cover create a warm, sophisticated look that appeals to the younger, fashionable cigar smoker.

PRIGMORE · KRIEVINS | *Architects*

DESIGN FIRM | Greteman Group
ART DIRECTORS | Sonia Greteman, James Strange
DESIGNER | Craig Tomson, James Strange
PHOTOGRAPHER | Paul Bowen
COPYWRITER | Deanna Harms
CLIENT | Learjet
TOOLS | Macromedia FreeHand, Adobe Photoshop
PAPER | Reflections
PRINTING PROCESS | Four-color process, spot metallic,
gloss varnish

This highly successful, four-color product brochure communicates the Learjet 31A's key selling points through stunning photography, graphs, fold outs, subtle screens, and generous white space.

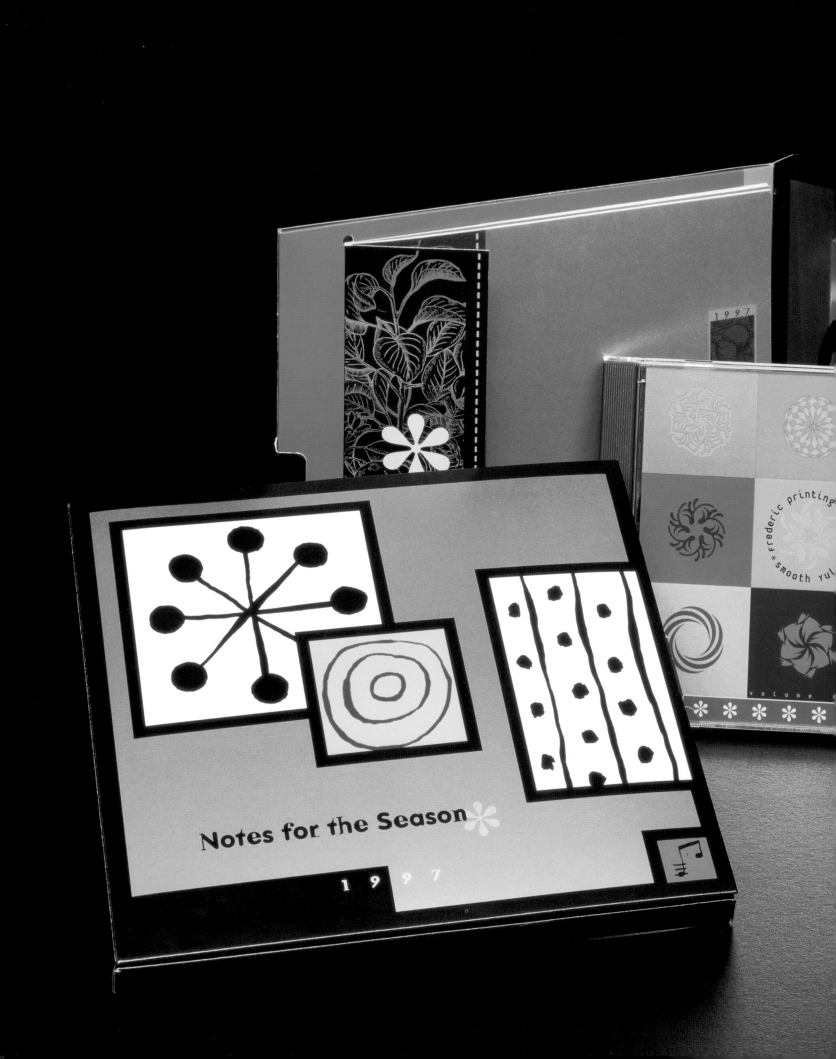

Notes for the Season *

1 9 9 7

SERVICE

BROCHURES

DESIGN FIRM **Lee Reedy Creative, Inc.**
ART DIRECTOR **Lee Reedy**
DESIGNER/ILLUSTRATOR **Heather Haworth**
COPYWRITER **Jamie Reedy**
CLIENT **Frederic Printing**
TOOLS **QuarkXPress**
PRINTING PROCESS **Six-color with metallic silver**

A holiday music CD was given to clients with
this brochure for diary notations about
Christmas dinners, gifts, and other holiday
pleasures. Handpainted graphics added to
the friendly mood of the holidays.

FOLLOWME
SPRACHAUFENTHALTE
ENGLAND, MALTA, FRANKREICH, WESTSCHWEIZ

SCHÜLERSPRACHKURSE 1998

DESIGN FIRM | revoLUZion

ALL DESIGN | Bernd Luz

COPYWRITER | Eveline Feier

CLIENT | Follow Me, Sprachautenthalle, Bern

TOOLS | QuarkXPress, Macromedia FreeHand

PRINTING PROCESS | Four-color offset

A low-budget brochure for language travels was designed to appeal to young clients 13–17 years of age.

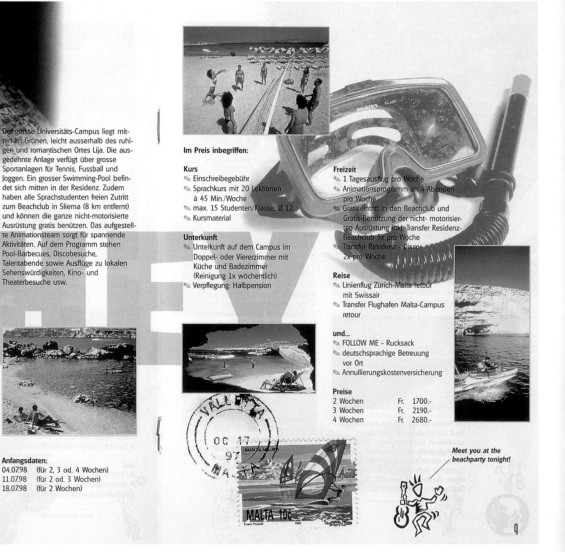

MALTA

Englisch ist neben Maltesisch die zweite Landessprache auf dieser kleinen Insel im Mittelmeer, da die Unabhängigkeit von Grossbritannien erst 1964 erlangt wurde. Sonne gibt es auf Malta im Überfluss und die geschützten Buchten mit kleinen Sandstränden an der sonst vorwiegend felsigen Küste werden Dich begeistern. Für Wasserratten ist Malta mit seinem kristallklarem Wasser ein Paradies und die Bedingungen für Tauchen, Segeln und Windsurfen sind optimal! Dank der ständigen leichten Brise wird es auch im Hochsommer nie unerträglich heiss. Das tolle Mittelmeerklima und verschiedenste Sportmöglichkeiten runden einen unvergesslichen Sprachaufenthalt auf Malta ab.

Der grosse Universitäts-Campus liegt mitten im Grünen, leicht ausserhalb des ruhigen und romantischen Ortes Lija. Die ausgedehnte Anlage verfügt über grosse Sportanlagen für Tennis, Fussball und Joggen. Ein grosser Swimming-Pool befindet sich mitten in der Residenz. Zudem haben alle Sprachstudenten freien Zutritt zum Beachclub in Sliema (8 km entfernt) und können die ganze nicht-motorisierte Ausrüstung gratis benützen. Das aufgestellte Animationsteam sorgt für spannende Aktivitäten. Auf dem Programm stehen Pool-Barbecues, Discobesuche, Talentabende sowie Ausflüge zu lokalen Sehenswürdigkeiten, Kino- und Theaterbesuche usw.

Anfangsdaten:
04.07.98 (für 2, 3 od. 4 Wochen)
11.07.98 (für 2 od. 3 Wochen)
18.07.98 (für 2 Wochen)

Im Preis inbegriffen:

Kurs
- Einschreibegebühr
- Sprachkurs mit 20 Lektionen à 45 Min./Woche
- max. 15 Studenten/Klasse, Ø 12
- Kursmaterial

Unterkunft
- Unterkunft auf dem Campus im Doppel- oder Viererzimmer mit Küche und Badezimmer (Reinigung 1x wöchentlich)
- Verpflegung: Halbpension

Freizeit
- 1 Tagesausflug pro Woche
- Animationsprogramm an 4 Abenden pro Woche
- Gratiseintritt in den Beachclub und Gratis-Benützung der nicht- motorisierten Ausrüstung inkl. Transfer Residenz-Beachclub 5x pro Woche
- Transfer Residenz - Disco 2x pro Woche

Reise
- Linienflug Zürich-Malta retour mit Swissair
- Transfer Flughafen Malta-Campus retour

und...
- FOLLOW ME - Rucksack
- deutschsprachige Betreuung vor Ort
- Annullierungskostenversicherung

Preise
2 Wochen Fr. 1700.-
3 Wochen Fr. 2190.-
4 Wochen Fr. 2680.-

Meet you at the beachparty tonight!

9

PRAIRIE CROSSING RESIDENTIAL COMMUNITY
GRAYSLAKE, ILLINOIS

Prairie Crossing–a 660-acre residential development in Grayslake, Illinois–is a "conservation community" devoted to maintaining and enhancing the prairie landscape. PLSLA, Inc. has designed all on-site planting, as well as the planting and detailing of the Market Square and Village Green. The design of individual home site landscapes is also being done by PLSLA, Inc. Collaborating with architectural, environmental and marketing consultants, the team is building a community that includes equestrian and pedestrian trails, passive/active recreation areas, flower gardens, and restored prairies and wetlands. The master plan was completed by William Johnson, FASLA.

DALEY CENTER PLAZA RENOVATION
CHICAGO, ILLINOIS

Daley Center Plaza is located in the heart of the Chicago Loop and is one of the city's great urban spaces. As part of a complete plaza renovation in 1995, PLSLA, Inc. provided design and full construction documentation for landscape improvements to the plaza. New enlarged planters, which are built over structure, display six "new" Honeylocust trees up to 35-feet tall at installation. Perennial grasses and flowers, highlighted by evergreen shrubs and groundcover, are the focus of the planters at ground level and add richness to the plaza's minimal modern composition.

DESIGN FIRM | Inland Group, Inc.

ART DIRECTOR/DESIGNER | Sandy Holtzscher

CLIENT | Robert Clark Design Studio

TOOLS | Macromedia FreeHand, Macintosh

PAPER | Wausau Royal Fiber, white

PRINTING PROCESS | Offset

The client wanted an upscale look to match their
salon and a unique shape to set the piece apart from
standard brochures. Printing pages individually allows
cost-effective reproduction in the event of price changes.

robert·clark
design studio

fi do

News

VOLUME 1 · NUMBER ONE JULY **1997**

Fido's Coming to Vancouver

Good Heavens, It's Fido!
Fido is a fearless breed. A rover at heart, he can be seen
sailing over the country behind the wheel of his airship.
Now floating over office towers, totem poles
and pine trees in Vancouver,
Fido was recently seen gliding over
Lake Ontario and past the CN Tower into
Toronto. Fido has also been spotted
gracefully poised above the Château
Frontenac and the Plains of Abraham in
Quebec City. In Ottawa, his logo was
reflected in the waters of the Rideau Canal. Drawn
by memories of his maiden voyage, he will even reappear
in Montreal. From coast to coast, Fido will fill the sky.

A Star Is Born FIDO IS THE RISING STAR IN PERSONAL COMMUNICATIONS SERVICES (PCS).
THE NAME FIDO INSPIRES CONFIDENCE, AN ESSENTIAL VALUE IN OUR CHANGING TIMES. WHEN HE CAME
INTO BEING, WE MADE A POINT OF SHOUTING IT FROM THE ROOFTOPS.

A Faithful Friend Fido always recognizes his owner. The smart card you insert in your handset contains the information the GSM network needs to identify you. The chip in your smart card also lets you access your services. But each time you turn on the handset, you must enter your PIN (personal identification number). Because when you're this smart, you can't be too careful!

A Clever Ally The moment he knows it's you, Fido's at your service. You can make and receive calls and take advantage of many different functions—including Call Waiting, Call Forwarding and Conference Call—all from one handset. You can even have Call Display and receive faxes (stored in memory), voice messages (through Personal Voice Messaging) and short text or numeric messages (displayed on your handset). Fido knows your needs are constantly expanding, becoming more urgent and more complex. Fido can handle them all.

Fido Is Always There To communicate effectively, you need quality sound. Fido's fully digital technology ensures optimum voice quality. Digital technology also codes signals so they're indecipherable to prying ears. How reassuring to know that nobody else can listen in on your conversations! All your communications are now totally confidential. ▶

FIDO IS A REGISTERED TRADEMARK OF
MICROCELL SOLUTIONS INC.

DESIGN FIRM | Goodhue & Associés Design Communication

CREATIVE DIRECTOR | Lise Charbonneau

ART DIRECTORS | Nathalie Houde, Anne Isabelle Roussy

DESIGNERS | Josee Barsalo, Florent DuFort

ILLUSTRATOR | Mark Tellok

PHOTOGRAPHER | Jean Vachon

COPYWRITER | Microcell Solutions Language Services

CLIENT | Microcell Solutions

TOOLS | QuarkXPress, Macromedia FreeHand, Adobe Photoshop

PRINTING PROCESS | Offset

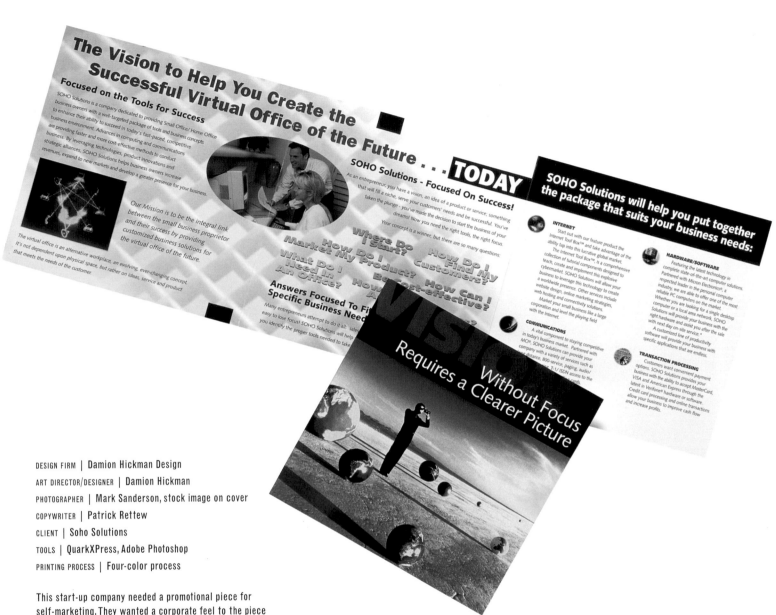

DESIGN FIRM | Damion Hickman Design

ART DIRECTOR/DESIGNER | Damion Hickman

PHOTOGRAPHER | Mark Sanderson, stock image on cover

COPYWRITER | Patrick Rettew

CLIENT | Soho Solutions

TOOLS | QuarkXPress, Adobe Photoshop

PRINTING PROCESS | Four-color process

This start-up company needed a promotional piece for
self-marketing. They wanted a corporate feel to the piece
to compete with businesses already in the marketplace.
This brochure was sent as part of a direct-mail strategy.

DESIGN FIRM | X Design Company

ART DIRECTORS/DESIGNER | Alex Valderrama

CLIENT | McDermott Planning and Design

The goal was to create a brochure that could double as a
leave-behind and as a direct mailer. Thus this brochure
was designed to stand alone, but it could also be rolled,
held together with a belly band, and placed in the box
when used for direct mailing.

está usted
colaborando
a construir
você está ajudando a fazer de

OU ARE

HELPING
to make
1998
a YEAR of
DISCOVERY
año de descubrimientos um ano de descobertas

DESIGN FIRM | Pinkhaus Design
ART DIRECTOR | Joel Fuller
DESIGNERS | Cindy Vasquez
COPYWRITER | Doug Paley
CLIENT | Discovery Network
TOOLS | Adobe Illustrator and Photoshop
PAPER | Simpson Evergreen Kraft, 80 lb. cover,
Champion Pagentry Handmade
PRINTING PROCESS | Four-color process plus two PMS

The client was planning to make a donation in the name of all those who received this Christmas card. The card needed to reflect the significance of this donation and the Spirit of Discovery.

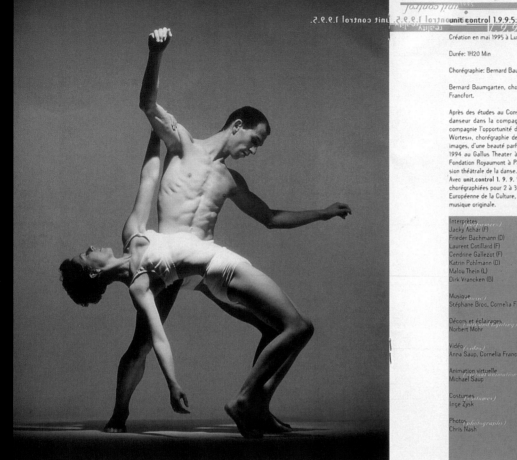

unit control 1.9.9.5.

Création en mai 1995 à Luxembourg aux Foires Internationales au Kirchberg

Durée: 1H20 Min

Chorégraphie: Bernard Baumgarten

Bernard Baumgarten, chorégraphe luxembourgeois, a débuté sa carrière au S.O.A.P. Dance Theatre à Francfort.

Après des études au Conservatoire de Luxembourg et chez Rick Odums à Paris, il fut engagé comme danseur dans la compagnie de Rui Horta. En 1993, le «Mousonturm» offrait aux membres de la compagnie l'opportunité de produire une soirée chorégraphique. «Im Falle des Fallens eines gefallenen Wortes», chorégraphie de B. Baumgarten, avait suscité l'intérêt par son langage très personnel et ses images, d'une beauté parfois glaciale et distante. Dans ses productions suivantes, «Jedes X Wenn Du», 1994 au Gallus Theater à Francfort, et «Honni soit qui mal y pense», 1994 à l'Atelier Cosmopolite Fondation Royaumont à Paris, il est resté fidèle à son approche chorégraphique, orientée vers l'expression théâtrale de la danse.
Avec unit.control 1. 9. 9. 5. B. Baumgarten franchit une étape importante: les premières pièces ont été chorégraphiées pour 2 à 3 interprètes - la production unit control, créée dans le cadre Luxembourg, Ville Européenne de la Culture, met en scène sept danseurs, un travail vidéographique et la composition d'une musique originale.

Interprètes (Performers)
Jacky Achar (F)
Frieder Bachmann (D)
Laurent Cotillard (F)
Cendrine Gallezot (F)
Katrin Pohlmann (D)
Malou Thein (L)
Dirk Vrancken (B)

Musique (Music)
Stéphane Broc, Cornelia Francke

Décors et éclairages (Lighting)
Norbert Mohr

Vidéo (Video)
Anna Saup, Cornelia Francke

Animation virtuelle (Virtual Animation)
Michael Saup

Costumes (Costumes)
Inge Zysk

Photos (Photography)
Chris Nash

DESIGN FIRM | Atelier Graphique Bizart
ART DIRECTOR | Raoul Thill
DESIGNER | Miriam Rosner
PHOTOGRAPHERS | Katrin Schander, Chris Nash
COPYWRITER | Stephane Broc
CLIENT | Theâtre Dansé & Muet
TOOLS | Adobe Photoshop, QuarkXPress
PAPER | Zanders Megamatt
PRINTING PROCESS | Black and silver offset

The client was very open to a free style of graphic design. Being able to break typographical rules was helpful in depicting movement, dynamism, and the way dancers expresses themselves.

DESIGN FIRM | Melissa Passehl Design
ALL DESIGN | Melissa Passehl
CLIENT | Interchange Family Services
TOOLS | QuarkXPress, Adobe Illustrator and Photoshop
PAPER | Lustro Dull
PRINTING PROCESS | Four-color lithography

This brochure is a quick reference for families with special-needs children aged one to three. Color and hand-rendered type help to create a child-friendly feeling.

the goal of Interchange is to promote appropriate and coordinated services for families and their infants and toddlers who have special needs or are at risk of developmental delays.

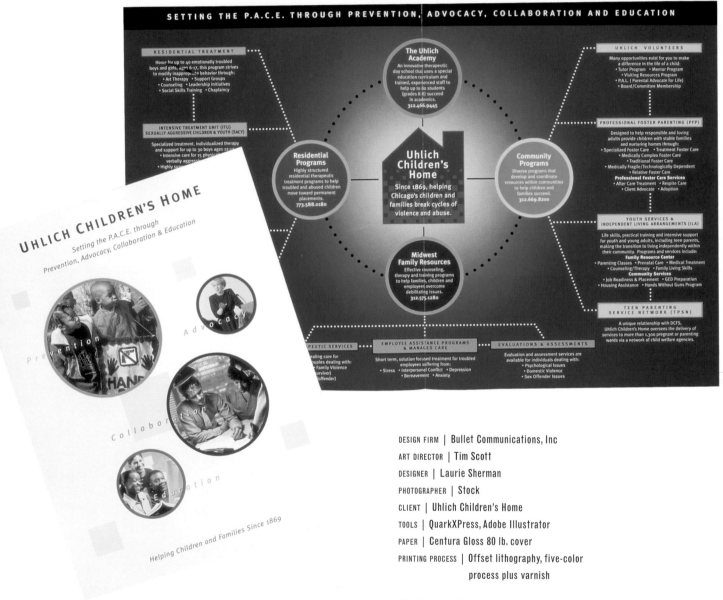

SETTING THE P.A.C.E. THROUGH PREVENTION, ADVOCACY, COLLABORATION AND EDUCATION

RESIDENTIAL TREATMENT
Home for up to 40 emotionally troubled boys and girls, ages 6-17, this program strives to modify inappropriate behavior through:
• Art Therapy • Support Groups
• Counseling • Leadership Initiatives
• Social Skills Training • Chaplaincy

INTENSIVE TREATMENT UNIT (ITU)
SEXUALLY AGGRESSIVE CHILDREN & YOUTH (SACY)
Specialized treatment, individualized therapy and support for up to 30 boys ages 12-17.
• Intensive care for 15 physically verbally aggressive
• Highly su...

The Uhlich Academy
An innovative therapeutic day school that uses a special education curriculum and trained, experienced staff to help up to 80 students (grades K-8) succeed in academics.
312.466.9445

Residential Programs
Highly structured residential therapeutic treatment programs to help troubled and abused children move toward permanent placements.
773.588.0180

Uhlich Children's Home
Since 1869, helping Chicago's children and families break cycles of violence and abuse.

Community Programs
Diverse programs that develop and coordinate resources within communities to help children and families succeed.
312.669.8200

Midwest Family Resources
Effective counseling, therapy and training programs to help families, children and employees overcome debilitating issues.
312.575.1280

UHLICH VOLUNTEERS
Many opportunities exist for you to make a difference in the life of a child:
• Tutor Program • Mentor Program
• Visiting Resources Program
• P.A.L. (Parental Advocate for Life)
• Board/Committee Membership

PROFESSIONAL FOSTER PARENTING (PFP)
Designed to help responsible and loving adults provide children with stable families and nurturing homes through:
• Specialized Foster Care • Treatment Foster Care
• Medically Complex Foster Care
• Traditional Foster Care
• Medically Fragile/Technologically Dependent
• Relative Foster Care
Professional Foster Care Services
• After Care Treatment • Respite Care
• Client Advocate • Adoption

YOUTH SERVICES &
INDEPENDENT LIVING ARRANGEMENTS (ILA)
Life skills, practical training and intensive support for youth and young adults, including teen parents, making the transition to living independently within their community. Programs and services include:
Family Resource Center
• Parenting Classes • Prenatal Care • Medical Treatment
• Counseling/Therapy • Family Living Skills
Community Services
• Job Readiness & Placement • GED Preparation
• Housing Assistance • Hands Without Guns Program

TEEN PARENTING
SERVICE NETWORK (TPSN)
A unique relationship with DCFS, Uhlich Children's Home oversees the delivery of services to more than 1,300 pregnant or parenting wards via a network of child welfare agencies.

...RAPEUTIC SERVICES
...ealing care for ...uples dealing with: ...Family Violence ...urvivor) ...ffender)

EMPLOYEE ASSISTANCE PROGRAMS
& MANAGED CARE
Short term, solution focused treatment for troubled employees suffering from:
• Stress • Interpersonal Conflict • Depression
• Bereavement • Anxiety

EVALUATIONS & ASSESSMENTS
Evaluation and assessment services are available for individuals dealing with:
• Psychological Issues
• Domestic Violence
• Sex Offender Issues

UHLICH CHILDREN'S HOME
Setting the P.A.C.E. through
Prevention, Advocacy, Collaboration & Education

Prevention
Advocacy
Collaboration
Education

Helping Children and Families Since 1869

DESIGN FIRM | Bullet Communications, Inc
ART DIRECTOR | Tim Scott
DESIGNER | Laurie Sherman
PHOTOGRAPHER | Stock
CLIENT | Uhlich Children's Home
TOOLS | QuarkXPress, Adobe Illustrator
PAPER | Centura Gloss 80 lb. cover
PRINTING PROCESS | Offset lithography, five-color
process plus varnish

This brochure illustrates how Uhlich Children's Home is Setting the P.A.C.E. in the social-services industry through its full array of programs and services.

DESIGN FIRM | Elton Ward Design
ART DIRECTOR | Jason Moore
DESIGNER | Justin Young
CLIENT | Australian Design Awards
TOOLS | Adobe Illustrator and Photoshop
PAPER | 350 gsm A2 Gloss Art
PRINTING PROCESS | Four-color offset plus special
plus varnish

A technical approach was required for this call-for-entries leaflet to encourage industrial designers to submit their product designs for judging in the 1998 awards competition. This brochure set the theme for the upcoming award-winners annual.

DESIGN FIRM | Integrated Marketing Services/IMS Design

ART DIRECTOR/DESIGNER | Michael Grant

PHOTOGRAPHER | Neil Molinaro

COPYWRITERS | Stan Mallis, Karen Goldman, Tony Casale

CLIENT | Ungerer & Co.

TOOLS | QuarkXPress, Adobe Illustrator and Photoshop

PAPER | Consort Royal Silk white, cover and text

PRINTING PROCESS | Offset

Using dramatic color and photography, the brochure repositions an older, mid-sized flavor-and-fragrance formulator as Master of the Elements. The idea was to create a visual experience of history, color, and capability. The transformation photo illustrates this idea.

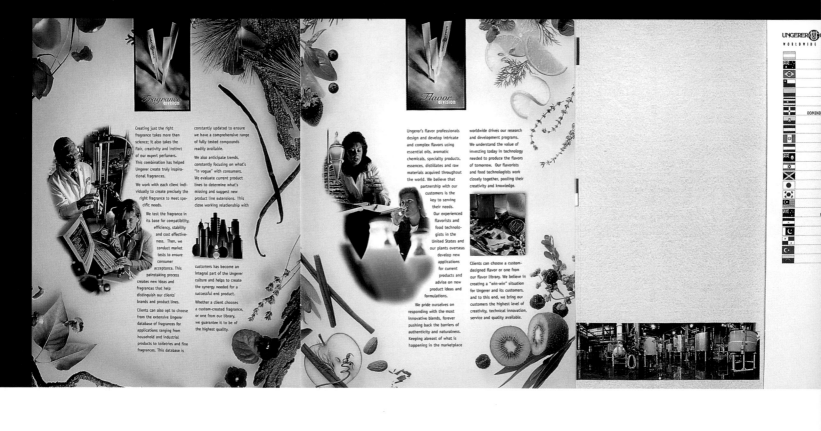

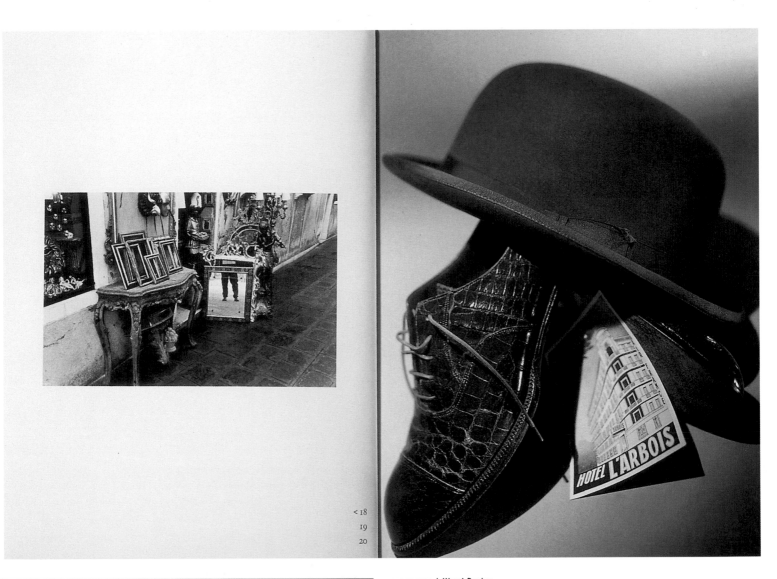

< 18
19
20

DESIGN FIRM | Wood Design
ART DIRECTOR | Tom Wood
DESIGNERS | Tom Wood, Alyssa Weinstein
PHOTOGRAPHER | Craig Cutler
CLIENT | Craig Cutler Photography
TOOLS | QuarkXPress
PAPER | Monadnock Astrolite
PRINTING PROCESS | Six-color offset

The photographer, recognized as a leading studio photographer, requested a promotion that would show his other photographic talents in portrait and location work. The designers played on the concept of travel and places. They paralleled and contrasted the photography in a leatherette-style passport book.

DESIGN FIRM | Price Learman Associates

ART DIRECTOR | Patricia Price Learman

DESIGNER | Sandy Goranson

COPYWRITER | Douglas Learman

CLIENT | Trammell Crow Residential Services:
Chandler's Reach

PAPER | Starwhite Vicksburg Archiva cover and text;
UV Ultra 36 lb. flysheet

PRINTING PROCESS | Four-color process

The client wanted to enhance the Chandler's Reach image,
gain upscale residents, and portray an overall feeling of
uniqueness. The brochure has the hint of a posh boathouse
atmosphere with views of the property's lake activity and
the rope that ties it all together.

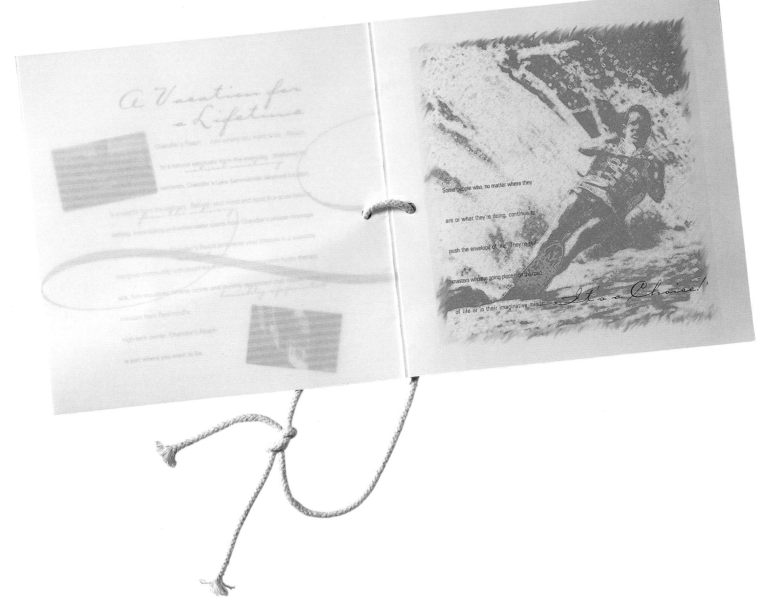

TRAIN for Change

THE TRAINING CONNECTION

...IONS: Rooms have been reserved at the *Holiday Inn,*
...*entucky* for the nights of *August 24, 25, and 26.*
...rate for TRAIN FOR CHANGE is *$75.00 plus tax.*
...the Holiday Inn directly at *606.331.1500* to
...please indicate that you are attending the
...rkshop when making your reservation.
...e that our special rate is reserved only until *July 30, 1998.*
...our convenience, the Holiday Inn offers a complimentary shuttle
...the airport. We will send you more information about the hotel
...es, including a map, in your enrollment confirmation packet.

...RATION DEADLINE: Your registration must be postmarked on or
...*July 24, 1998,* to guarantee your spot at TRAIN FOR CHANGE.

...ESTIONS? If you have questions about TRAIN FOR CHANGE or
...eed any assistance, please call JULIE HILE or CAROL HOENIGES at
THE TRAINING CONNECTION at *309.454.2218.*

TRAIN FOR CHANGE – AUGUST 25, 26, AND 27, 1998
THE TRAINING CONNECTION

DESIGN FIRM | Griffin Design
DESIGNER/ILLUSTRATOR | Tracy Sleeter
COPYWRITER | Carol Hoeniges
CLIENT | The Training Connection
PAPER | Neenah Peppered Bronze Duplex
Classic Laid (folder)
PRINTING PROCESS | Two-color offset by Commercial Printing
Associates (folder and inserts);
four-color Indigo by Starnet (stickers)

The goal was to produce a multi-functional marketing tool.
The self-mailing folder, printed with two colors on the
inside only, can be used to hold conference promotions or
marketing information. An indigo press was used to create
multiple sets of stickers that provide artwork on the out-
side of the folder.

DESIGN FIRM | Adele Bass & Co. Design
ALL DESIGN | Adele Bass
COPYWRITER | Tina Gordon-McBee
CLIENT | Social Model Recovery Systems
TOOLS | Adobe Illustrator and Photoshop, QuarkXPress
PAPER | Evergreen 80 lb., Kraft Cover
PRINTING PROCESS | One-color lithography

Budget was a major consideration for this pamphlet.
The theme of violence inspired the typography on the
cover and the inside copy. The Kraft paper adds to the
raw nature of the subject matter.

Divine Dividends a Heavenly STIR

Brentwood Mall launched our Divine Dividends Customer Rewards Program in 1997 with the intent to encourage Brentwood customers to shop more frequently, increase individual expenditures per visit and encourage these goals throughout the year. The incentive was a collectible series of custom-designed Angels created exclusively for Brentwood Mall. Advertised within the shopping centre only, the program boasted over 600 members and represented over $98,000.00 in sales revenue.

Winner of MERIT Maple Leaf Award: Overall Marketing Campaign

This award recognizes a single campaign that combines elements from at least two areas of shopping centre marketing. The category looks for synergy of well-integrated marketing programs that use multiple and varied efforts to benefit their shopping centres. Our 'Make the Season Bright' Christmas campaign integrated sales promotion, consumer advertising, customer relations and community program initiatives to give customers unique reasons to shop at Brentwood Mall.

1997 HIGHLIGHTS

special EVENTS for 1998

ITEMS TO REMEMBER SO YOU CAN PLAN AHEAD

Youth Week: May	Antique Show: September
Antique Show: May	Halloween Festivities: October
Safety Week: June	Christmas Promotions: November/December
Sidewalk Sale: July	
Back To School Promotion: August/September	Sidewalk Sale: January 1999

DESIGN FIRM | Big Eye Creative, Inc.
ALL DESIGN | Nancy Yeasting
COPYWRITERS | Nancy Yeasting, Folanda Smits
CLIENT | Brentwood Mall
TOOLS | Adobe Illustrator and Photoshop
PAPER | Currency Cover Silver and blueprint paper
PRINTING PROCESS | Lithography and blueprints

This annual meeting for a local mall required economical print material to promote their war against the retail competition. The designer creatively used blueprint paper (an inspiration being the blueprint shop around the corner) rolled into a camouflaged tube, and an oversized dog tag invitation card (complete with chain) printed with black on a metallic stock.

Great Valley Center

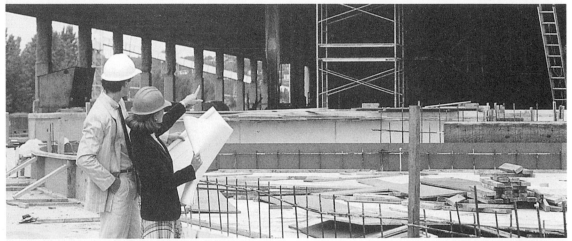

LEGACI Grants

DESIGN FIRM | Shields Design
ART DIRECTOR/DESIGNER | Charles Shields
PHOTOGRAPHER | Stock
COPYWRITER | Carol Whiteside
CLIENT | Great Valley Center
TOOLS | Adobe Illustrator and Photoshop
PAPER | Classic Crest 70 lb. text
PRINTING PROCESS | Offset

This was an inexpensive, two-color brochure for a local client. It combines information about available grants and an application form. Within a limited budget, the client wanted a sophisticated brochure to showcase the new program.

DESIGN FIRM | X Design Company
ART DIRECTOR/DESIGNER | Alex Valderrama
CLIENT | Northwest Bank
TOOLS | QuarkXPress, Adobe Photoshop
PAPER | Cougar Opaque, Beckett RSVP
PRINTING PROCESS | Cougar Opaque, Beckett RSVP

The challenge was to design an invitation that did not look
like a direct-mail piece. The solution drew inspiration from
researching visuals of China. He treated the invitation like
packaging and established a creative visual language.
Client expected 1,200 responses and received double that.

DESIGN FIRM | Marketing and Communication Strategies, Inc.

DESIGNER | Eric Dean Freese

PHOTOGRAPHER | Barb Gordon

CLIENT | Guaranty Bank & Trust Company

TOOLS | Adobe Illustrator and Photoshop, QuarkXPress

PAPER | Beckett RSVP Greenbriar,
Beckett Expression Iceberg

PRINTING PROCESS | Three-color offset plus varnish,
foil stamped, die-cut band

The Trust Department of this bank wanted an identity
piece at a reasonable cost that would be upscale yet
friendly. The bank president provided his collection of
antique bank illustrations to lend a nostalgic feel,
and the foil-stamped, die-cut band added sophistication
that pleased the client.

THE TAO OF NEVER ENOUGH

To think is to be alive, or so said Descartes.

Is the universe dead?

Are earthquakes alive?

Are we the only thinking creatures? When animals protect their young
are they thinking, or merely responding instinctively? Do computers
think or merely respond to instructions? For that matter, do we
ourselves merely respond to genetic instructions?

I presume that Hitler, the unabomber, the Menendez brothers, were
once trusting infants and loveable babies. What virulent instructions
were mixed with their daily formula? And how do we accept that they,
like us, are human beings, offspring of male and female coupling, born
of mothers' wombs?

Somehow love was not enough, or perhaps there was not enough love.

Perhaps there is never enough love.

There is never enough art

For art is an act of love.

Corinne Whitaker

lower: *Battered*, 1998 30 x 30" upper: *Man with Blue Tongue*, 1998 30 x 30"

CORINNE WHITAKER

DESIGN FIRM | Digital Giraffe
ALL DESIGN | Corinne Whitaker

The challenge was to design an eye-catching brochure
on a small budget, to promote the digital painting
of Corinne Whitaker.

TECNOLOGÍA AL SERVICIO DEL MEDIO AMBIENTE

DESIGN FIRM | GN diseño gráfico

ART DIRECTOR/DESIGNER | Guillermo Novelli

PHOTOGRAPHER | Guillermo Novelli

COPYWRITER | Graciela Radice (from Borg Austral)

CLIENT | Borg Austral S.A.

TOOLS | Adobe Illustrator and Photoshop, QuarkXPress

PAPER | Ilustracion Mate Oreplus 240 gsm

PRINTING PROCESS | Four-color offset, and Pantone 328

The client, an environmentally sensitive industrial-waste management firm, wanted to show their appreciation of the special technology they use. Novelli chose the butterfly and color scheme to reflect the eco-friendly theme of the brochure.

● PLANTA INTEGRAL DE TRATAMIENTO Y DISPOSICIÓN FINAL

La planta presta servicios integrales de análisis, clasificación, reciclado, recuperación y tratamiento de residuos industriales.

Cuenta con las siguientes áreas de procesamiento:

■ Instalaciones de recepción y pesaje de cargas.

■ Laboratorio de análisis físico-químico donde se realiza la identificación y la verificación de los materiales, su análisis y clasificación, el control de los procesos de tratamiento y el monitoreo ambiental.

■ Nave de almacenamiento de tambores, de 1.500 m2 de superficie cubierta, con capacidad para almacenar 10.000 tambores, complementada por instalaciones de vaciado y transferencia de material bombeable a tanques.

■ Playa de tanques de almacenamiento a granel de diversos productos bombeables, diseñada y construida según normas API.

■ Unidades de recuperación de materiales combustibles, impurificados con sólidos y agua, mediante separaciones físicas de decantación y centrifugación. El producto recuperado es utilizado como combustible alternativo en hornos de cemento.

■ Unidad de incineración, compuesta de un horno de tipo rotativo, de 500 kg por hora de capacidad de procesamiento, doble cámara de quemado, sistema de enfriamiento y depuración de gases de combustión e instalaciones de alimentación continua y automática de líquidos, sólidos y semisólidos, tanto a granel como en tambores. Cuenta con un diseño altamente flexible que le permite manejar diversos tipos de materiales, en diferentes condiciones físicas y de almacenamiento. Cuenta con un completo sistema de purificación de gases y monitoreo continuo de emisiones.

■ Unidad de tratamiento físico-químico de estabilización-solidificación, para el procesamiento de cenizas y escorias generadas durante la incineración, y de semisólidos inorgánicos.

■ Oficinas, comedor y vestuarios para el personal de la planta, báscula para control de cargas y servicios de mantenimiento liviano preventivo.

UNIDAD DE INCINERACIÓN

La tecnología de incineración adoptada se basa en un horno de tipo rotativo, con cámara de post-combustión y extracción continua de cenizas, apto para tratar térmicamente materiales líquidos, sólidos y semisólidos, los cuales pueden ser alimentados separadamente tanto a granel como en tambores. La cámara de post-combustión opera a temperaturas de 1200° C y tiempo de residencia superior a 2,5 seg. Se complementa con un moderno sistema de purificación y depuración de gases, compuesto por un enfriador evaporativo, un venturi, un reactor neutralizador de ácidos, adsorción de moléculas orgánicas y filtro de mangas para la retención de partículas sólidas. Las emisiones por chimenea son monitoreadas en forma continua con registro y archivo de datos a través de un PLC. Cuenta con instalaciones para el almacenamiento, procesado y alimentación de residuos en sus

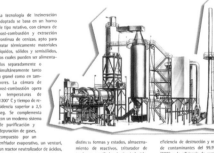

Sistema de control del proceso de incineración

distintas formas y estados, almacenamiento de reactivos, triturador de tambores, ventilador de tiro inducido, chimenea de descarga de gases y demás servicios auxiliares.

Estas unidades combinadas destruyen térmicamente los distintos contaminantes orgánicos presentes y tratan los gases resultantes de la combustión hasta su purificación. Opera con una

eficiencia de destrucción y remoción de contaminantes del 99,9999 % (DRE) y la eficiencia de combustión (CE) es superior al 99,99 %.

La planta incorpora la mejor tecnología disponible demostrada (BDAT) para el procesamiento de desechos peligrosos.

LABORATORIO

El laboratorio está equipado con el instrumental necesario para realizar ensayos analíticos integrales de análisis y clasificación de desechos factibles de ser tratados, el control del proceso y el monitoreo ambiental. Los ensayos que se realizan incluyen determinación de pH, porcentaje total de sólidos, densidad, aceites y grasas, líquidos libres, punto de inflamación, poder calorífico, contenido de inertes, de metales pesados, compuestos orgánicos volátiles y semivolátiles, control de PCB's, cianuros, sulfuros, compuestos orgánicos halogenados e hidrocarburos.

Las tareas que se realizan en las instalaciones del laboratorio incluyen:

I. Caracterización de los residuos previo al tratamiento.

II. Análisis de verificación diaria.

III. Control de las operaciones y procesos de la planta.

IV. Monitoreo ambiental.

V. Servicios de análisis y caracterización de residuos y efluentes industriales a terceros.

Los equipos para el desarrollo de las funciones antes descriptas incluyen: espectrofotómetro de absorción atómica, cromatógrafo de gases, espectrómetro infrarrojo, F.I.A.S., peachímetros, bombas calorimétricas, muflas, balanzas, destiladores, hornos, densímetros y viscosímetros, además de los equipos necesarios para preparación de muestras, calibración, control, y QA/QC.

TRATAMIENTO DE ESTABILIZACIÓN-SOLIDIFICACIÓN

Los residuos de características inorgánicas con metales pesados y con ausencia de contaminantes orgánicos incinerables, si no es factible su reciclado y recuperación, son tratados por estabilización físico-química y solidificación (inertización), en una unidad de procesamiento continuo, para luego ser adecuadamente dispuestos en relleno de seguridad. La tecnología de inertización consiste en procesos que eliminan las características peligrosas del residuo

mediante la transformación química de los contaminantes presentes, limitando su solubilidad y movilidad, y eliminando su toxicidad. Los líquidos libres presentes se transforman en sólidos estables. El contaminante es aislado mediante su encapsulación en un sólido monolítico de alta integridad estructural. La encapsulación limita la migración de contaminantes ya que reduce la exposición a la lixiviación y los aísla dentro de una

cápsula impermeable. El producto ya estabilizado presenta propiedades de alta estabilidad, una estructura rígida, friable, similar a muchos suelos o al hormigón.

RECICLADO Y RECUPERACIÓN DE MATERIALES COMBUSTIBLES

Los líquidos de características combustibles, impurificados con sólidos y agua son recuperados mediante operaciones físicas de decantación y/o centrifugación y una vez libres de impurezas son utilizados como combustibles alternativos, siendo aporte de energía en el proceso de incineración o en hornos de cemento.

Para tal propósito se emplean tanques de tipo tronco-cónicos y unidades de centrifugación que permiten separar las fases agua-aceite-sólido con alto rendimiento y de tipo modular. Se complementa con instalaciones para el almacenamiento y acondicionamiento del material a recuperar, que incluye el agregado de aditivos, el calentamiento, instalaciones de bombeo y de recepción y almacenamiento de producto recuperado.

RELLENO DE SEGURIDAD

El relleno de seguridad de BORG AUSTRAL S.A., diseñado y construido con el objeto de lograr el confinamiento seguro de los residuos inertizados, utiliza tecnología de probada eficiencia, dando total cumplimiento a legislación ambiental aplicable, principalmente los requerimientos del Decreto Reglamentario de la Ley de Residuos Especiales de la Pcia. de Buenos Aires.

Los estándares de diseño y las características generales de las celdas de disposición final se basan en la normativa vigente en Argentina, considerando además los lineamientos y recomendaciones de la Agencia de Protección Ambiental de EEUU (EPA).

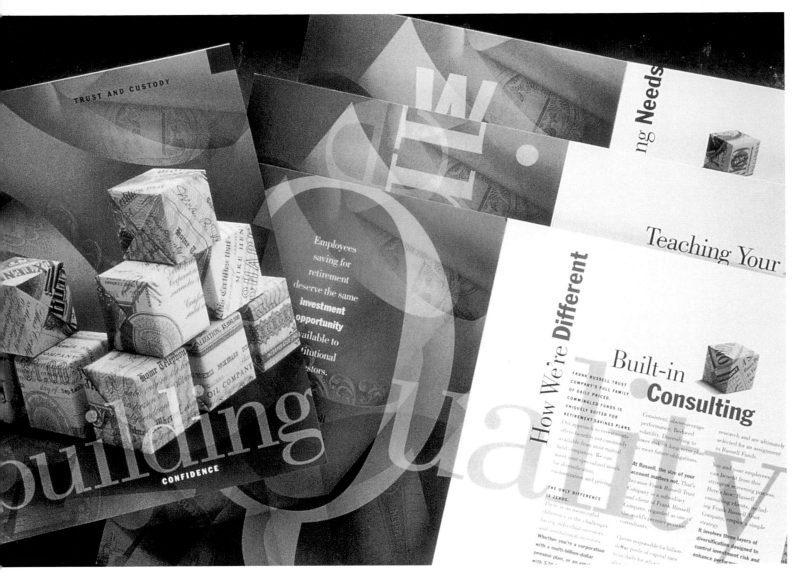

DESIGN FIRM | Hornall Anderson Design Works, Inc.

ART DIRECTOR | Jack Anderson

DESIGNERS | Jack Anderson, Lisa Cerveny, Jana Wilson Esser,
Alan Florsheim, Michael Brugman

PHOTOGRAPHERS | Robin Bartholick,
Will Agranoff (composites only)

COPYWRITER | Client

CLIENT | Frank Russell Company

TOOLS | QuarkXPress, Macromedia FreeHand,
Adobe Photoshop

PAPER | Mohawk Superfine

Bold and enlarged type treatments alleviate the
intimidating print that is frequently found in financial
material. The warm color palette lends an upscale look
and feel to the piece. Photo composite illustrations, a
textured lineal-grooved paper stock, emboss, and special
Velcro closures all contribute to making this kit
simple, yet elegant.

We're taking off the gloves on this one! Yes, we've given away cars before, but never like this. Steer your customers in the right direction and your sales will shift into high gear. So will your chances to win! You're in the driver's seat and the race to the finish is in your hands.

WE'LL STEER you IN A CAREL RIGHT!

TURN ON THE POWER

WIN

DESIGN FIRM | Vaughn Wedeen Creative
ART DIRECTOR | Steve Weeden
DESIGNERS | Steve Weeden, Pam Farrington
COPYWRITER | Foster Hurley
CLIENT | US West

CLIENT | Seattle Opera's Bravo! Club

TOOLS | Macromedia FreeHand, Adobe Photoshop

PAPER | Fox River White

PRINTING PROCESS | One-color plus varnish

Varnish worked beautifully in this brochure,
lending rich color.

You and a guest are cordially invited to celebrate La Vie Bohème with Seattle Opera's Bravo! Club

Friday, May 15th, 1998, 10 PM to 1:30 AM, immediately following the opera

A post-performance celebration in honor of *La bohème* featuring live music from Seattle's own Nightcaps

Join us at ColorArts, a magnifique venue on Lake Union in Seattle 2501 North Northlake Way

Exquisite Lakeside Location ✳ Superbe Patisseries ✳ No Host Bar

Please join us whether or not you attend the performance ✳ Attire: Opera / Cocktail

Fête Bohème

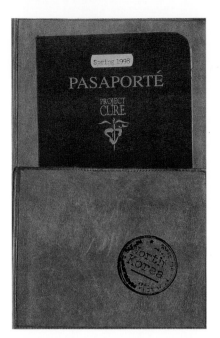

DESIGN FIRM | Wood Design & Art Studio

ART DIRECTOR/DESIGNER | Linda Wood

COPYWRITER | Doreen Lecheler, Project C.U.R.E.

CLIENT | Project C.U.R.E

TOOLS | QuarkXPress, Adobe Photoshop

PAPER | Grafika Vellum—Autumn Mist

PRINTING PROCESS | One-color offset

The Pasaporté's key visual feature is the passport-style leather pocket created to simulate a quarterly invitation for armchair travel to featured countries. Project C.U.R.E. collects and donates surplus medical supplies to Third World countries.

Pasaporté to North KOREA

Editor
Doreen M. Lecheler

Contributing Editor
Erin E. Jackson

Graphic Design
Wood Design & Art Studio
Linda Wood

President
Dr. W. Douglas Jackson

PASAPORTÉ to North Korea
Spring 1998
Volume 1, Number 1 7.7

PASAPORTÉ is a quarterly publication of Project C.U.R.E. If you know someone who would like to receive a free subscription to PASAPORTÉ, please call (303) 727-9414. Please send address corrections to the address below. Copyright © 1998. Permission to reprint in whole or in part is hereby granted, provided a copy of the reprinted article is sent to Project C.U.R.E. and a version of the following credit line is included: "Reprinted by permission from PASAPORTÉ, the quarterly journal of Project C.U.R.E."

Project C.U.R.E.
2040 South Navajo
Denver, Colorado
80223-3848

Phone
303.727.9414

Fax
303.727.8397

projectcure@juno.com

North Korea
a view from inside
by
James W. Jackson

The Palace of Gifts, housing treasures given to Kim Il Sung by other world leaders (1995)

James W. Jackson is a successful businessman, author, international economic consultant and humanitarian. Jackson has served as economic consultant to various governments and businesses. He received the Gold Medallion Book Award in recognition of his works. He is the founder, chairman of the board and past president of the Benevolent Brotherhood Foundation, Inc. For the past 10 years, Jackson has volunteered full-time to direct Project C.U.R.E. To date he has consulted with heads of governments and health officials in 58 countries, including DPRK, China, Cuba and the former Soviet countries.

Jackson was the first person to receive State Department clearance and licensing for shipping to DPRK and Cuba. His work with foreign officials has awarded him many national and international honors, including "Who's Who in Business" and "International Man of the Year" in 1991.

A HISTORY OF RISK

Since 1950 the Democratic People's Republic of Korea (North Korea) was one of the most adamant Communist players in the Cold War stalemate. The country, with its socialist leader Great Leader Kim Il Sung, was seen as the most natural and least expensive safeguard for protecting the back door of Russia and China. Following the Korean War, Joseph Stalin and Mao Tse-tung determined to subsidize the government and army of Kim Il Sung for the purpose of defense against the United States and Republic of Korea troops stationed south of the 38th Parallel. It was more efficient to pay for Kim's efforts than to deploy Soviet or Chinese armies to guard the borders.

The strategy toward D.P.R.K. has been quite simple and very consistent: one of deterrence through a strong military defense. Throughout the years, there has been a legitimate threat of rekindled aggression. Many times both sides have been totally convinced that out-and-out war would again commence as a result of some overt provocation from one camp or the other, e.g. the South's Francis Gary Powers situation, the Pueblo occurrence, the North's bombing of the South Korea Airline KAL flight #858 in 1987 or the recent submarine grounding on the South Korean coast.

This risk management strategy has worked well to bring relative stability to the Korean peninsula. Neither the North nor the South has engaged in any type of preemptive strike. However, the strategy of deterrence has come at a very high price. For South Korea, the price has been approximately $15 billion per year for military defense. The U.S. spends more than $3 billion per year to support some 37,000 troops in

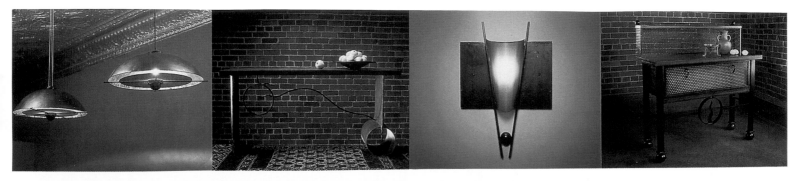

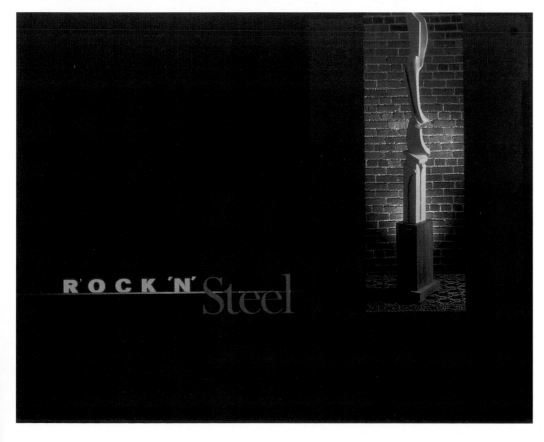

DESIGN FIRM | Greteman Group

ART DIRECTOR | Sonia Greteman

DESIGNERS | Craig Tomson, Sonia Greteman

PHOTOGRAPHER | Steve Rasmussen

COPYWRITER | Deanna Harms

CLIENT | Rock-n-Steel

TOOLS | Macromedia FreeHand, Adobe Photoshop

PAPER | Reflections

PRINTING PROCESS | Four-color process

In spite of a low budget, this four-color, accordion-fold brochure does its job. Its postcard-sized photographs showcase samples of the firm's work in sculpture, metal, stone, and wood.

Timmendorf & Göteborg

9 Tage kombinierbarer Urlaubsgenuß

Sonne, Strand, Wellen und Ostsee; Freizeit, Entspannung und gesunde Luft - das ist Timmendorfer Strand. In Kombination zum Badeurlaub haben Sie die Gelegenheit, eine Schiffsreise nach Göteborg zu unternehmen. Neben der Seereise mit einem komfortablen Schiff der „Stena Line" können Sie die zweitgrößte und gemütlichste Stadt Schwedens sowie die Meerengen und romantischen Buchten der Westküste kennenlernen.

Programm
Samstag: Anreise über Ulm, Würzburg und Fulda zur Zwischenübernachtung nach Hannover. Hotelbezug.

Sonntag: Weiterfahrt nach Timmendorfer Strand. Ankunft am frühen Nachmittag. Begrüßung im Hotel, Zimmerbezug. Erster Orientierungsbummel.

Montag-Mittwoch: Genießen Sie Ihren Urlaub am Timmendorfer Strand!

Donnerstag: Am späten Vormittag Fahrt nach Kiel. Einschiffung auf einem modernen Schiff der „Stena-Line". Kabinenbezug. Um 19.00 Uhr legt das Schiff nach Göteborg ab. Teilnahme am abwechslungsreichen Bordleben mit „Arcade-Bar", Kino, Duty-Fee-Shop, Night-Club u.v.m. Übernachtung an Bord.

Freitag: Ankunft im Hafen von Göteborg um 9.00 Uhr. Anschließend Stadtrundfahrt und Ausflug an die Westküste mit unserem eigenen Bus. Aufenthalt/Freizeit. Am frühen Abend Einschiffung. Genießen Sie nochmals die vielfältigen Unterhaltungsmöglichkeiten an Bord.

Samstag: Ankunft in Kiel in den Morgenstunden. Weiterfahrt zur Zwischenübernachtung im Raum Würzburg. Hotelbezug.

Sonntag: Heimreise über Ulm. Rückkunft am frühen Abend.

Grundleistungen
◆ Busfahrt, Zubringerdienst
◆ 8 Übernachtungen im exzellenten ★★★★Hotel „Princess" in Timmendorfer Strand (6x) im ★★★ Hotel in Hannover (1x), im ★★★Hotel i.R. Würzburg (1x)
◆ 8x Frhst.buffet, 2x Halbpension
◆ komfort. Zimmer (BD/DU/WC)
◆ Reiserücktrittskostenversicherung

Preis für Grundarrangement
pro Person im DZ 920,- DM
(EZ-Zuschlag 200,- DM)

Zusatzleistungen
◆ Seereise Kiel-Göteborg-Kiel mit der „Stena-Line"
◆ 2 Übern./Frhst.buffet an Bord, Innenkabinen (DU,WC)
◆ ganztägige Stadtrundfahrt Göteborg mit Ausflug Westküste

Aufpreis zum Grundarrangement
pro Person in der DK 70,- DM
(EK-Zuschlag 20,- DM)
(Zuschlag DK außen 80,- DM)

Ihr ★★★★Hotel „Princess" in Timmendorf
Das Hotel liegt am Stadtrand im Grünen. Bis zum Strand sind es nur 100m. Das Hotel verfügt über ein eigenes Restaurant und einen Swimmingpool mit Fitness-Bereich. Alle Zimmer sind mit Bad oder Dusche und WC, Fernseher, Radio, Telefon und Balkon ausgestattet.

8.-16. August

Kurzurlaub in Südtirol

5 tägige Reise mit Open-Air-Konzert von Stefanie Hertl & Stefan Mross

Für alle Freunde der Volksmusik sind die Konzerte von Stefanie Hertl & Stefan Mross ein besonderes Ereignis. Sie sollten es sich nicht entgehen lassen, ein paar abwechslungsreiche Tage in der atemberaubenden Landschaft des Pustertals und der Dolomiten mit einem Konzertbesuch zu verbinden.

Programm
Mittwoch: Anreise über Bregenz und über die Brennerstraße in das zauberhafte Puster-/Eisacktal. Hotelbezug.

Donnerstag: Start zur faszinierenden Dolomitenrundfahrt: Cortina d'Ampezzo, Monte Cristallo, Tre Croci Paß, Misurinasee, 3 Zinnen, Höhelsattel und zurück über Toblach zum Hotel.

Freitag: Ausflugsfahrt in das Tauferer Ahrntal mit herrlichem Panorama auf die Zillertaler Alpen zunächst nach Sand in Taufers. Anschließend Weiterfahrt nach Kasern. Kleine Wanderung in wunderschöner Alpenflora nach Heilig-Geist. Besichtigungen der bekannten Wallfahrts-

kirche. Rückfahrt zum Hotel. Am frühen Abend Fahrt an den Kalterer See. Um 19.30 Uhr Beginn des Open-Air-Konzertes mit Stefanie Hertl & Stefan Mross. Nach Ende der Veranstaltung Rückfahrt zum Hotel.

Samstag: Vormittags Freizeit. Am Nachmittag unternehmen Sie einen halbtägigen Ausflug an den idyllisch gelegenen Pragser Wildsee. Kleine Seenwanderung.

Sonntag: Heimreise über Dorf Tirol mit Aufenthalt, weiter über den Reschenpaß und Arlberg. Rückkunft am Abend.

Leistungen: ◆ Fahrt im modernen Fernreisebus ◆ Reisebegleitung, Hostess
◆ 4 Übernachtungen im heimeligen ★★★Berghotel im Puster-/Eisacktal
◆ behagliche Zimmer (BD/DU/WC) ◆ 4x Frühstücksbuffet, 1x Halbpension
◆ Besichtigungen lt. Programm mit örtlichem Gästeführer (außer Pragser Wildsee) ◆ Eintrittskarte für das Open-Air-Konzert

Arrangementpreis pro Person im DZ 510,- DM (EZ-Zuschlag 80,- DM)

26.-30. August

41

DESIGN FIRM | revoLUZion
ALL DESIGN | Bernd Luz
COPYWRITER | Armin Stork
CLIENT | Stork Bustouristik
TOOLS | QuarkXPress, Adobe Photoshop
PRINTING PROCESS | Four-color

A catalog for a bus tour was designed as a calendar, allowing clients to use it the whole year. Watercolor in different shades for each month gives it a special flair.

STORK
BUSTOURISTIK

Ihr
persönlicher
Reisekalender
1998

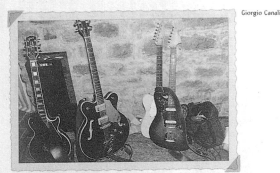

Giorgio Canali

TABULA RASA ELETTRIFICATA

Più di un anno fa, d'estate, mentre a Paris alla terrazza di un bar mi sto suicidando con il sesto Ricard, scopro in un tra-filetto interno di un quotidiano italiano di essere invece in quel momento in Mongolia. Mi guardo intorno sospettoso: Montmartre è ancora qui, quella di sempre, Place des Abèsses a sa place comme toujours, il cameriere del St. Jean con la solita faccia che fa voglia di chiedergli (s'il vous plait) di mettersi di profilo per poterla più comodamente spiacccicare con una padella da caldarroste. Mi tranquillizzo, il nome collettivo "C.S.I." non mi contiene per forza, tiro un sospiro di sollievo, mi mancava solo la Mongolia....
Il cameriere pure lui tira il suo sospiro di sollievo: mica è stagione di caldarroste e di padelle a portata di mano non ce n'è. La stagione della castagna arriva. Per comporre ci si ritrova in montagna, montagna tra virgolette ma pur sempre abbastanza montagna da farmi venire i brufoli, montagna deprimente quanto la pioggerellina merdosa che vedo dalla finestra e sullo sfondo montagne. Nessuna idea musicale già decisa in testa, come al solito, siamo qui per scrivere un album mongolo.
Ma io in Mongolia mica ci sono stato.
Non è grave, sono anni che faccio finta di saper suonare la chitarra, è tutta una vita che simulo felicità, mi sono persino spinto a spacciarmi per violinista, posso benissimo inventarmi una mia Mongolia virtuale, orribile almeno quanto la paro-la virtuale.
Le composizioni arrivano una dietro l'altra, veloci e, incredibilmente, non si litiga fra di noi. Bam! L'album è registrato, a primavera mixato e, manco in questa fase, ci sono screzi tra di noi. "Tabula Rasa Elettrificata" esce in agosto, d'estate, il ciclo è chiuso, l'album mi piace tutto, moltissimo, non sto simulando.
Al St. Jean il cameriere con la faccia a culo non c'è più. Peccato, soprattutto per l'energia che ho sprecato per far entra-re a forza la padella da caldarroste nella mia borsa da viaggio.

Giorgio Canali

14 15

Tabula Rasa Elettrificata

All'inizio dell'anno, mentre lavoravo alla copertina degli estAsia, sono andato diverse volte a trovare i C.S.I. che stavano registrando il nuovo album, e in una di quelle occasioni Massimo mi ha dato la cassetta del documentario "Viaggio In Mongolia". Nelle settimane successive ho "macinato" il film guardandolo e riguardandolo, cercando in ogni foto-gramma gli elementi che, assieme ai racconti di Giovanni e Massimo su quell'esperienza, potevano darmi gli spunti necessari per realizzare una proposta per la copertina per l'album che stava nel frattempo prendendo forma. In un primo momento avevo pensato di fotografare le scene del film così come erano, con i pixel dello schermo TV in bella evidenza e le prime bozze che ho realizzato avevano questa caratteristica. Poi finalmente ho avuto la desideratissima cassetta demo del nuovo disco "Tabula Rasa Elettrificata", fresco di registrazione. Fin dal primo ascol-to mi è sembrato non solo il più bel disco dei C.S.I. ma anche l'album più emozionante e sensuale che avessi ascoltato negli ultimi anni. Ho capito che la copertina doveva essere diversa da come l'avevo immagi-nata in un primo tempo, e così ho cercato non più solo nel film ma anche e soprattutto nelle canzoni le immagini che potevano "vestire" il disco. L'estrema naturalezza dei brani, la loro luminosità (Giovanni otti-mista?!?) mi hanno alla fine portato a realizzare questi "dipinti" basati su montaggi di diverse scene del film. Dipinti elettronici però, realizzati con un Macintosh, il programma "Painter" e una tavoletta grafica, par-tendo da collages che mescolavano vari personaggi, animali, e elementi di paesaggio naturale e urbano. Ho cercato di non caratterizzare in maniera troppo esotica le immagini: la fabbrica con l'aquila, il cavallo e la linea elettrica, la pianura con la centrale lontana, quelle tende di nomadi, potevano infatti far parte anche di un paesaggio "nostro"; solo il cavaliere in primo piano può alla fine far pensare a un mondo (e forse a un tempo) diverso.

Diego Cuoghi

Forma E Sostanza
CDs

Tabula Rasa Elettrificata
CD - MC - LP

DESIGN FIRM | Punto e Virgola S.A.S

ART DIRECTOR/DESIGNER | Anna Palandra

COPYWRITER | Andrea Tinti

CLIENT | Consorzio Produttori Indipendenti

TOOLS | QuarkXPress, Adobe Photoshop

PAPER | Serenissima

PRINTING PROCESS | Lithography

The purpose of this brochure was to present the biography of the Italian rock band C.S.I. and their new album, *Skimming*, through a sepia-colored 1950s-style photo album design.

TRAVELING TODAY IS NOTHING LIKE IT USED TO
BE. THE PROBLEMS CAN BE INCREDIBLY COM-
PLEX. AND NOT JUST INCONVENIENT. THEY CAN
BE EXPENSIVE. IT TAKES COMPREHENSIVE PLAN-
NING AND COORDINATION TO ASSURE SUCCESS.
PURCHASING AND CONTROL SYSTEMS THAT
PROVIDE THE GREATEST COST EFFICIENCIES
AND EXECUTING MEETING PLANS THAT MOTIVAT
PARTICIPANTS TO REACH TARGETED OBJECTIVE

BALBOA TRAVEL MANAGEMENT HELPS L
CORPORATIONS AND EMERGING COMPA
SUCCEED BY EFFECTIVELY USING T
AS A STRATEGIC TOOL. BALBOA MOTI
SUPPORTS MEETING PLANNERS AND MA
STRATEGISTS WITH A FULL SPECTRUM
VICES, FROM SELECTING MEETING SI
SMALL GROUPS TO PLANNING AND P
A FULL-SERVICE MOTIVATIONAL M
CAMPAIGN. BALBOA VACATIONS IS
TO FULFILLING THE VACATION TRAVE
OF INDIVIDUALS AND TO OFFERING
CLIENTS ENHANCED EMPLOYEE
VIA TAILORED VACATION TRAVEL

WITH A
WE'VE GOT A WHOLE WORLD OF
TRAVEL MANAGEMENT. SO WE
WHERE YOU WANT TO GO, WHEN
GO, FOR WHAT YOU WANT TO S
WE STILL DO ONE THING THE
WAY. WE TAKE THE TIME TO G
PERSONALIZED CARE. SO LET U
MANAGEMENT PARTNER. WE
MILE TO MAKE IT A SMOOTH

YOU

DESIGN FIRM | Vaughn Wedeen Creative
ART DIRECTOR/DESIGNER | Steve Weeden
PHOTOGRAPHER | Julie Dean
COPYWRITER | Client
CLIENT | Balboa Travel
TOOLS | QuarkXPress, Adobe Photoshop,
 Macromedia FreeHand

DESIGN FIRM | Barbara Ferguson Design
ALL DESIGN | Barbara Ferguson
COPYWRITER | Stephanie Weaver
CLIENT | Zoological Society of San Diego
TOOLS | Adobe Illustrator
PRINTING PROCESS | Two-color process

This booklet in a series of three was developed by t
Education Department to aid students and teachers
their exploration of the zoo and the animals.

Field Notebook for kids in grades pre-2

SHUTTERBUGS ON

SAFARI

Take a picture of
your Shutterbugs.

Paste photo here and
write your names on the cover.

Das Volkshochschulheim Inzigkofen ist eine unabhängige, überkonfessionelle und überparteiliche Einrichtung der freien Erwachsenenbildung und wird getragen vom Verein "Volkshochschulheim Inzigkofen e.V." Finanziell und ideell unterstützt wird es vom Land Baden-Württemberg und einem Freundeskreis, der sich aus begeisterten Kursteilnehmern und Dozenten gebildet hat.

KONTAKTE KNÜPFEN

HORIZONTE ERWEITERN

Die ruhige Umgebung und die besondere Atmosphäre des Hauses bieten beste Voraussetzungen für konzentriertes Arbeiten, für Gespräche und Entspannung. Unser Ziel ist es einerseits, Erwachsenen eine umfassende Allgemeinbildung sowie die Fähigkeit zu selbständigem, kritischen und zukunftsorientierten Denken und Handeln in unserer Gesellschaft zu vermitteln, andererseits die individuellen Begabungen des Einzelnen zu fördern und so die positive Entfaltung seiner Persönlichkeit zu unterstützen.

WISSBEGIERDE BEFRIEDIGEN

IN SICH GEHEN
- AUS SICH HERAUS GEHEN

Sie wohnen bei uns in den ehemaligen Nonnenzellen, die jetzt als 32 Einzelzimmer, sieben Doppel- und zwei Familienzimmer eingerichtet sind.

UNTERKUNFT & VERPFLEGUNG

Alle Zimmer sind konsequent einfach eingerichtet, verfügen über fließend Warmwasser und wirken ganz besonders durch ihre Butzenscheiben und individuell gestalteten Stuck- oder Holzkassettendecken. Außerdem stehen zehn komfortable Einzelduschen zur Verfügung. Unsere Küche versorgt Sie mit vier Mahlzeiten pro Tag, immer frisch und mit Liebe zubereitet. Sie haben die Wahl zwischen bürgerlicher Normal- und vegetarischer Kost. Alle Kurse können aber auch ohne Übernachtung und Verpflegung gebucht werden.

AKTIVER URLAUB

HISTORISCHES AMBIENTE

NATUR
Kennenlernen von Blütenpflanzen, Bäumen, Sträuchern, Moosen, Flechten, Pilzen, Vögeln, Insekten, Plankton, Versteinerungen und Gesteinen, sowie erkunden von Landschaften und ökologischen Zusammenhängen.

MUSIK
Musik hören, erleben und verstehen. Musizieren in kleinen Ensembels und großen Orchestern. Gesangs- und Instrumentalunterricht von Klassik bis Jazz.

KÖRPER & GEIST
Ganzheitliche Methoden im Gesundheitsbereich, wie Yoga, Autogenes Training, Tai Chi Chuan, Qigong, Feldenkrais, Meditation, Heilfasten, Spiel und Tanz.

FREMDSPRACHEN
Intensivkurse in Englisch, Französisch, Italienisch und Spanisch. Zum Teil nach der Suggestopädiemethode mit speziellen Entspannungsübungen.

KÜNSTLERISCHES GESTALTEN
Grund-, Aufbau- und Fortgeschrittenenkurse für Malen und Zeichnen in den unterschiedlichsten Techniken und Themen; Radierung, Holzschnitt, Kalligraphie, Fotografie und Modellieren mit Ton.

GESCHICHTE & KULTURGESCHICHTE
Europäische Geschichte, Kunst und Kultur von der Steinzeit bis zur Moderne; die Lebenswelt der "kleinen und großen Leute", Philosophie, Musik, Literatur, Kunst- und Bauwerke der jeweiligen Epoche.

GESELLSCHAFT
Umweltschutz, Rhetorik, Erziehung, Politik, Soziales

HANDWERK
Buchbinden, Krippenbau, Klöppeln, Spinnen u. Weben

LITERATUR & SCHREIBEN
Literatur verschiedenster Epochen und Gattungen. Gedichte, Kurzgeschichten, Erzählungen, Märchen oder Autobiographisches selber schreiben.

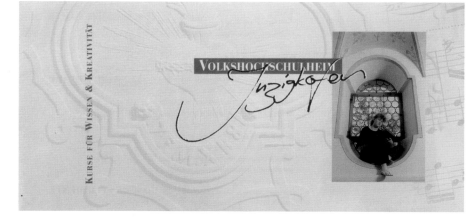

DESIGN FIRM | revoLUZion
ALL DESIGN/PHOTOGRAPHER/COPYWRITER | Bernd Luz
CLIENT | Volkshochschulheim Inzigkofen
TOOLS | QuarkXPress, Adobe Photoshop
PRINTING PROCESS | Four-color offset

In a small folder format, the brochure supports seminars for knowledge and creativity that are held in an old convent.

The Practical Application of Innovation

Integrated
Composites

DESIGN FIRM | Charney Design

ART DIRECTOR/DESIGNER | Carol Inez Charney

PHOTOGRAPHER | Thomas Burke

CLIENT | Integrated Composites

TOOLS | QuarkXPress, Adobe Illustrator and Photoshop

PAPER | Vintage Velvet

PRINTING PROCESS | Four-color process offset

Intrigued by the unusual way the carbon fibers caught the light, Charney used photography to convey sophistication and to capture the fibers' unique visual qualities. The final piece could not be converted into a folder, so firm and client settled for a flap in the back to hold cut-to-fit sales sheets.

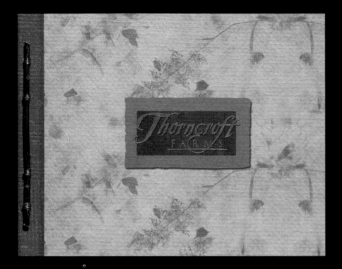

DESIGN FIRM | Price Learman Associates
ART DIRECTOR | Patricia Price Learman
DESIGNER | Mollie Kellogg Cirino
ILLUSTRATORS | Mollie Cirino, watercolor;
 Michael Dawson, Photoshop
PHOTOGRAPHER | John Gussman, still lifes
COPYWRITER | Douglas Learman
CLIENT | Trammell Crow Residential: Thorncroft Farms
TOOLS | Macromedia FreeHand, Adobe Photoshop
PAPER | Strathmore 80 lb. Americana cover; Vellum Gilclear
 flysheet; 100 lb. Book Lustro text
PRINTING PROCESS | 4/4 plus metallic foil cover; 1/0 metallic
 PMS flysheet; 4/4 plus dull varnish pages

Price Learman's directions were to create a present to unwrap or a field diary. The designer's personal goal was to create a work that evoked the emotional responses of peace and harmony. She hand bound the brochure with a willow twig and copper wire to give it special appeal.

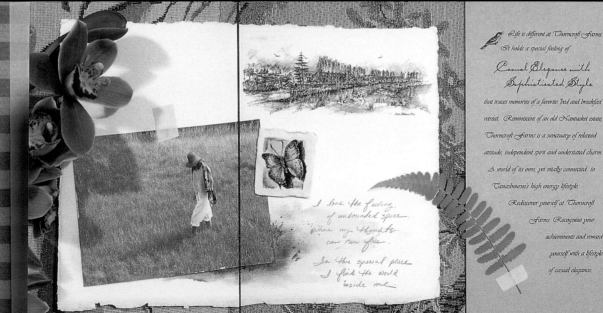

Life is different at Thorncroft Farms It holds a special feeling of

Casual Elegance with Sophisticated Style

that traces memories of a favorite bed and breakfast retreat. Reminiscent of an old Nantucket estate, Thorncroft Farms is a sanctuary of relaxed attitude, independent spirit and understated charm. A world of its own, yet vitally connected to Tanasbourne's high energy lifestyle. Rediscover yourself at Thorncroft Farms. Recognize your achievements and reward yourself with a lifestyle of casual elegance.

I love the feeling of unbounded space, where my thoughts can run free.

In this special place I find the world inside me.

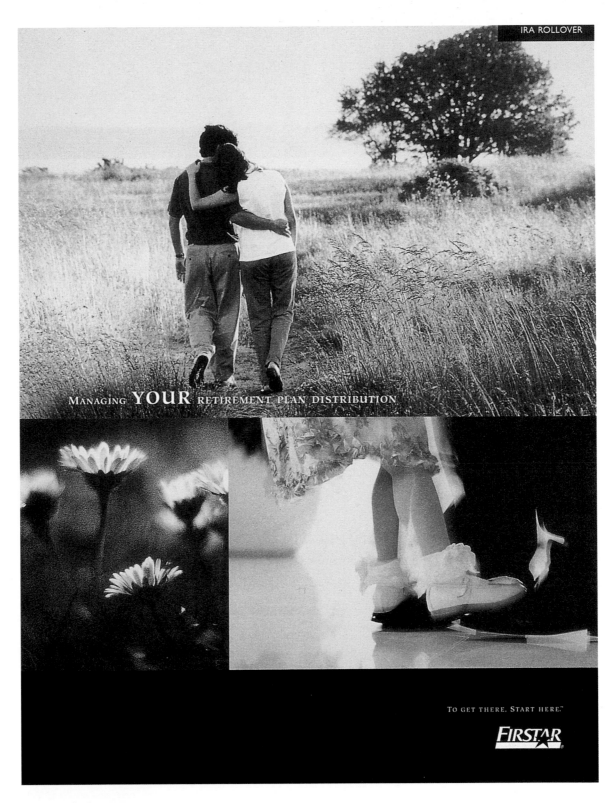

MANAGING YOUR RETIREMENT PLAN DISTRIBUTION

TO GET THERE. START HERE.™

FIRSTAR®

DESIGN FIRM | Tim Noonan Design

DESIGNER | Tim Noonan

COPYWRITER | Victoria Morrison

CLIENT | Firstar Corporation

TOOLS | QuarkXPress, Adobe Photoshop

PAPER | Beckett Uncoated

PRINTING PROCESS | Four-color process with spot color

The point of this brochure is to explain rollover options
to clients of Firstar Corporation with IRA accounts. The
design needed to tie in to the Firstar brand look.

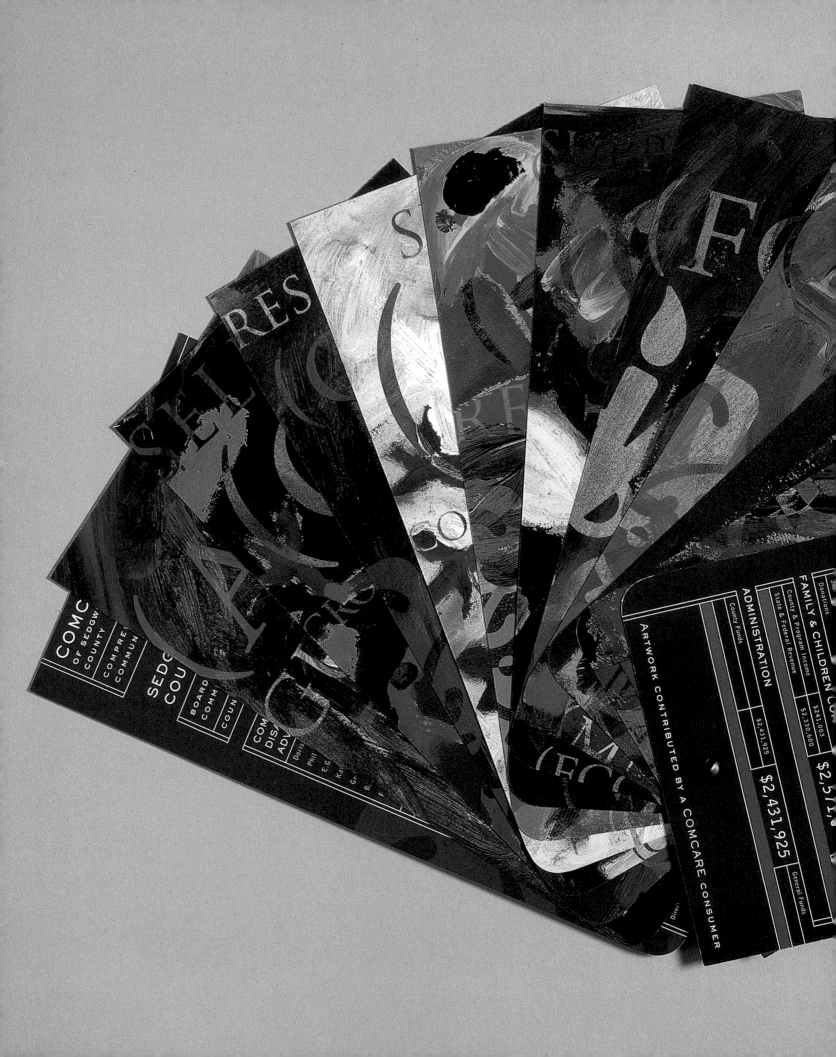

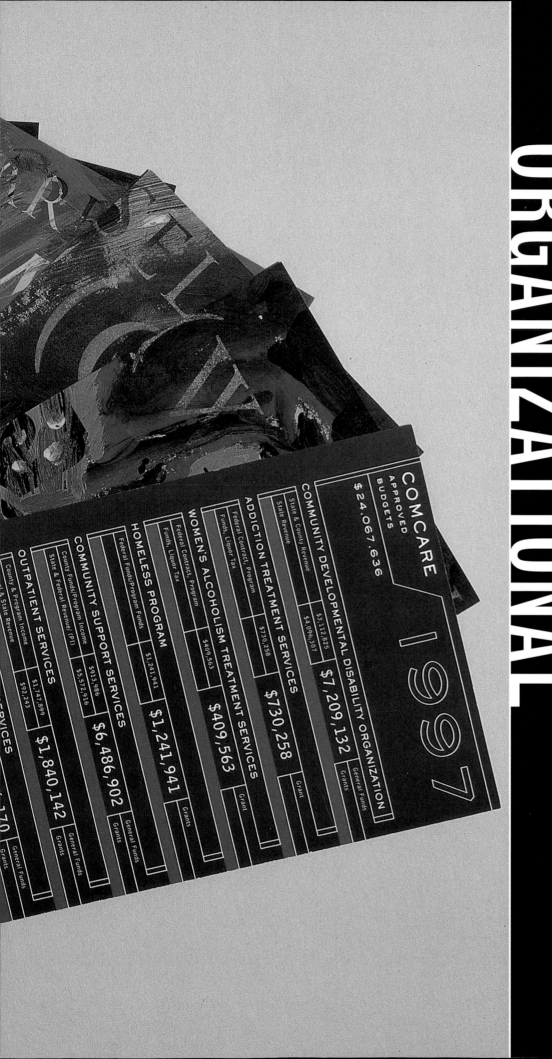

INSTITUTIONAL & ORGANIZATIONAL

BROCHURES

DESIGN FIRM | Insight Design Communications
ART DIRECTORS | Tracy and Sherrie Holdeman
DESIGNER | Chris Parks
CLIENT | Comcare
TOOLS | Macromedia FreeHand, Adobe Photoshop

Mental-health professionals use art therapy as one of their tools in treating patients. This annual report incorporates actual art therapy illustrations and the treatment goals these illustrations represent to exemplify the services of the individual departments.

DESIGN FIRM | Morgan Design Studio, Inc.

ART DIRECTOR | Michael Morgan

DESIGNER | Kevin Fitzgerald

PHOTOGRAPHER | Kara Brennan

CLIENT | Atlanta Community Food Bank

TOOLS | QuarkXPress

PAPER | Coated on two sides

PRINTING PROCESS | Four-color process

The client wanted a marketing campaign that would inspire families and people of all ages to join the Hunger Walk. The design team used four different photos to promote the event and to entice viewers to look, read, and participate.

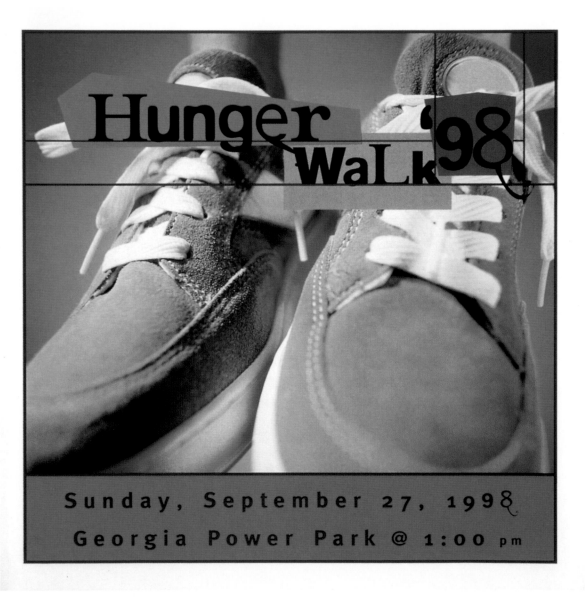

THE ENTERTAINMENT INDUSTRY

EXPANDS

1998 ELECTRONIC ARTS ANNUAL REPORT

DESIGN FIRM | The Leonhardt Group
DESIGNERS | Ray Ueno, Jon Cannell
PHOTOGRAPHERS | Jim Linna Photography,
Jonathan Daniel—1994 World Cup Crowd
CLIENT | Electronic Arts

Firmly in the driver's seat of interactive entertainment,
Electronic Arts continues to expand and redefine its own
industry. EA is now the world's top-selling publisher of
interactive entertainment software. The Leonhart Group
felt "expansion was a natural theme for EA in 1998."

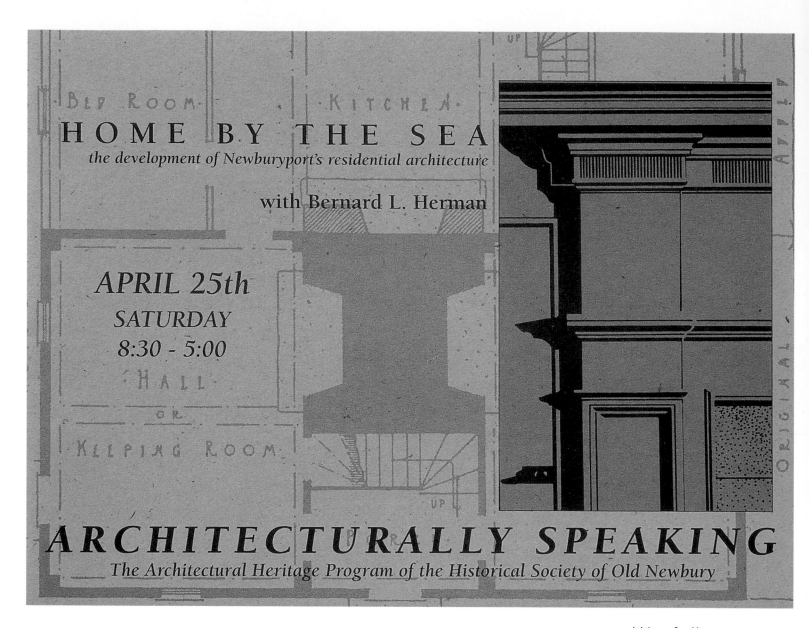

HOME BY THE SEA

the development of Newburyport's residential architecture

with Bernard L. Herman

APRIL 25th
SATURDAY
8:30 - 5:00

ARCHITECTURALLY SPEAKING

The Architectural Heritage Program of the Historical Society of Old Newbury

DESIGN FIRM | Johnson Graphics
ART DIRECTOR/DESIGNER | Irene Johnson
ILLUSTRATOR | Richard W. Johnson
COPYWRITER | Adair Rowland
CLIENT | Historical Society of Old Newbury
TOOLS | QuarkXPress, Adobe Photoshop
PAPER | Desert Storm
PRINTING PROCESS | One-color, black with screen

Johnson Graphics created a single-use, economical self-mailer advertising a seminar on historic homes. The period architectural element placed over an old floor plan on Kraft paper imparts the antique feeling the client desired.

"Now that we have this expertise, staff and training, how do we meet new clients?"

"How do we find a firm with the expertise for our project?"

DESIGN FIRM | Michael Courtney Design
ART DIRECTOR/DESIGNER | Michael Courtney
PHOTOGRAPHER | Stock
COPYWRITERS | Susan Ruby, SMDS team
CLIENT | Society for Marketing Professionals,
Seattle chapter
TOOLS | Macromedia FreeHand, Adobe Photoshop
PRINTING PROCESS | Duotone

The objective was to design a distinctive announcement to draw a design literate group (marketing directors) to a professional seminar. The solution was to create an over-sized piece with distinctive colors, stock photography, and a tickler reminder card.

Crafts National 30 Juried Exhibition Call For Entries

1 9 9 6
CENTRAL
PENNSYLVANIA
FESTIVAL
OF THE
ARTS

DESIGN FIRM | Sommese Design

ART DIRECTOR/ILLUSTRATOR | Lanny Sommese

DESIGNER | Marina Garza

COPYWRITER | Phil Walz

CLIENT | Central Pennsylvania Festival of the Arts

TOOLS | QuarkXPress

PAPER | Cross Point Genesis

PRINTING PROCESS | Offset lithography

The brochures needed to be individualized while retaining
a consistent look that was harmonious with the graphics
of the arts festival.

30th Annual Juried Sidewalk Sale and Exhibition Call For Entries

1 9 9 6
CENTRAL
PENNSYLVANIA
FESTIVAL
OF THE
ARTS

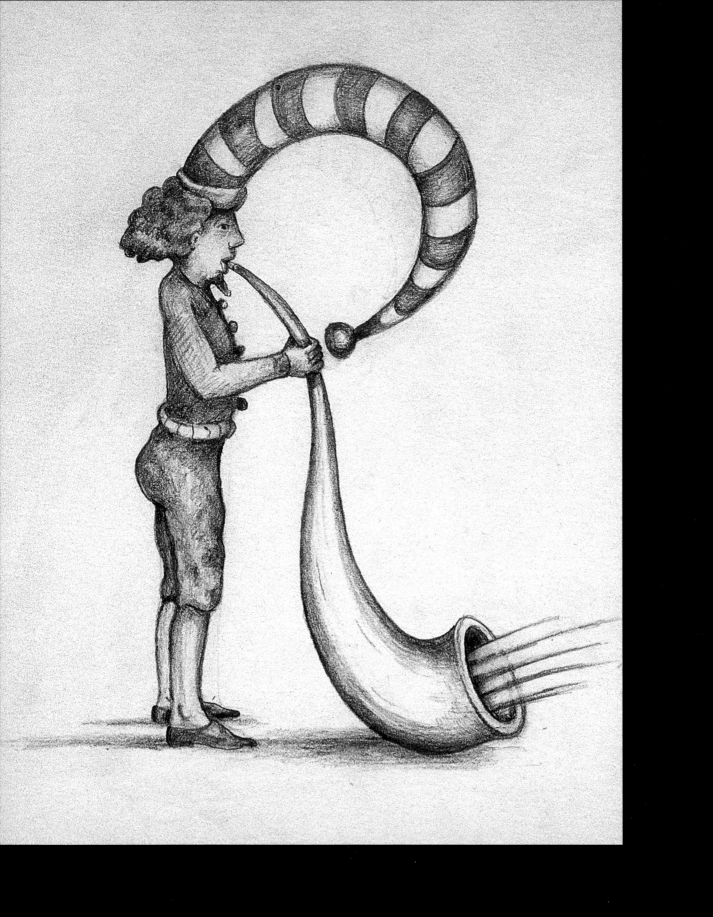

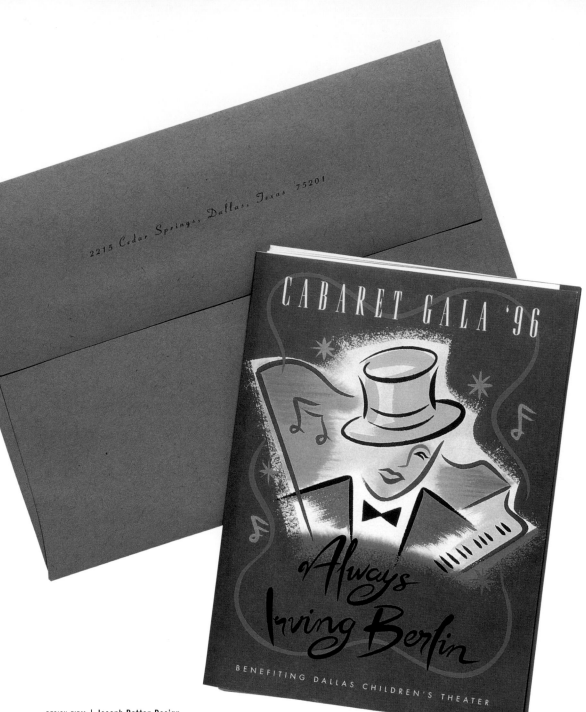

DESIGN FIRM | Joseph Rattan Design
ART DIRECTOR | Joe Rattan
DESIGNERS | Joe Rattan, Brandon Murphy
ILLUSTRATOR | Michael Crampton
CLIENT | Dallas Children's Theatre
PAPER | Starwhite
PRINTING PROCESS | Offset

This is a vehicle for the marketing communications firm
to announce its name change and to provide its clients
with a taste of its marketing and branding philosophies,
in a format that commands attention.

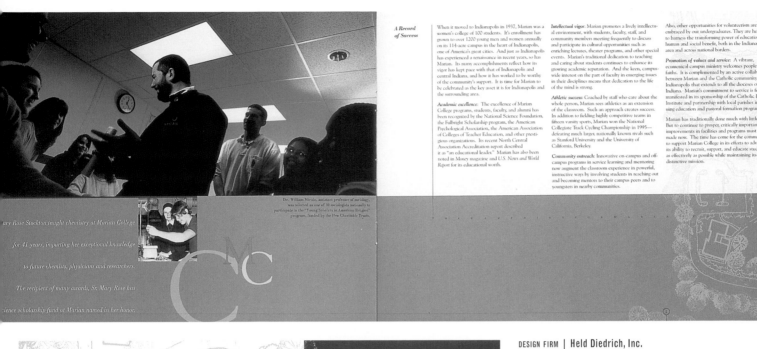

A Record of Success

When it moved to Indianapolis in 1937, Marian was a women's college of 100 students. It's enrollment has grown to over 1200 young men and women annually on its 114-acre campus in the heart of Indianapolis, one of America's great cities. And just as Indianapolis has experienced a renaissance in recent years, so has Marian. Its many accomplishments reflect how its vigor has kept pace with that of Indianapolis and central Indiana, and how it has worked to be worthy of the community's support. It is time for Marian to be celebrated as the key asset it is for Indianapolis and the surrounding area.

Academic excellence: The excellence of Marian College programs, students, faculty, and alumni has been recognized by the National Science Foundation, the Fulbright Scholarship program, the American Psychological Association, the American Association of Colleges of Teacher Education, and other prestigious organizations. Its recent North Central Association Accreditation report described it as "an educational leader." Marian has also been noted in Money magazine and U.S. News and World Report for its educational worth.

Intellectual vigor: Marian promotes a lively intellectual environment, with students, faculty, staff, and community members meeting frequently to discuss and participate in cultural opportunities such as enriching lectures, theater programs, and other special events. Marian's traditional dedication to teaching and caring about students continues to enhance its growing academic reputation. And the keen, campus-wide interest on the part of faculty in emerging issues in their disciplines means that dedication to the life of the mind is strong.

Athletic success: Coached by staff who care about the whole person, Marian sees athletics as an extension of the classroom. Such an approach creates success. In addition to fielding highly competitive teams in fifteen varsity sports, Marian won the National Collegiate Track Cycling Championship in 1995—defeating much larger, nationally known rivals such as Stanford University and the University of California, Berkeley.

Community outreach: Innovative on-campus and off-campus programs in service learning and mentoring now augment the classroom experience in powerful, instructive ways by involving students in reaching out and becoming mentors to their campus peers and to youngsters in nearby communities.

Also, other opportunities for volunteerism are eagerly embraced by out undergraduates. They are helping to harness the transforming power of education for human and social benefit, both in the Indianapolis area and across national borders.

Promotion of values and service: A vibrant, ecumenical campus ministry welcomes people of all faiths. It is complemented by an active collaboration between Marian and the Catholic community in Indianapolis that extends to all the dioceses of Indiana. Marian's commitment to service is further manifested in its sponsorship of the Catholic Principals Institute and partnership with local parishes in continuing education and pastoral formation programs.

Marian has traditionally done much with little. But to continue to prosper, critically important improvements in facilities and programs must be made now. The time has come for the community to support Marian College in its efforts to advance its ability to recruit, support, and educate students as effectively as possible while maintaining its distinctive mission.

ary Rose Stockton taught chemistry at Marian College

for 41 years, imparting her exceptional knowledge

to future chemists, physicians and researchers.

The recipient of many awards, Sr. Mary Rose has

cience scholarship fund at Marian named in her honor.

Dr. William Mirola, assistant professor of sociology, was selected as one of 30 sociologists nationally to participate in the "Young Scholars in American Religion" program, funded by the Pew Charitable Trusts.

THE CAMPAIGN FOR MARIAN COLLEGE

DESIGN FIRM | Held Diedrich, Inc.
ART DIRECTOR | Dick Held
DESIGNER | Megan Snow
PHOTOGRAPHER | Larry Ladig
COPYWRITER | Marian College
CLIENT | Marian College
TOOLS | QuarkXPress
PAPER | Potlatch Vintage Velvet 80 lb. cover
PRINTING PROCESS | Offset

Molly D. Smith/Artistic Director

DESIGN FIRM | Mires Design

ART DIRECTORS | Scott Mires, Neill Archer Roan,
Laura Connors

DESIGNER | Miquel Perez

ILLUSTRATORS | Jody Hewgill, Mark Ulriksen

COPYWRITER | Neill Archer Roan

CLIENT | Arena Stage

TOOLS | QuarkXPress, Adobe Illustrator

PAPER | 80 lb. Cougar Opaque

PRINTING PROCESS | Web printing

It is a challenge to capture a whole season's worth of plays in one piece and convince people to sign on the dotted line. The designer's solution was to highlight each show with its own spread and personal reflections of Arena's artistic director. Since this book's publication, Arena Stage's income has exceeded previous sales figures.

Cat on a Hot Tin Roof
by Tennessee Williams
Directed by Molly D. Smith
September 11 through
October 18 in the Fichandler

We launch the 1998-99 season with a great American classic. I love this play; I am excited by the blood and the thunder and the sheer life vibrating through it. At its center is an unforgettable scene between Brick and Big Daddy. It is a scene about lies and mendacity; a theme that is always timely in Washington and which seems especially resonant today. At its heart, it tells the story of life triumphing over death, disappointment, betrayal and the past. This is my first production at Arena and Arena's first production of this play.
m.d.s.

This Pulitzer Prize-winning play has been lauded as one of the greatest American dramas of all time. With it, the celebrated author of *A Streetcar Named Desire* immortalized his vividly drawn characters of Big Daddy, Big Mamma and Maggie the Cat. In the summer heat of a Mississippi cotton plantation, Big Daddy's family gathers to celebrate his 65th birthday. Passions rise with the temperature, as painful secrets are revealed, dreams are denied, and everyone tries, like "a cat on a hot tin roof," to hold on as long as they can.

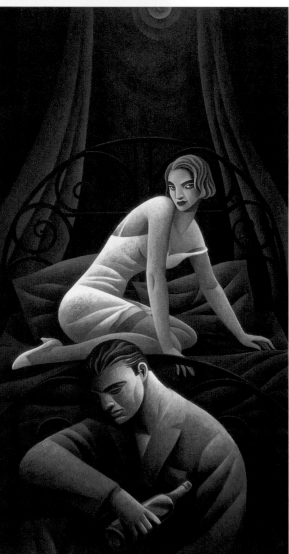

DESIGN FIRM | Lee Reedy Creative, Inc.

ART DIRECTOR | Lee Reedy

DESIGNERS | G. Patrick Gill, Heather Haworth

ILLUSTRATORS | Bob, Rob and Christian Clayton

COPYWRITER | Jamie Reedy

CLIENT | The Art Directors' Club of Denver

TOOLS | Adobe Photoshop, QuarkXPress

PRINTING PROCESS | Six-color, stochastic, embossing, metallic inks

The design team's concept was to do a contemporary slant on the swing era. The firm has great creative talent to achieve the illustrations, and the copywriting captures the swing concept perfectly.

We have a responsibility to build the strongest nonprofit and philanthropic sector possible, through leadership with vision, management with accountability, and strategic planning with research.
Sara E. Meléndez, President, INDEPENDENT SECTOR

IS Board Chairperson Barbara Finberg and President Sara Meléndez discuss the changing role of the independent sector with Arianna Huffington at the Annual Meeting.

.Mission.

INDEPENDENT SECTOR is a national leadership forum, working to encourage philanthropy, volunteering, not-for-profit initiative, and citizen action that help us better serve people and communities.

INDEPENDENT SECTOR 1996 Annual Report

INDEPENDENT SECTOR

1996 Annual Report

DESIGN FIRM | Fernández Design
ART DIRECTOR/DESIGNER | Tracy Fernández
PHOTOGRAPHER | Stock
COPYWRITER | Elizabeth Rose
CLIENT | Independent Sector
TOOLS | QuarkXPress
PAPER | Mead Moistrite Matte, Gilbert Voice
PRINTING PROCESS | Three-color offset

This annual report was designed and produced in ten business days on a minimal budget.

WHATMAKES
MEAD HAPPY?

THE MEAD 60 CALL FOR ENTRIES DEADLINE DECEMBER 31,1997

DESIGN FIRM | Pinkhaus Design
ART DIRECTOR | Joel Fuller
DESIGNER | Todd Houser
PHOTOGRAPHER | Gallen Mei
COPYWRITER | Frank Cunningham
CLIENT | Mead 60: Call for Entries
TOOLS | Adobe Illustrator and Photoshop
PAPER | Signature Dull Mead 100 lb. cover
PRINTING PROCESS | Four color Process

This brochure was meant to stand out from the myriad entry forms that arrive on most designers' desks each week and to impress upon designers the prestige of winning Mead's award medal.

CLUELESSNESS TOTAL CLUELESSNESS

DESIGN FIRM | Muller and Co

ALL DESIGN | Jeff Miller

ILLUSTRATORS | Jack Harris, Emory Au

PHOTOGRAPHER/COPYWRITER | Alvin Ailey

CLIENT | Alvin Ailey

TOOLS | Adobe Photoshop, QuarkXPress

PAPER | Strobe

PRINTING PROCESS | Two-color offset

The biggest thrill for Muller and Co. was receiving
their own brochures in the mail with all of the scratches,
smears, and grime that come from mailing anything.
This assignment made the design team feel as though
they were participating in the world of dance rather than
designing in a vacuum.

DESIGN FIRM | Sagmeister Inc.
ART DIRECTOR | Stefan Sagmeister
DESIGNERS | Stefan Sagmeister, Veronica Oh, Hjalti Karlsson
PHOTOGRAPHERS | Adam Fuss, Wolfgang Tillmans, et al.
COPYWRITER/CLIENT | France Morin
TOOLS | QuarkXPress, Adobe Illustrator and Photoshop
PAPER | 100 lb. matte coated
PRINTING PROCESS | Offset

This brochure for an art project featured contemporary artists working at a Shaker Community.

the quiet in the land

EVERYDAY LIFE, CONTEMPORARY ART and THE SHAKERS

Institute of Contemporary Art
@ Maine College of Art
ICA

August 9 - September 21, 1997

Opening Reception, Saturday,
August 9, 10am - 12pm

the shaker community at
sabbathday lake:

Sisters Frances A. Carr,
Marie Burgess, June Carpenter,
Minnie Greene and Brothers
Arnold Hadd, Wayne Smith, and
Alistair Bate

and artists:

Janine Antoni, Domenico de Clario,
Adam Fuss, Mona Hatoum,
Sam Samore, Jana Sterbak,
Kazumi Tanaka, Wolfgang
Tillmans, Nari Ward, and
Chen Zhen.

conceived and organized by
France Morin

exhibition at the ICA organized
with Jennifer R. Gross and the
Maine College of Art

DESIGN FIRM | Clarke Communication Design

ART DIRECTOR/DESIGNER | John V. Clarke

PHOTOGRAPHERS | John V. Clarke, students

COPYWRITER | William Harris

CLIENT | University of Illinois at Urbana—Champaign
for the School of Art and Design

TOOLS | QuarkXPress, Adobe Photoshop

PRINTING PROCESS | Offset lithography

Entitled Positions Available, this was the first catalog
done for an exhibition of graduate students' artwork.
The budget was limited, so all photography was provided
by the artists themselves. John Clarke shot additional
black-and-white photos at a local exhibition of the
students' work, to add visual impact to the catalog.

DESIGN FIRM | Illinois Wesleyan University
ART DIRECTOR/DESIGNER | Sherilyn McElroy
PHOTOGRAPHER | Kevin Strandberg
CLIENT | Merwin School of Art, Wakeley Galleries
TOOLS | QuarkXPress
PRINTING PROCESS | Offset

The design goal was to create a brochure that
could be used both as a gallery announcement and
as a recruiting enticement for prospective students
(the top vellum page can be removed for recruiting).
McElroy's intent in the design was to unify disparate
artistic techniques: differing styles, media, and sizes.

DESIGN FIRM | Bentley College, Communication
and Publications
ART DIRECTOR | Amy Coates
COPYWRITER | Jennifer Spira
CLIENT | Bentley College, Student Activities
TOOLS | QuarkXPress, Adobe Photoshop
PAPER | Zanders Mega Gloss 80 lb. text
PRINTING PROCESS | Digital

To meet the client's deadline without sacrificing quality,
the designer used digital printing, an inexpensive print
method that delivers a four-color finished product in as
little as four days.

les week-ends culturels

février mars 1998

cinéma danse musique documentaires émotions

Télé-Québec

DESIGN FIRM | Sonia Poirier

ART DIRECTOR/DESIGNER | Sonia Poirier

PHOTOGRAPHER | Georges Dufaux

COPYWRITER | Suzie Koberge

CLIENT | Tele-Quebec

TOOLS | QuarkXPress, Adobe Photoshop

PAPER | Rolland Supreme Dull

PRINTING PROCESS | Two-color offset

This brochure promotes the two-month series of artistic
programs translated as cultural weekends.

It started with

in 1986 when The Joffrey Ballet premiered *The Heart of the Matter*. With that work Hancher launched its commissioning program which now, as we prepare to celebrate the Silver Anniversary, has resulted in 43 works of dance, music and music/theater.

The creator of *The Heart of the Matter* was James Kudelka who was just making the transition from his own career as a dancer to that of a choreographer. *The Heart of the Matter* was a haunting work of powerful emotional content about people who come together but are never able to connect.

How fitting that James Kudelka should figure so prominently in Hancher's twenty-fifth season.

American Ballet Theatre dances *Cruel World* on September 26.

Eight years later James Kudelka created *Cruel World* for American Ballet Theatre. There is no doubt that he has matured as a choreographer, but as he describes himself, he remains "the conscientious observer," still creating dances that are meditations on the classic themes of love, sex and death.

Eighteen dancers move in various formations—solos, trios, large ensembles and pas de deux. The emotional coloring is just as varied as the dance formations. To a passionate score by Tchaikovsky (*Souvenir of Florence*), the dancers express joy and misery, desire and repulsion. There is sexual tension and partnerships are always uneasy. Emotions are telegraphed through movement that is almost dizzying in the variety of speeds, steps and images.

Writing about *Cruel World*, The Toronto Globe and Mail critic concluded, "Kudelka's exploration of human relationships, in this and other ballets, is strikingly original. Traditionally, ballet is about balance. But in the hands of Canada's undisputed genius of the genre, ballet is given a whole new meaning. And that bodes well for the future of the art."

ART DIRECTOR/DESIGNER | Ron McClellen

COPYWRITER | Judith Hurtig

CLIENT | Hancher Auditorium

TOOLS | Adobe PageMaker and Photoshop, Macintosh

PAPER | Stock Simpson Sundance Felt

PRINTING PROCESS | Offset

This small-budget brochure was sent to dance patrons and ticket buyers to inform them on the connections between the choreographer, the director, the company, and past presentations of dance at Hanch

DESIGN FIRM | River City Studio

ALL DESIGN | Jennifer Elliott

COPYWRITER | Dennis Pruitt

CLIENT | Rick's Place

TOOLS | QuarkXPress, Adobe Illustrator and Photoshop

PAPER | Starbrite, Opaque 80 lb. cover

PRINTING PROCESS | Five PMS lithography

Rick's Place invitation booklet presented a two-fold problem: how to educate recipients about the foundation and convince them to attend a fundraiser. The designer's single solution was to make this invitation as exciting as the feel-good party of the summer!

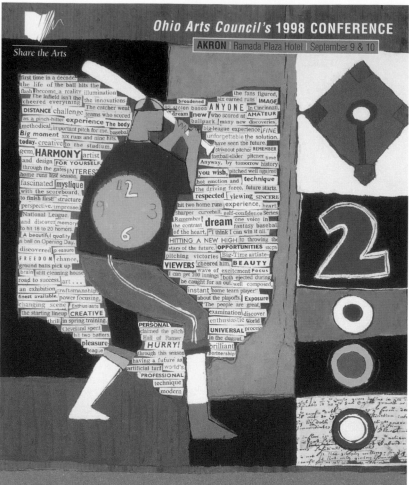

DESIGN FIRM | Base Art Company

ART DIRECTOR/DESIGNER | Terry Alan Rohrbach

ILLUSTRATOR | Kirk Richard Smith

COPYWRITER | Charles Fenton, Editor

CLIENT | Ohio Arts Council

TOOLS | QuarkXPress, Adobe Photoshop,
Macromedia FreeHand

PAPER | Mohawk Navajo

PRINTING PROCESS | Four-color process plus two PMS

Themed Batting 2000: Facing the Fastball of Change, the brochure/return registration form draws inspiration from the obvious. Textural qualities of the cover illustration were retained throughout the piece in headers and backgrounds. Event speakers were displayed in line-ups according to their day of appearance.

DESIGN FIRM | St. Joseph's Hospital
ALL DESIGN | Ken Morris, Jr.
PHOTOGRAPHER | Rich Green
COPYWRITER | Sister Jane Frances
CLIENT | St. Joseph's Hospital and Medical Center
TOOLS | QuarkXPress, Adobe Illustrator and Photoshop
PAPER | Warren Lustro Dull
PRINTING PROCESS | Six-color process, spot and varnish

The cover design was inspired by the proportional scale artists use to resize artwork. The designer used this element to encourage viewers to interact with the design. Due to budget restraints, he was limited to four colors on the cover, but by enlarging the black-and-white photos to full pages and surrounding them with decorative color borders, he was able to add color to the inside pages.

Bettendorf
Public Library

Information Center

DESIGN FIRM | Gackle Anderson Henningsen, Inc.

DESIGNER/ILLUSTRATOR | Wendy Anderson

PHOTOGRAPHER | Mike Newell

COPYWRITER | Greg Gackle

CLIENT | Bettendorf Public Library

TOOLS | QuarkXPress, Adobe Photoshop, Power Center Pro

PAPER | Consolidated Productolith

PRINTING PROCESS | Four-color process

This brochure was designed to be bold and eye-catching, like the newly renovated library it describes. Sculpted faces accent the services provided, from the forefront of technology to the intimate café.

DESIGN FIRM | Hoffman & Angelic Design

ART DIRECTOR/DESIGNER | Andrea Hoffman

ILLUSTRATOR | Ivan Angelic

HAND LETTERERS | Ivan Angelic, Michael and Suzanne Cohen

CLIENT | Seattle Study Club

TOOLS | Adobe Illustrator

PAPER | Neenah Environment, UV Ultra II, Simpson Quest

PRINTING PROCESS | Offset and foil

The design team created an elegant manner with an approachable feel in this brochure by using bold zen-like brush illustrations, hand-lettered quotations, and the juxtaposition of textures against matte uncoated stock. Speckled UV fly sheets revealed bold illustrations beneath. The natural, serene color scheme of sand, sage, and terra-cotta, and the square and circle elements, balanced harmoniously and elegantly.

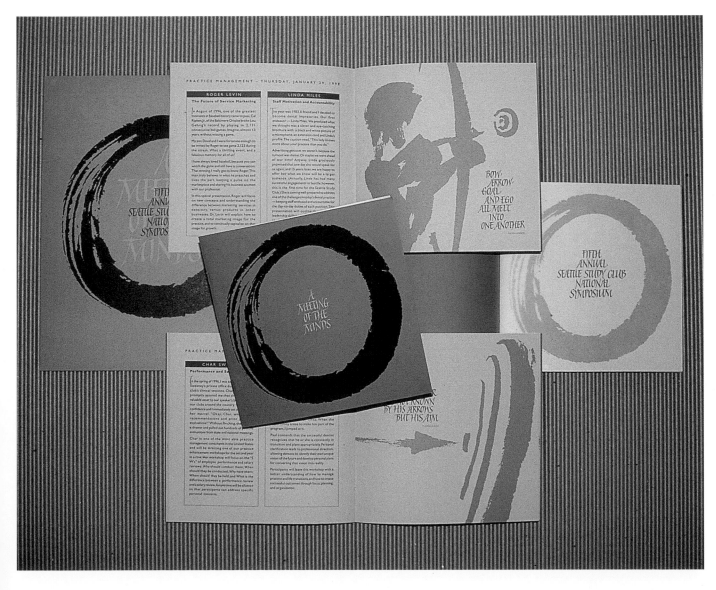

The Three Arts Club of Chicago presents our eighth annual Landmark Jazz Series:

eclectica

It is with great pride that we open this season with pianist Jodie Christian. A life-long South-sider, Christian has kept the best of company, recording with jazz greats Stan Getz, Lester Young, Coleman Hawkins, and Chet Baker, to name just a few. Downbeat Magazine says, "Christian offers the straight ahead, purely musical side of bop… lyricism with a crystal touch is the heart and soul of his art."

joDie cHrisTian
September 23, 1998

Karl Montzka brings his Hammond organ and his innovative quartet for an evening of smooth and swinging jazz. Montzka is emerging on the local scene as **a gifted band leader, organist, arranger and composer, exploring everything from street beat grooves to bright swing.** Joining Montzka in the quartet are his brother Eric on drums, guitarist John McLean and Ryan Schultz on bass trumpet.

karL montzKa quarTet
November 18, 1998

Patricia Barber is noted for her gorgeous voice, depth of vision and fresh, incisive interpretations. A leader on the local scene for the past decade, Ms. Barber was named the #1 "Female Jazz Vocal Talent Deserving Wider Recognition" by Downbeat's International Critics poll. Thomas Conrad of Stereophile magazine wrote of her work, "If you've lived it yourself, you can sing to people …and they will not only love it, they will need it."

paTriciA barBer
January 27, 1999

This acoustic jazz quartet delivers what Lloyd Sachs of the Chicago SunTimes calls "…hard-bopping delights and flowing meditations by a band that deserves to go places." Leaders Brian Gephart (saxophone) and Bob Long (piano) are joined by Ken Haebich on bass and Mark Otto on drums. All of these artists have outstanding reputations for their work, both locally and nationally, and together they deliver an evening of extraordinary jazz.

briAn gePhart bOb long quarTet
March 24, 1999

Recipient of the 1998 Back Stage Bistro award for outstanding achievement, Audrey Morris graces Landmark Jazz with her outstanding vocal and piano talents. The former resident pianist/vocalist for Mr. Kelly's and a member of the in-house trio at the legendary London House, Ms. Morris has played with such luminaries as Oscar Peterson, Carmen McRae and Bobby Short. Howard Reich, writing for the Chicago Tribune said, "A local treasure by any standard, Morris reaffirms her place at the pinnacle of seasoned singer-pianists with utterly unaffected, haunting readings of standards."

audRey morRis
May 26, 1999

land mark jazz

DESIGN FIRM | WATCH! Graphic Design
DESIGNER | Carolyn Chester
CLIENT | The Three Arts Club of Chicago
TOOLS | Adobe Illustrator, QuarkXPress
PAPER | Cougar
PRINTING PROCESS | Two PMS plus black

Landmark Jazz is a bimonthly series featuring live performances by Chicago's most distinguished jazz artists. The design is inspired by early jazz albums.

DESIGN FIRM | 1049 Design

ART DIRECTOR | Rachel Lom, Wisconsin Foundation for School Music (WFSM)

DESIGNERS/ILLUSTRATORS | Mary Kay Warner, 1049 Design

PHOTOGRAPHERS | Rick Trummer, Don Christensen

COPYWRITERS | Rachel Lom, Linda Peterson, WFSM

CLIENT | Wisconsin Foundation for School Music

TOOLS | QuarkXPress, Adobe Illustrator

PAPER | 80 lb. Productolith Gloss cover; 100 lb. Productolith Gloss text

To achieve a creative, rich design on a two-color budget, textures, duotones, and many different screens were used. Photos and quotes from kids provided a personal connection to their music.

DESIGN FIRM | Sayles Graphic Design

ALL DESIGN | John Sayles

COPYWRITER | Kristin Lennert

CLIENT | National Society of Fund Raising Executives

PAPER | Astro Brite Goldenrod

PRINTING PROCESS | Offset

Professional fundraisers group wanted an attention-getting campaign package for its 1998 regional gathering. When the initial design (themed: Raising Dough: Recipes for Success) was presented at the 1997 annual meeting, each attendee received a bakery bread bag printed with the theme and filled with a fresh loaf of bread. The later mailing included a wooden spoon tied inside the box and an informational brochure.

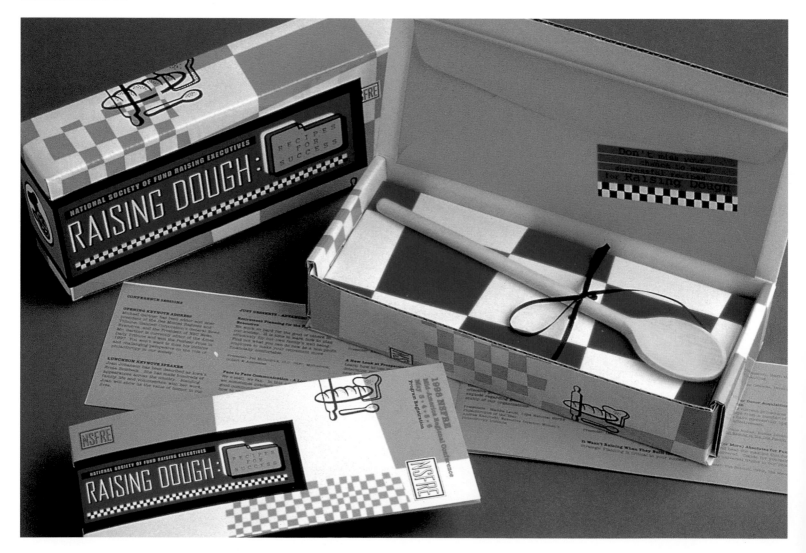

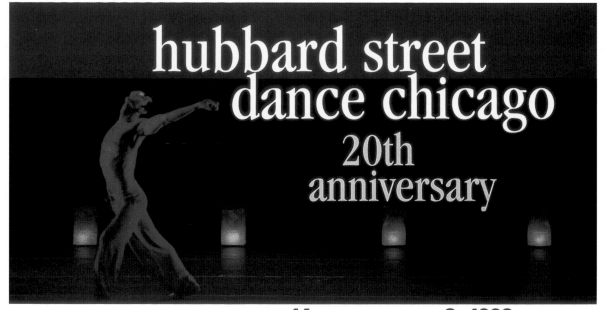

hubbard street
dance chicago
20th
anniversary

APRIL **14** THROUGH MAY **3**, 1998
auditorium theatre

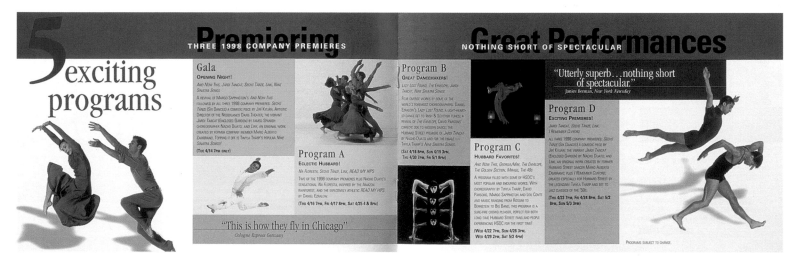

DESIGN FIRM | Fernández Design

ART DIRECTOR/DESIGNER | Tracy Fernández

PHOTOGRAPHERS | Lois Greenfield, Gert Krautbauer

COPYWRITER | Michael Pauren

CLIENT | Hubbard Street Dance Chicago

TOOLS | QuarkXPress

PAPER | Utopia I

PRINTING PROCESS | Four-color offset

This brochure was designed and produced within
one week. The design goal was to create an interesting
direct-mail piece that is easy to follow

DESIGN FIRM | Solar Design
ART DIRECTOR | Jennifer Schmidt
DESIGNERS | Jennifer Schmidt, Susan Russellu
COPYWRITER | Bill Watson
CLIENT | Maryville City of Youth
TOOLS | QuarkXPress, Adobe Photoshop
PAPER | Neenah Classic Crest 80 lb. cover
PRINTING PROCESS | Four-color offset

This brochure promotes the Chicagoland Sports
Hall of Fame facility.

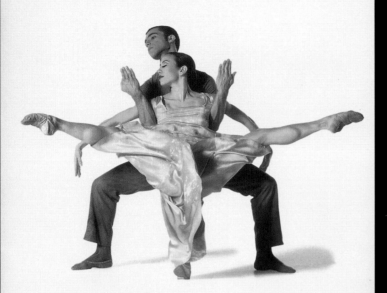

Twentieth Anniversary Album

HUBBARD STREET DANCE CHICAGO

DESIGN FIRM | Fernández Design
ART DIRECTOR/DESIGNER | Tracy Fernández
PHOTOGRAPHERS | Lois Greenfield, Reudi Hoffman
COPYWRITER | Michael Pauken
CLIENT | Hubbard Street Dance Chicago
TOOLS | QuarkXPress
PAPER | Mead Signature Gloss 100 lb. text and cover
PRINTING PROCESS | Four-color plus one PMS plus
 aqueous coat

The objective was to have an attractive piece that would celebrate the 20th anniversary season of the company and that could also be sold as a souvenir at performances. Photos were taken with a telephoto lens at performances. The production time was two weeks, and the budget was minimal.

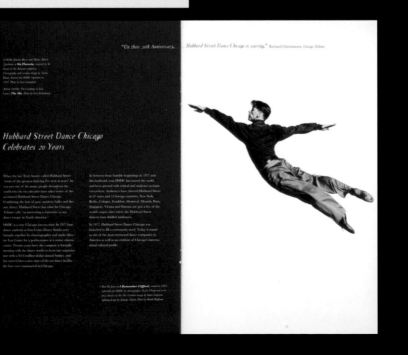

DESIGN FIRM | GAF Advertising/Design

ALL DESIGN | Gregg A. Floyd

PHOTOGRAPHER | David Obar

COPYWRITERS | Gregg A. Floyd, Linda Bryza

CLIENT | Ft. Worth Housing Authority: Amaka
Childcare Center

TOOLS | QuarkXPress, Adobe Illustrator and Photoshop

PAPER | Confetti, cover; Productolith, text

PRINTING PROCESS | 1/1 spot, cover; 4/4 process, text

A revitalization program was created to build a day-care center in a low-income development. The logo concept and brochure had to reflect the name of the center and the theme of investing in the future.

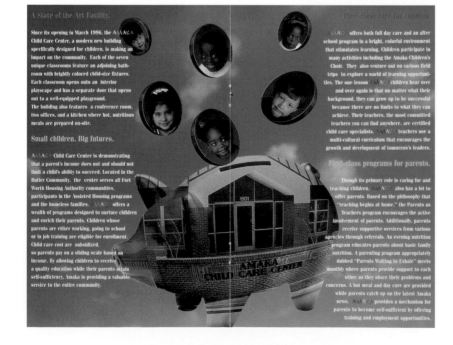

A State of the Art Facility.

Since its opening in March 1996, the AMAKA Child Care Center, a modern new building specifically designed for children, is making an impact on the community. Each of the seven unique classrooms feature an adjoining bathroom with brightly colored child-size fixtures. Each classroom opens onto an interior playscape and has a separate door that opens out to a well-equipped playground. The building also features a conference room, two offices, and a kitchen where hot, nutritious meals are prepared on-site.

Small children. Big futures.

AMAKA Child Care Center is demonstrating that a parent's income does not and should not limit a child's ability to succeed. Located in the Butler Community, the center serves all Fort Worth Housing Authority communities, participants in the Assisted Housing programs and the homeless families. AMAKA offers a wealth of programs designed to nurture children and enrich their parents. Children whose parents are either working, going to school or in job training are eligible for enrollment. Child care cost are subsidized, so parents pay on a sliding scale based on income. By allowing children to receive a quality education while their parents attain self-sufficiency, Amaka is providing a valuable service to the entire community.

First-class care for children.

AMAKA offers both full day care and an after school program in a bright, colorful environment that stimulates learning. Children participate in many activities including the Amaka Children's Choir. They also venture out on various field trips to explore a world of learning opportunities. The one lesson AMAKA children hear over and over again is that no matter what their background, they can grow up to be successful because there are no limits to what they can achieve. Their teachers, the most committed teachers you can find anywhere, are certified child care specialists. AMAKA teachers use a multi-cultural curriculum that encourages the growth and development of tomorrow's leaders.

First-class programs for parents.

Though its primary role is caring for and teaching children, AMAKA also has a lot to offer parents. Based on the philosophy that "teaching begins at home," the Parents as Teachers program encourages the active involvement of parents. Additionally, parents receive supportive services from various agencies through referrals. An evening nutrition program educates parents about basic family nutrition. A parenting program appropriately dubbed "Parents Waiting to Exhale" meets monthly where parents provide support to each other as they share their problems and concerns. A hot meal and day care are provided while parents catch up on the latest Amaka news. AMAKA provides a mechanism for parents to become self-sufficient by offering training and employment opportunities.

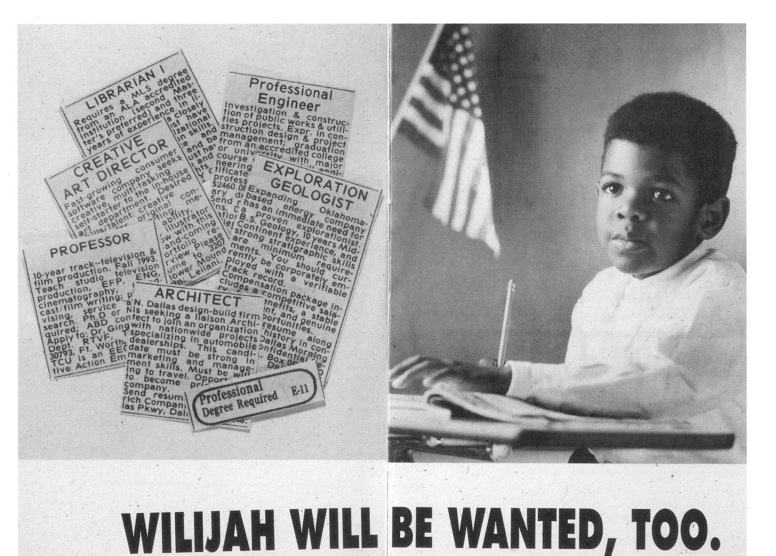

WILIJAH WILL BE WANTED, TOO.

MOST OF THE KIDS THAT GREW UP IN WILIJAH'S NEIGHBORHOOD ARE NOW WANTED

DESIGN FIRM | GAF Advertising/Design

ART DIRECTOR/DESIGNER | Gregg A. Floyd

PHOTOGRAPHER | Ken Brock

COPYWRITER | Gregg A. Floyd

CLIENT | St. Philip's School and Community Center

TOOLS | QuarkXPress, Adobe Illustrator and Photoshop

PAPER | Genesis

PRINTING PROCESS | 2/2 spot color

This brochure was created to generate underwriting for low-income students' tuition. The design succeeded by increasing awareness and participation in the program.

DESIGN FIRM | GAF Advertising/Design

ART DIRECTOR/DESIGNER | Gregg A. Floyd

ILLUSTRATORS | *The Wall Street Journal* Art Department,
　　　　　　　Gregg A. Floyd

PHOTOGRAPHERS | Jess Hornbuckle, David Obar,
　　　　　　　Linda Bryza, Alice Sykes, Kelly Buizch

COPYWRITER | Gregg A. Floyd

CLIENT | Dallas Housing Authority

TOOLS | QXD, Adobe Illustrator and Photoshop

PAPER | Environmental

PRINTING PROCESS | 1/1 spot color

This biennial report's theme reflects the mission of using
education and DHA programs as the equation to move
low-income people towards self-sufficiency. The design
incorporates a community newspaper style to describe
program and individual successes.

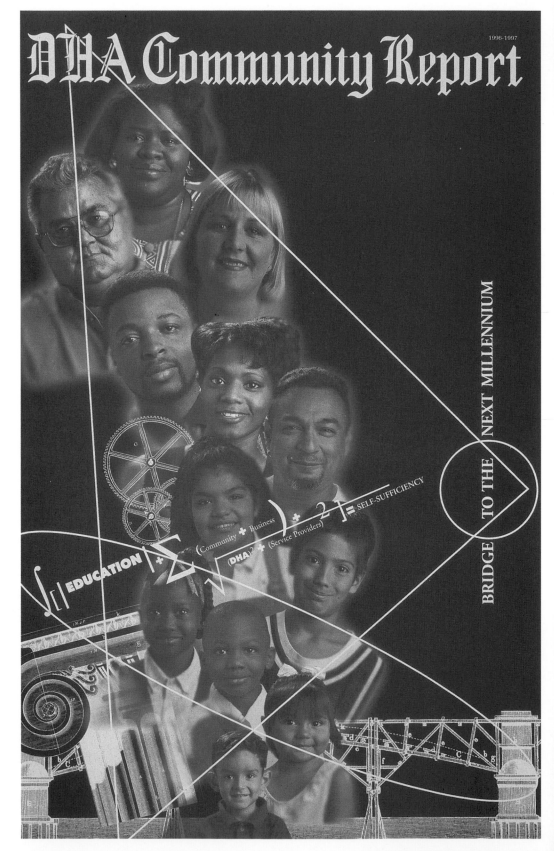

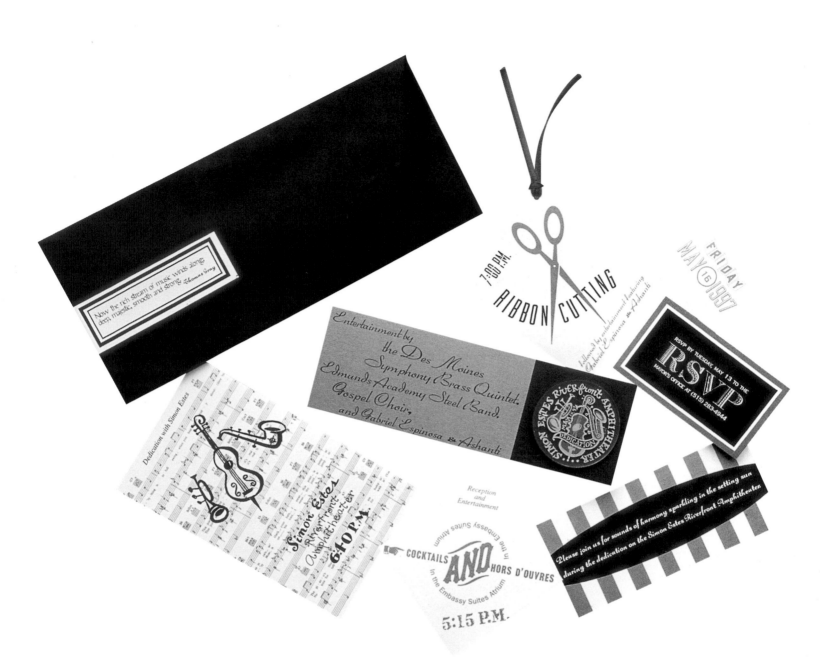

DESIGN FIRM | Sayles Graphic Design

ALL DESIGN | John Sayles

COPYWRITER | Jack Carey

CLIENT | Des Moines Parks and Recreation Department

PAPER | Crown Vintage Antique White

PRINTING PROCESS | Offset

A series of activities meant a versatile invitation was
needed, since not all guests would attend each event.
Sayles' solution was an elegant collection of cards, each
printed with the time and location for individual events.
Copper and black ink are used on cream paper; the
hand-tied ribbon references the ribbon cutting and adds
an unexpected touch. The trimmed cards fit into a black
#10 envelope that can be mailed with one postage
stamp. To commemorate the event, each invitation included
an oversized Lucite lapel pin printed in metallic copper
and silver inks.

public

COMMUNITY

A sense of community.
Of what has come before.
Of what is. Of what can be.

This is public art.

DESIGN FIRM | Greteman Group
ART DIRECTOR | Sonia Greteman
DESIGNER | Craig Tomson
COPYWRITER | Deanna Harms
CLIENT | Public Art Advisory Board
PAPER | Warren Lustro Dull Cream
PRINTING PROCESS | Four-color process

This brochure serves to educate a broad audience:
government leaders, potential donors, artists, architects,
and the general public. It educates aptly through strong
photography, art elements, and engaging copy.

ART DIRECTOR | Renate Gokl

DESIGNERS | Renate Gokl, Robert Fisher

PHOTOGRAPHERS | Renate Gokl, Robert Fisher

CLIENT | University of Illinois at Urbana—Champaign
 School of Art

TOOLS | QuarkXPress

PRINTING PROCESS | Offset

On a very limited budget, the designers' aim was to
provide information about the school's graduate programs.
The framing around the images reflects the acts of
selective viewing and seeing that artists and designers
do habitually.

Program philosophy

The Master of Fine Arts in Graphic Design is
a two to three-year program which provides students
with an opportunity to pursue in-depth investigation in
specific areas of visual communication. The program's
primary goal is to strengthen practical, conceptual, and
theoretical knowledge as it applies to the design process
and its product—communication of a message. The
focus is not only on the development of design solutions,
but on how and why design problems are addressed.
In light of emerging technologies and the shift to digital
communication, students are encouraged to critically
examine current practices while exploring the relevance
of traditional design approaches. By encouraging
students to intelligently look forward while expanding
their knowledge of current communication, the program
provides a forum in which to interpret the role designers
play in the unfolding and shaping of information.

The program is intended neither as a replace-
ment for an undergraduate design education, nor as
merely an extension of the undergraduate experience.
Rather it is a highly individualized course of study which
allows students to further their own personal design
career goals. Therefore, professional design experience,
maturity, and inquisitiveness often serve as catalysts to
motivate the most successful candidates.

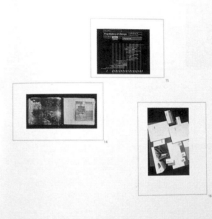

Facilities

Program requirements

The Graphic Design Program provides
a spacious studio with individual work
spaces, common areas for project
assembly, and fully equipped presenta-
tion, critique, and seminar rooms in the
School of Art and Design's main build-
ing. Adjacent to the main building is
the Link Gallery, a large exhibition area
and public lounge with entry into the
University's Krannert Art Museum and
Kinkead Pavilion.

Graduate students have 24-
hour access to the School's Center for
Graphic Technologies (CGT), a state
of the art computer facility, operated
by a professional technology staff
and supervised by a team of graduate
assistants. The Center consists of five
separate laboratories housing a total
of 70 Power Macintosh computers and
a DOS lab with the latest versions of
publication, imaging, and multimedia
software, black and white and color
laser printers, flatbed and slide scan-
ners, zip drives, and sophisticated video
editing equipment. CGT also provides
black and white as well as color dark-
rooms with a wide range of accompa-
nying equipment that support the rich
course offerings through the School's
degree programs in Photography.

Although digital technology
is the workhorse of contemporary
design and production, a more tradi-
tional letterpress laboratory also
awaits interested graduate students.

The Master of Fine Arts in Graphic
Design requires the completion of 16
units of graduate credit over a minimum
two year period. Course work is distrib-
uted in the following areas:
GRAPHIC DESIGN COURSES 7 units
DESIGN HISTORY 1 unit
ELECTIVES 7 units
SEMINAR 1 unit

Specific course selection is determined
in consultation with the faculty adviser.
The first year of graduate study involves
students in the theory and practical
applications of the visual communica-
tion process. Courses and independent
study experiences concentrate on the
role of typography and image making in
the broad discipline of information
design. The second year is devoted to
personal research and focused investi-
gations of individually selected design
topics culminating in a final graduate
project. Students work closely with
the graduate adviser and other faculty
project advisers. Progress toward the
MFA degree is subject to periodic review
by the faculty. In the final year of study,
students exhibit work in an annual
group MFA exhibition at Krannert Art
Museum, and also take part in an
annual exhibition with graduating
seniors at I Space. In addition, a docu-
mentation of the graduate project
approved by the student's committee
and a public presentation during their
final semester are required for the
MFA degree.

During their second year, gradu-
ate students have the opportunity to
teach beginning design courses in the
undergraduate Graphic Design Program
or the School's Foundation Program.

23 GRAPHIC DESIGN

Program
Coordinator's
Guide

ENLIGHTEN™
A New Light on Depression in Older Adults

How to Talk to
Your Doctor About
Depression...

and Be Well Again

ENLIGHTEN™
A New Light on Depression in Older Adults

New Views of Depression
for Older Adults

How to Recognize
Depression, Get Help,
and Be Well Again

ENLIGHTEN™
A New Light on Depression in Older Adults

It is estimated that 15% of adults over
age 65 may suffer from depression.

Fortunately, depression is an illness
that responds well to a number of
treatments. But many older adults do
not get the treatment they need for
depression. They may not realize that
depression is a medical illness that
requires professional attention. They
may mistakenly believe that depression
is a sign of weak character and feel
ashamed of their condition.

Depression is an illness that can make
other health problems worse and harm
overall quality of life. In fact, when
depression goes untreated, it can cause as
much pain and suffering as heart disease,
high blood pressure, diabetes, or arthritis.

Many older adults who suffer from
depression feel that life is not worth
living. Given proper treatment through
psychotherapy, medicine, or a combination
of both, these same people can experience
renewed vitality and enjoy life once again.

This booklet addresses some common
concerns about depression in older
adults. It will help you to:

■ Put an end to common myths about
depression

■ Understand the causes of depression in
older adults

■ Identify the signs and symptoms of
depression

■ Understand the treatments currently
available

DESIGN FIRM | Malik Design
ART DIRECTOR/DESIGNER | Donna Malik
ILLUSTRATOR | Jeff Cornell
COPYWRITER | Polly Edelson
CLIENT | Eden Communications: Pfizer, Inc.
TOOLS | QuarkXPress
PAPER | Plainwell

This brochure series was developed to educate senior
citizens that depression is a medical condition, not just a
part of aging. Text size was a key design issue: it had to
be large enough for older people to read easily.

DESIGN FIRM | Punto e Virgola S.A.S

ART DIRECTOR/DESIGNER | Anna Palandra

COPYWRITER | Andrea Tinti

CLIENT | Polygram Italia

TOOLS | QuarkXPress, Adobe Photoshop,
Macromedia FreeHand

PAPER | Recycled paper

PRINTING PROCESS | Offset

This brochure was ordered by Polygram Italia to present
their artists in a thirty-two-page promotional magazine.
The client wanted a design with modern, legible graphics.

DESIGN FIRM | Punto e Virgola S.A.S.

ART DIRECTOR | Anna Palandra

COPYWRITER | Andrea Tinti

CLIENT | Commune of Bologna: Zero in Condotia

TOOLS | QuarkXPress, Adobe Photoshop

PAPER | Newspaper Type

PRINTING PROCESS | Daily newspaper processes

This brochure was ordered by the Commune of Bologna to promote the musical festival Scandellara Rock. The format and paper were chosen to create an aggressive marketing piece for young audiences. With a budget of 5,000,000 lire, the client needed a simple format and minimal color.

The Fourth International

Teaching
for Intelligence
Conference
Final Program

A Gathering for the Millennium

April 21–26, 1998

Marriott Marquis Hotel

45th and Broadway

New York, NY

DESIGN FIRM | B² Design

ART DIRECTOR/DESIGNER | Carol Benthal-Bingley

COPYWRITER | Linda Fuller

CLIENT | International Renewal Institute

TOOLS | Adobe PageMaker and Photoshop

This conference program was designed for an Educators Conference in New York City.

DESIGN FIRM | Greenzweig Design

ART DIRECTOR/DESIGNER | Tim Greenzweig

PHOTOGRAPHER | Jason Jones

COPYWRITER | Mary Curran

CLIENT | Stamats Communications, Inc.

TOOLS | QuarkXPress, Adobe Photoshop

PAPER | Mohawk 50/10

PRINTING PROCESS | Four-color process, offset

This is one in a series of informational brochures that reflects the effects of Lake Superior and its surroundings on the students at the University of Minnesota, Duluth.

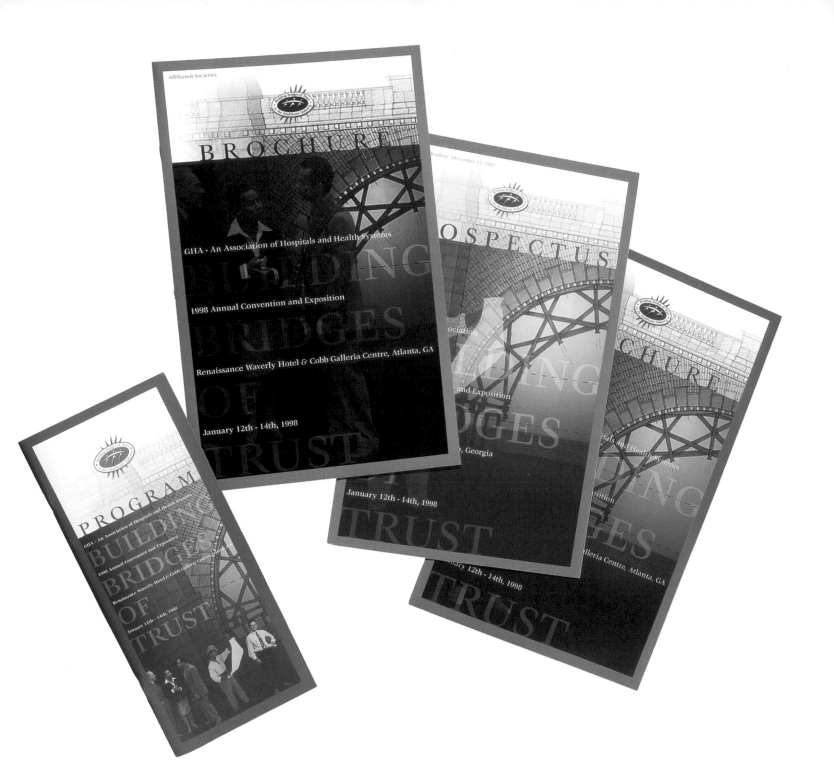

DESIGN FIRM | Worldstar Design
ART DIRECTOR/DESIGNER | Greg Guhl
COPYWRITER | Greg Guhl
CLIENT | GHA
TOOLS | QuarkXPress, Adobe Illustrator and Photoshop
PRINTING PROCESS | Four-color offset

The design concept supported the convention's slogan,
Build Bridges of Trust. Images of architects and
contractors with a bridge created a unique design.
Different colors were selected for each brochure.

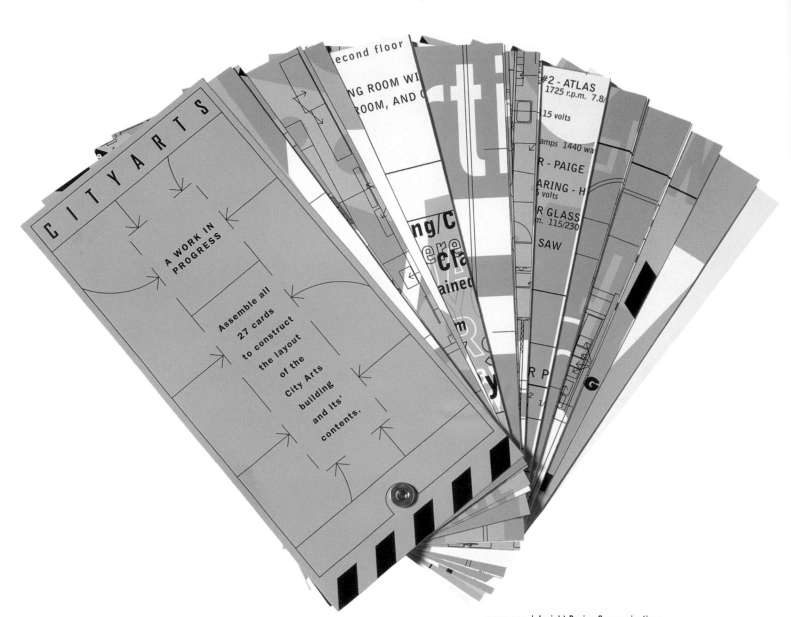

DESIGN FIRM | Insight Design Communications

ART DIRECTORS | Tracy and Sherrie Holdeman

DESIGNERS | Sherrie Holdeman, Chris Parks

ILLUSTRATOR | Chris Parks

PHOTOGRAPHER | Dimitris Skliris

CLIENT | City Arts

TOOLS | Macromedia FreeHand

Since this art event took place in a partially finished gallery, where actual construction was taking place, the brochure took on a functional construction theme. Aside from developing construction icons, the pages assemble into a functional blueprint layout of the building and gallery itself.

it's a boy!

Last year nearly 1,500 newborns began life in a place where the guiding rule is compassionate, comprehensive care.

The Maternal/Child Unit at Lake Cumberland Regional Hospital allows parents to labor, deliver and recover in a loving family environment. Brothers, sisters and grandparents are encouraged to share in feeding and holding the newest family member in a warm, homelike setting with maximum support and minimum stress.

And when some newborns require intensive care, our Special Care Nursery is certified to handle all but the most critically ill babies.

Do you know who we are?

A Report to the Community

DESIGN FIRM | Kirby Stephens Design

ART DIRECTOR/DESIGNER | Kirby Stephens

PHOTOGRAPHER | William Cox, stock

COPYWRITER | Kirby Stephens

CLIENT | Lake Cumberland Regional Hospital

TOOLS | Macromedia FreeHand, Adobe Photoshop

PAPER | Repap Matte

PRINTING PROCESS | Five-color spot, offset

To help mend a local hospital's waning reputation, new management gave the designers specific areas to address in this direct, to-the-point, report to the community.

DESIGN FIRM | Worldstar Design

ART DIRECTOR/DESIGNER | Greg Guhl

PHOTOGRAPHER | Stock

CLIENT | GHA

TOOLS | QuarkXPress, Adobe Illustrator

PRINTING PROCESS | One-color offset

GHA wanted a commemorative book featuring twelve articles written by Dr. Underwood. Guhl designed a title page for each article that features the article name, a quote or quotes, a supporting photo, and the issue of the publication that had featured the article.

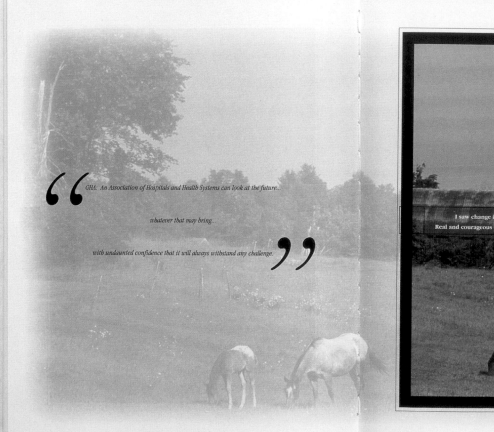

"

GHA: An Association of Hospitals and Health Systems can look at the future...

whatever that may bring...

with undaunted confidence that it will always withstand any challenge. "

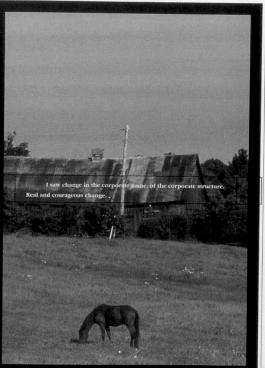

I saw change in the corporate name, of the corporate structure. Real and courageous change. .

Twenty Three

DESIGN FIRM | Worldstar Design

ART DIRECTOR/DESIGNER | Greg Guhl

CLIENT | Henderson High School

TOOLS | Adobe Illustrator and Photoshop, QuarkXPress

PRINTING PROCESS | One-color

Posterized effects applied to photos of cougars, and
the creation of a 20th anniversary logo, gave this reunion
invitation its snap.

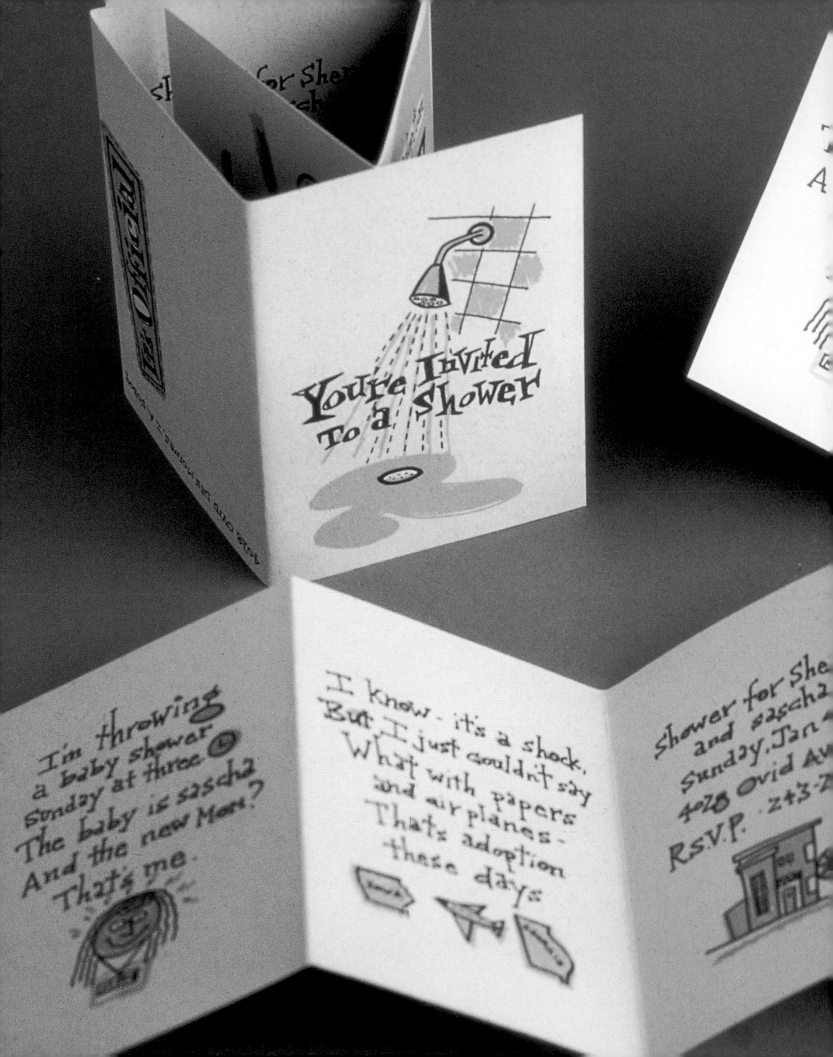

It's Official!

You're Invited To a Shower

I'm throwing a baby shower
Sunday at three ☺
The baby is sascha
And the new Mom?
That's me.

I know - it's a shock,
But I just couldn't say
What with papers
and air planes -
That's adoption
these days

Shower for Sher
and sascha
Sunday, Jan 4
4020 Ovid Av
R.S.V.P. 243-?

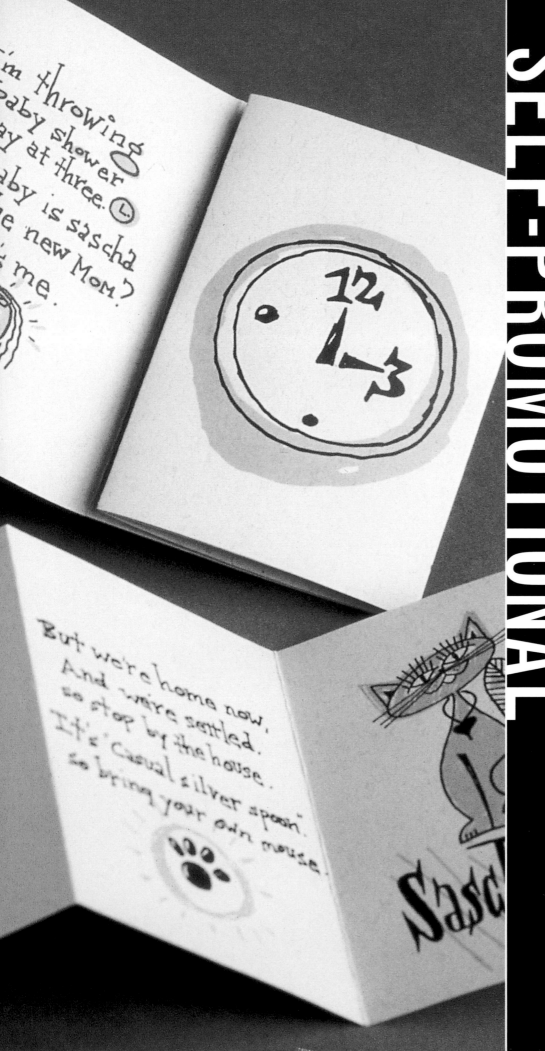

DESIGN FIRM | Sayles Graphic Design
ALL DESIGN | John Sayles
COPYWRITER | Annie Meacham
PAPER | Terracoat Gray
PRINTING PROCESS | Offset

This one-color invitation uses storytelling graphics: a shower on the front and an airplane hopping from one home to the next. The piece folds out to reveal the recipient of the baby shower—an adopted kitten named Sascha B.

FREEMAN
LAU 劉 小 康 訊
WORKS 息 的
OF 存 在 与 再 現
MESSAGE

DESIGN FIRM | Kan & Lau Design Consultants
ART DIRECTOR/DESIGNER | Lau Siu Hong
TOOLS | Adobe PageMaker, Macromedia FreeHand,
Adobe Photoshop

The artwork in the Works of Message were inspired by
books but without words.

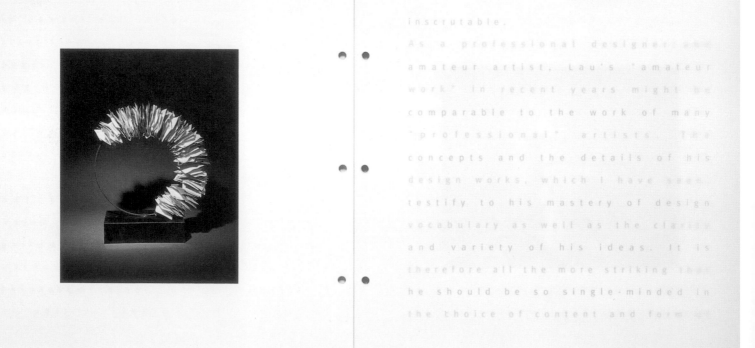

inscrutable.
As a professional designer and
amateur artist, Lau's "amateur
work" in recent years might be
comparable to the work of many
"professional" artists. The
concepts and the details of his
design works, which I have seen,
testify to his mastery of design
vocabulary as well as the clarity
and variety of his ideas. It is
therefore all the more striking that
he should be so single-minded in
the choice of content and form of

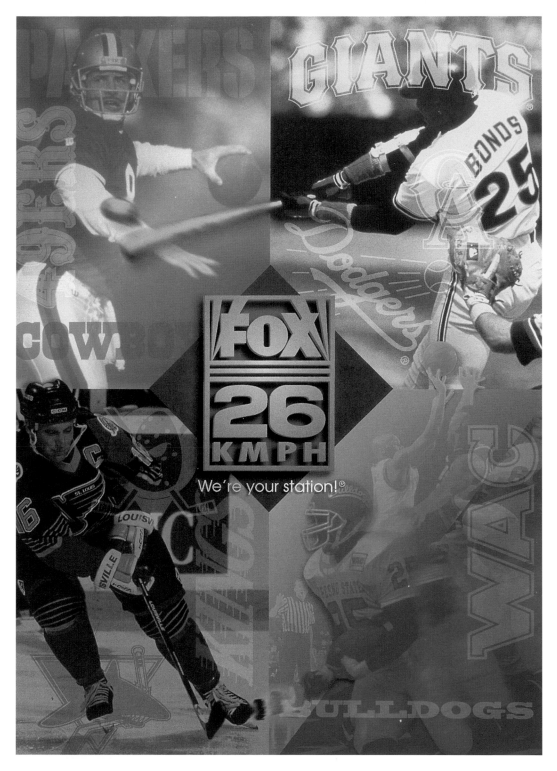

DESIGN FIRM | KMPH Fox 26
DESIGN DIRECTOR | Rebecca M. Barnes
COMPUTER PRODUCTION | Mullins and Son
PRINTING PROCESS | Four-color process

The designers began with the traditional folder to present
an annual sports package designed to help their Marketing
Department with client presentations. A separate one-sheet
insert is held inside the folder, so the folder can be used
throughout the year.

DESIGN FIRM | Roslyn Eskind Associates Limited
ART DIRECTOR | Roslyn Eskind
DESIGNERS | Roslyn Eskind, Heike Sillaste, Gary Mansbridge
COPYWRITER | Roslyn Eskind
CLIENT | Services Group of America
TOOLS | QuarkXPress, Adobe Illustrator and Photoshop
PAPER | Horizon 8pt. cover dull
PRINTING PROCESS | Heidelberg (direct to plate)

DESIGN FIRM | João Machado, Design Lda.
ALL DESIGN | João Machado
TOOLS | Macromedia FreeHand, QuarkXPress

DESIGN FIRM | Orbit Integrated

ART DIRECTOR/DESIGNER | Jack Harris

ILLUSTRATORS | Jack Harris, Emory Au

COPYWRITER | William Harris

CLIENT | Orbit Integrated

TOOLS | QuarkXPress, Adobe Illustrator and Photoshop

PAPER | 80 lb. Mohawk Poseidon Cover

PRINTING PROCESS | Four-color offset

This is a vehicle for the marketing communications firm
to announce its name change, and to provide its clients
with a taste of its marketing and branding philosophies,
in a format that commands attention.

DESIGN FIRM | Mires Design

ART DIRECTOR | John Ball

DESIGNER | Gale Spitzley

ILLUSTRATORS | Miquel Perez, Jeff Samaripa

COPYWRITER | Brian Woosley

TOOLS | QuarkXPress, Adobe Illustrator

PAPER | Zanders Mirricard silver, cover; 12 pt. Zanders
Chromolux Vario Cover, red, interior

PRINTING PROCESS | Four-color offset

The Mires Design identity book is used to present their
work to potential clients, both in person and via direct
mail. The designer used a mirror-like cover stock to reflect
the firm's philosophy on corporate and brand identity.

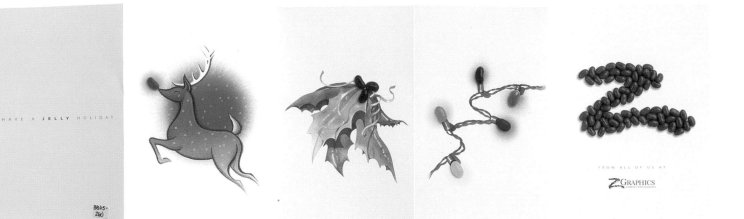

DESIGN FIRM | ZGraphics, Ltd.

ART DIRECTOR | Joe Zeller

DESIGNER | Gregg Rojewski

ILLUSTRATOR | Paul Turnbaugh

Jelly beans for the holiday season! What could be more yummy? ZGraphics' greeting card emphasizes the jelly bean theme by using photos of actual jelly beans in conjunction with illustrations of the holiday season.

DESIGN FIRM | Muller and Co.

ART DIRECTORS | John Muller, Joann Otto

DESIGNER | Joann Otto

PHOTOGRAPHER | Steve Curtis

COPYWRITER | Pat Piper

TOOLS | Adobe Photoshop, QuarkXPress

PAPER | Strobe Silk

PRINTING PROCESS | Four-color process plus dull gloss
dry-trap varnish

To show prospective clients that advertising and design
can work together with incredible results, the designer
literally divided up the brochure into the two disciplines
for an interesting presentation.

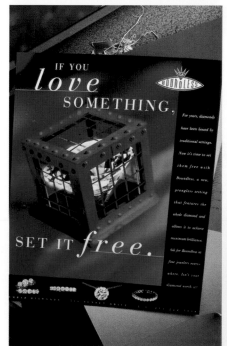

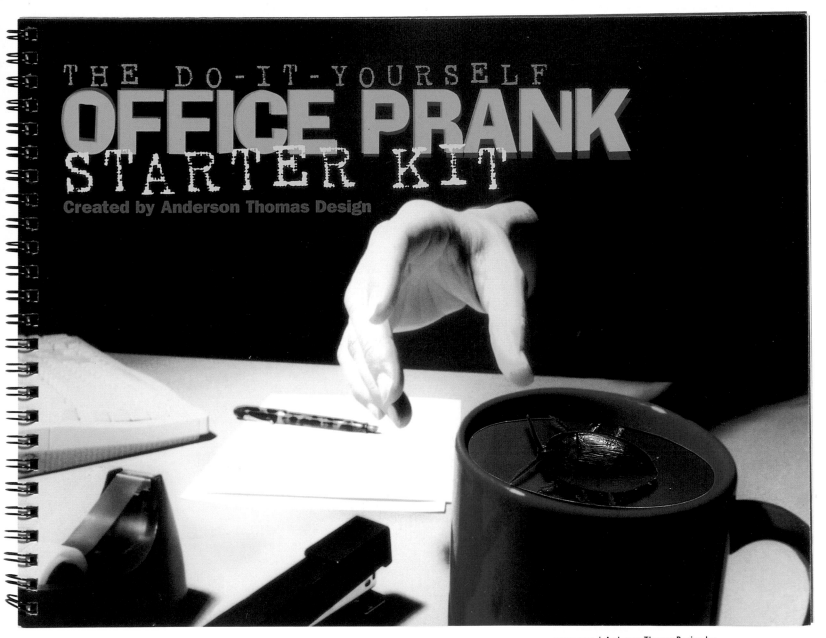

THE DO-IT-YOURSELF OFFICE PRANK STARTER KIT

Created by Anderson Thomas Design

DESIGN FIRM | Anderson Thomas Design Inc.

ART DIRECTOR | Joel Anderson

DESIGNERS | Joel Anderson, Abe Goolsby, Susan Browne,
Roy Roder, Jay Thatcher, Jay Smith

ILLUSTRATOR | Kristi Carter

PHOTOGRAPHER | Scott Thomas

TOOLS | QuarkXPress, Adobe Illustrator and Photoshop

PAPER | Domtar: Excellence gloss, Sandpiper oat,
Fusion ivory and goldenrod

PRINTING PROCESS | Four-color process plus fluorescent PMS
plus spot varnish

The design process involved conceptual meetings
from which the idea and the gags originated. From there,
groups of designers were assigned to design and execute
the different sections, thus showcasing their different
creative styles.

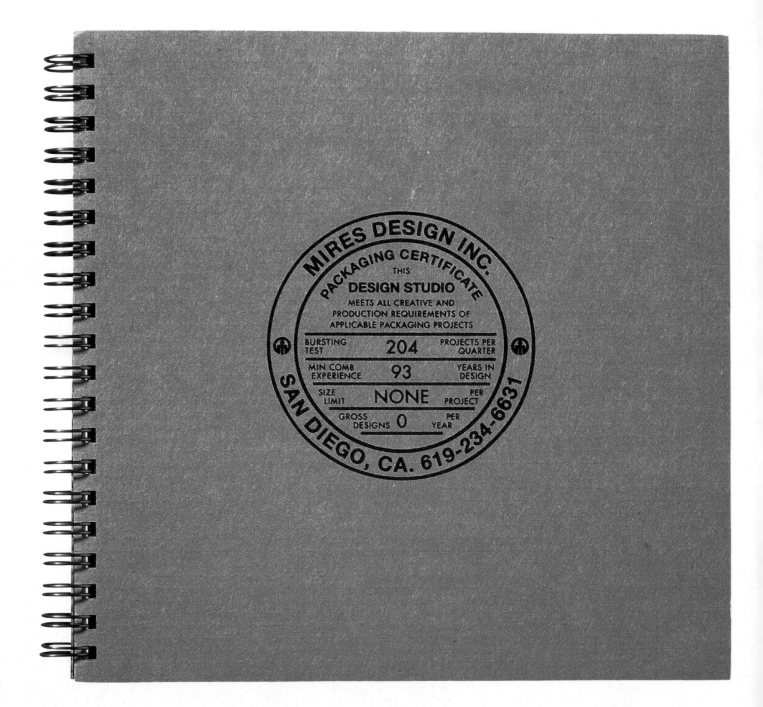

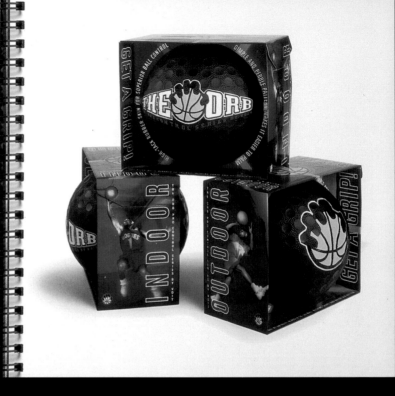

VOIT SPORTS | THE ORB BASKETBALL

IT'S A WHOLE NEW KIND OF BASKETBALL. A DIMPLED PRACTICE
BALL DESIGNED TO HELP AVERAGE-SIZED HANDS PLAY MORE
LIKE NBA-SIZED HANDS. IN ADDITION TO NAMING THE PRODUCT,
WE CREATED A UNIQUE IDENTITY AND PACKAGING THAT GIVES
CONSUMERS AN INSTANT GRIP ON WHAT THIS BALL'S ALL ABOUT.

DESIGN FIRM | Mires Design

ART DIRECTOR | Jose A. Serrano

DESIGNERS | Deborah Hom, Gale Spitzley

COPYWRITER | John Kuraoka, Brian Woosley

TOOLS | QuarkXPress

PRINTING PROCESS | Four-color offset

This promotion was created to showcase Mires Design's
latest packaging projects. Their strategy was to present
the work in a format that made use of corrugated board
to give a tactile feel and make the book memorable.

DESIGN FIRM | Architectural Brochures
ART DIRECTOR | Liza Bachrach
ALL DESIGN | Liza Bachrach
TOOLS | QuarkXPress, Adobe Illustrator
PAPER | Gilclear, oxford, white 28 lb.
PRINTING PROCESS | Four PMS colors

The firm wanted a brochure that would demonstrate to the public all the wonderful design options there are for brochures: color, unique paper, emboss, dye cut, score, fold, and bleed. They created a design that coordinates well with their letterhead, and is simple, yet elegant.

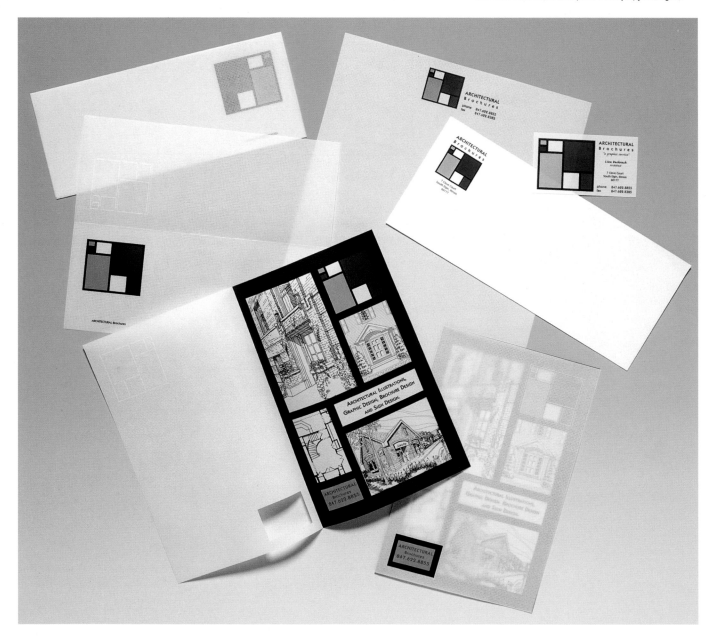

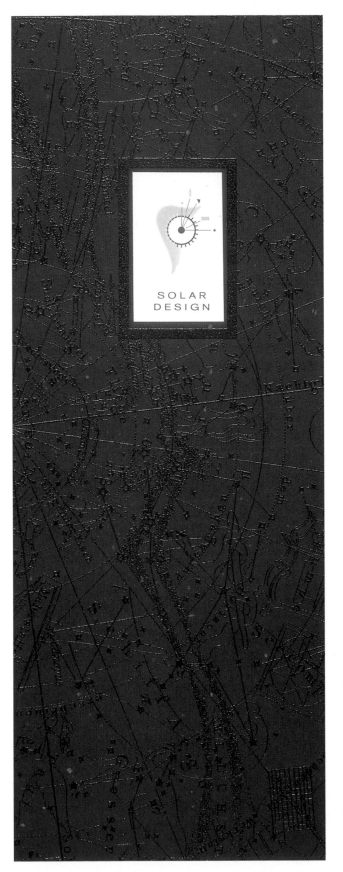

DESIGN FIRM | Solar Design
ART DIRECTOR | Jennifer Schmidt
DESIGNERS | Jennifer Schmidt, Susan Russell
TOOLS | QuarkXPress, Adobe Illustrator and Photoshop
PAPER | Cover: Fox River Confetti;
interior: Neenah Classic Crest
PRINTING PROCESS | Black thermography, cover;
two-color PMS, interior

This brochure educates the reader on the process of
design and is one component of the firm's presentation
folder. Sun facts are included to reinforce the firm's
goal: to give each client Solar's energy!

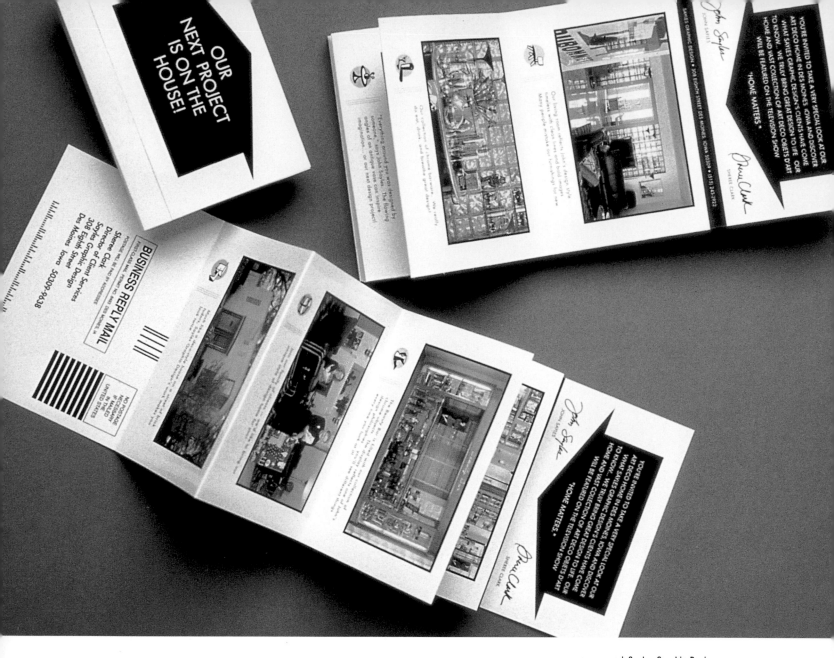

DESIGN FIRM | Sayles Graphic Design

ART DIRECTOR/DESIGNER | John Sayles

PHOTOGRAPHER | Bill Nellans

COPYWRITER | Wendy Lyons

PAPER | Crown Vantage Terracoat Gray

PRINTING PROCESS | Offset

Sayles and Clark commemorated the airing of a promotional
TV show with a special announcement. The accordion-fold
mailer, appropriately titled Our Next Project Is on the
House, is reminiscent of a wallet full of photos. A dozen
detailed shots display their eye-catching collections,
showcasing their appreciation for the elegance and style
of the Art Deco era.

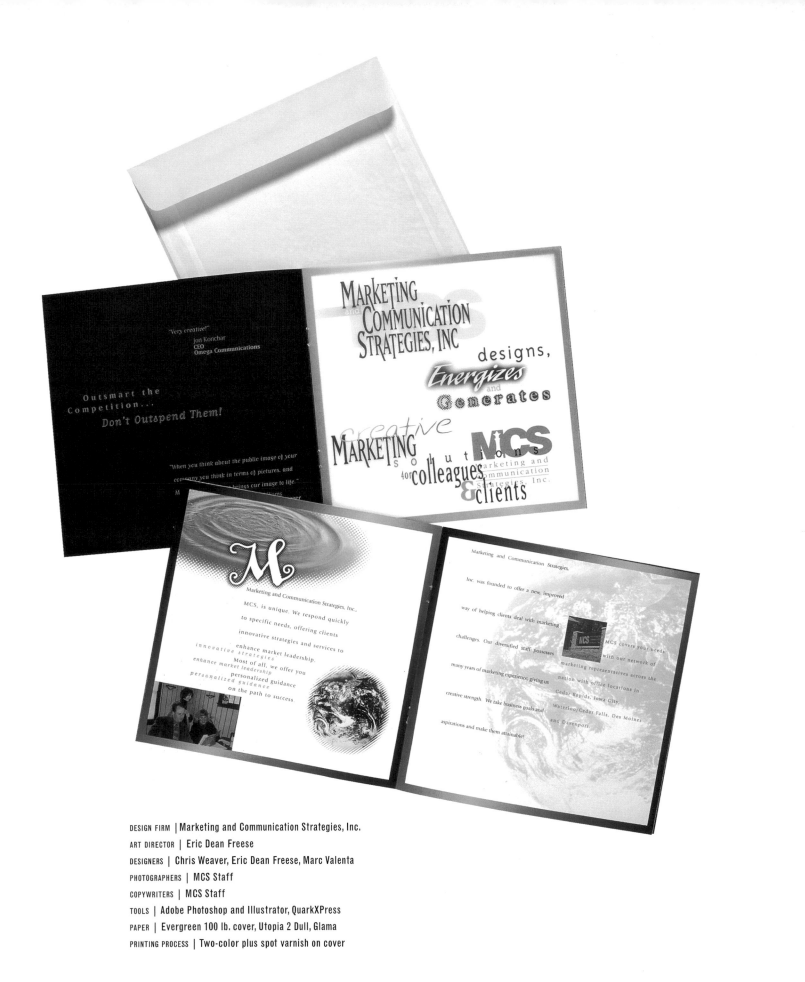

DESIGN FIRM | Marketing and Communication Strategies, Inc.

ART DIRECTOR | Eric Dean Freese

DESIGNERS | Chris Weaver, Eric Dean Freese, Marc Valenta

PHOTOGRAPHERS | MCS Staff

COPYWRITERS | MCS Staff

TOOLS | Adobe Photoshop and Illustrator, QuarkXPress

PAPER | Evergreen 100 lb. cover, Utopia 2 Dull, Glama

PRINTING PROCESS | Two-color plus spot varnish on cover

FACTOR DESIGN FACTOR DESIGN

über neugierde on curiosity

Tja, das war er, der erste Eindruck, für den es keine zweite Chance gibt. Wir hoffen, wir konnten Sie ein bißchen neugierig machen. Da hätten wir dann nämlich schon eine gemeinsame Basis. Wir sind neugierig. Ganz enorm sogar. Und ganz besonders darauf, was Sie jetzt wohl über uns denken. Rufen Sie uns doch mal an und erzählen Sie es uns. Sprechen wir über Details.

Well, that was it—the first impression. There's no second chance. We hope we've made you a bit curious. Then we already have something in common. Because at Factor Design, we're extremely curious. For example, right now we're wondering what you think of us. Why not give us a call and let us know?

BILDTAFEL/PLATE OF LEUKOZYTEN **13**

DESIGN FIRM | Factor Design
ART DIRECTOR | Olaf Stein
DESIGNER | Eva Ralle
ILLUSTRATOR | Stock
PHOTOGRAPHER | Frank Stôckel
COPYWRITER | Hannah S. Fricke
TOOLS | Macromedia FreeHand, QuarkXPress
PAPER | Romerturn Esparto
PRINTING PROCESS | Four-color offset

This brochure is part of Factor's self promotional piece that tells clients about the firm's general philosophy on graphic design.

fd

IDEA BOOK 4.0

DESIGN FIRM | Caesar Photo Design, Inc.
ART DIRECTOR | Caesar Lima
DESIGNERS | Caesar Lima, Pouane Dinso
PHOTOGRAPHER | Caesar Lima
COPYWRITER | Jennifer Castle
PRINTING PROCESS | 5/5 colors

Since Caesar Photo Design is a 100% digital photo studio, they wanted to display a futuristic image to potential clients. This brochure eliminated the need to send portfolios of their photographic work, because it speaks for itself: big images and few words are key elements of its success.

Beyond the hum of the computer,

beyond the glare of the screen...

There is always the art.

Software can not generate creativity.

Without the idea, there is no image

Without the idea, there is nothing...

DESIGNERS/ILLUSTRATORS | Doreen Kiepsel and Marlena Sang
COPYWRITERS | Doreen Kiepsel and Marlena Sang
PRINTING PROCESS | Inkjet and photocopier

Ten sheets were put together in one piece to create
Christmas greetings that use the designers' own
illustrations, texts, forms, and fonts. The recipient can
pick the one he or she likes best and just enjoy it.

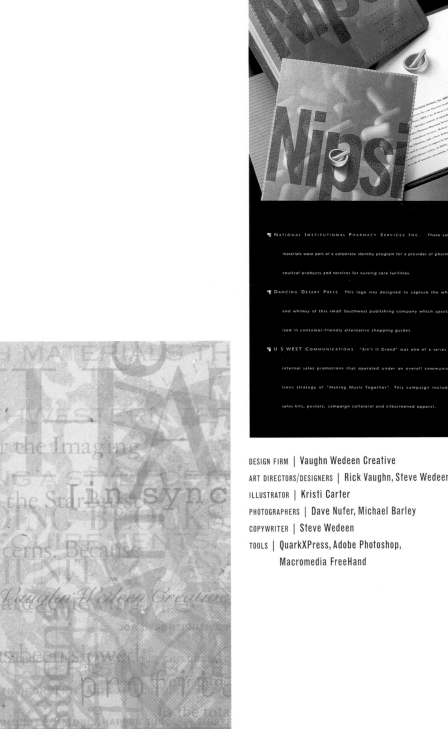

DESIGN FIRM | Vaughn Wedeen Creative
ART DIRECTORS/DESIGNERS | Rick Vaughn, Steve Wedeen
ILLUSTRATOR | Kristi Carter
PHOTOGRAPHERS | Dave Nufer, Michael Barley
COPYWRITER | Steve Wedeen
TOOLS | QuarkXPress, Adobe Photoshop,
 Macromedia FreeHand

1049 DESIGN
1603 Cypress Trail
Middleton, WI 53562
608-232-1049

ADELE BASS & CO. DESIGN
758 E. Colorado Boulevard
Suite 209
Pasadena, CA 91101
626-304-0306

ALAN CHAN DESIGN COMPANY
2/F Shiu Lam Building
23 Luard Road
Wanchai, Hong Kong
852-2527 8228

ANDERSON THOMAS DESIGN INC.
110 29th Avenue North
Suite 100
Nashville, TN 37203
615-327-9894

ARCHITECTURAL BROCHURES
7 Clove Court
South Elgin, IL 60177
847-622-8855

ATELIER GRAPHIQUE BIZART
20 Rue J. P. Beicht
L-1226 Luxembourg
00352 462255 1

AWG GRAPHICS COMUNICAÇÃO LTDA
R. Maestro Cardim, 377
8 and Saspualo
Sao Paulo, Brazil
55 11 289 0099 R29

B² DESIGN
220 South 5th Street
Dekalb, IL 60115
815-748-5876

BARBARA FERGUSON DESIGN
10211 Swanton Drive
Santee, CA 92071
619-562-5078

BASE ART COMPANY
209 South High Street, #212
Columbus, OH 43215
614-280-9369

BELYEA DESIGN ALLIANCE
1809 7th Avenue, #1007
Seattle, WA 98101
206-682-4895

BENTLEY COLLEGE
175 Forest Street, LEW-205
Waltham, MA 02452
781-891-2241

BIG EYE CREATIVE, INC.
1300 Richards Street
Suite 101
Vancouver, BC V6B 3G6
Canada
604-683-5655

BLACK CAT DESIGN
637 3rd Avenue West #412
Seattle, WA 98119
206-270-8758

BRABENDERCOX
2100 Wharton Street
Pittsburgh, PA 15203
412-488-6400

BULLET COMMUNICATIONS, INC.
200 South Midland Avenue
Joliet, IL 60436
815-741-2804

CAESAR PHOTO DESIGN
21358 Nordhoff Street #107
Chatsworth, CA 91311
818-718-0878

CHARNEY DESIGN
1120 Whitewater Cove
Santa Cruz, CA 95062
831-479-4675

CLARKE COMMUNICATION DESIGN
1608 Bentbrook Court
Champaign, IL 61822
217-244-8539

COMMUNICATION ARTS COMPANY
129 East Pascaquola Street
Jackson, MS 39201
601-354-7955

CREATIVE CONSPIRACY INC.
110 East 9th Street
Durango, CO 81301
970-247-2262

THE CREATIVE RESPONSE CO., INC.
217 Nicanor Garcia Street
Bel-Air II, Makati City
Philippines
632-896-1535

DAMEON HICKMAN DESIGN
1801 Dove #104
Newport Beach, CA 92660
949-261-7857

DENISE KEMPER DESIGN
505 Wintergreen Drive
Wadsworth, OH 44281
330-335-5200

DESIGN GUYS
119 North Fourth Street, #400
Minneapolis, MN 55401
612-338-4462

DIA
Central House, Alwyne Road
London JW19 7AB
United Kingdom
0181 879 7090

DIGITAL GIRAFFE
PO Box D-1
Carmel, CA 93921
831-624-1833

ELTON WARD DESIGN
PO Box 802, Parramatta
NSW 2124, Australia
61-2 9635 6500

FACTOR DESIGN
Schulterblatt 58
20357 Hamburg
Germany
49 40 432 571 0

FERNÁNDEZ DESIGN
920 North Franklin Street
Suite 303
Chicago, IL 60610
312-944-7003

GACKLE ANDERSON HENNINGSEN INC.
2415 Eighteenth Street
Bettendorf, IA 52722
319-355-8074

GAF ADVERTISING DESIGN
7215 Holly Hill Drive
Suite 102
Dallas, TX 75231
214-360-9677

GN DISEÑO GRÁFICO
Rodriguez Pena 431-4 F
1020 Buenos Aires
Argentina
541 374 1501

GOODHUE AND ASSOCIES
DESIGN COMMUNICATION
465 McGill Street
8th Floor
Montreal, QB H2T 2H1
Canada
514-985-4181

GREENZWEIG DESIGN
2156 North 89th Street
Seattle, WA 98103
206-729-2391

GRETEMAN GROUP
142 N Mosley
Third Floor
Wichita, KS 67202
316-263-1004

GRIFFIN DESIGN
RR 22 Box 6
Bloomington, IL 61701
309-829-4295

HELD DIEDRICH, INC.
703 East 30th Street
Suite 16
Indianapolis, IN 46205-4613
317-926-6161

HOFFMAN AND ANGELIC DESIGN
317-1675 Martin Drive
Surrey, BC V4A 6E2
Canada
604-535-8551

HORNALL ANDERSON
DESIGN WORKS, INC.
1008 Western Avenue
Suite 600
Seattle, WA 98104

BARRY HUTZEL
2058 Breeze Drive
Holland, MI 49424

ILLINOIS WESLEYAN UNIVERSITY
302 East Graham Street
PO Box 2900
Bloomington, IL 61702-2900
309-556-3048

INLAND GROUP, INC.
22A North Main
Edwardsville, IL 62025
618-656-8836

INSIGHT DESIGN COMMUNCATIONS
322 South Mosley
Wichita, KS 67202
316-262-0085

INTEGRATED MARKETING SERVICES
279 Wall Street
Princeton, NJ 08540
609-683-9055
JANICE AITCHISON
25 Slocum Avenue
Tappan, NY 10983
914-365-8607

JD THOMAS COMPANY
820 Monroe #333
Grand Rapids, MI 49503
616-235-1700

JEFF FISHER
LOGO MOTIVES
PO Box 6631
Portland, OR 97228-6631
503-283-8673

JOAO MACHADO DESIGN LDA
Ria Padre Xavier Coltinho, No. 125
4150 Porto
Portugal
351 2-6103772 16203778

JOHNSON GRAPHICS
2 Riverfront
Newbury, MA 01951
978-462-8414

JOSEPH RATTAN DESIGN
5924 Pebblestone Lane
Plano, TX 75093
972-931-8044

JULIA TAM DESIGN
2216 Via La Brea
Palos Verdes, CA 90274
310-378-7583

KAN & LAU DESIGN CONSULTANTS
2817 Great Smart Tower
230 Wanchai Road, Hong Kong
852-2574-8399

KEN WEIGHTMAN DESIGN
7036 Park Drive
New Port Richey, FL 34652
727-849-8166

DOREEN KIEPSEL AND
MARLENA SANG
Lornsenstr. 36
22767 Hamburg
Germany
0049-40-3800-690

KIRBY STEPHENS DESIGN
219 East Mt. Vernon Street
Somerset, KY 42501
606-679-5634

KMPH FOX 26
5111 East McKinley Avenue
Fresno, CA 93727
209-255-2600

LEE REEDY CREATIVE, INC.
1542 Williams
Denver, CO 80218
303-333-2936

THE LEONHARDT GROUP
1218 3rd Avenue #620
Seattle, WA 98101

LOUISA SUGAR DESIGN
1650 Jackson Street
Suite 307
San Francisco, CA 94109
415-931-1535

MALIK DESIGN
88 Merritt Avenue
Sayreville, NJ 08879-1955
732-727-4352

MARKETING AND COMMUNICATIONS
STRATEGIES, INC.
2218 1st Avenue NE
Cedar Rapids, IA 52402
319-363-6005

MCGAUGHY DESIGN
3706-A Steppes Court
Falls Church, VA 22041
703-578-1375

MELISSA PASSEHL DESIGN
1275 Lincoln Avenue #7
San Jose, CA 95125
408-294-4422

MENDIOLA DESIGN STUDIO
Calle 37 No. 523 Mercedes
Buenos Aires, Argentina
54-324-33469

MERVIL PAYLOR DESIGN
1917 Lennox Avenue
Charlotte, NC 28203
704-375-4444

MICHAEL COURTNEY DESIGN
121 East Boston
Seattle, WA 98102
206-329-8188

MIRES DESIGN
2345 Kettner Boulevard
San Diego, CA 92101

MODELHART GRAFIK-DESIGN DA
Ing. Ludwig Pech Strasse 1
A-5600 St. Johann
Austria
43-6412-4679

MORGAN DESIGN STUDIO, INC.
345 Whitehall Street Southwest
Suite 106
Atlanta, GA 30303
4-584-0746

MULLER AND COMPANY
4739 Belleview
Kansas City, MO 64112
816-531-1992

NESNADNY & SCHWARTZ
1080 Magnolia Drive
Cleveland, OH 44106
216-791-7721

ORBIT INTEGRATED
722 Yorklyn Road
Hockessin, DE 19707
302-234-5700, x25

PENSARE DESIGN GROUP LTD.
729 19th Street Northwest
Second Floor
Washington, DC 20005
202-638-7700

PEPE GIMENO, SL
C/Cadirers, SN
46110 Godella
Valencia, Spain
34-963904074

PHILLIPS DESIGN GROUP
25 Drydock Avenue
Boston, MA 02210
617-423-7676

PINKHAUS DESIGN
2424 South Dixie Highway
Suite 201
Miami, FL 33133
305-854-1000

PRICE LEARMAN ASSOCIATES
737 Market Street
Kirkland, WA 98033
425-803-0333

PUNTO E VIRGOLA S.A.S.
Via Battindarno 177
40133 Bologna
Italy
0038-051-56.58.97

Q DESIGN
Neuberg 14
65193 Wiesbaden
Germany
0045-611-1S1310

RAMONA HUTKO DESIGN
4712 South Chelsea Lane
Bethesda, MD 20814
301-656-2763

RENATE GOKL
803 South Coler Avenue, #5
Urbana, IL 61801
217-367-7124

REVOLUZION
Uhlandstrasse 4
78579 Neuhausen ob Eck
Germany
011-49-7467-1467

THE RIORDON DESIGN GROUP INC.
131 George Street
Oakville, Ontario L68 3B9
Canada
905-339-0750

RIVER CITY STUDIO
116 West 3rd Street
Kansas City, MO 64105
816-474-3922

ROSLYN ESKIND ASSOCIATES LIMITED
471 Richmond Street West
Toronto, Ontario MSV 1X9
Canada
416-504-6075

SAGMEISTER INC.
222 West 14 Street
New York, NY 10011
212-647-1789

ST. JOSEPH'S HOSPITAL
703 Main Street
Paterson, NJ 07503
973-754-2874

SAYLES GRAPHIC DESIGN
308 Eighth Street
Des Moines, IA 50309
515-243-2922

SHIELDS DESIGN
415 East Olive Avenue
Fresno, CA 93728

SJI ASSOCIATES INC.
1133 Broadway
Suite 635
New York, NY 10010
212-727-1657

SOLAR DESIGN
1225 West Oakton Street
Arlington Heights, IL 60004
847-398-6842

SOMMESE DESIGN
481 Glenn Road
State College, PA 16803
814-238-7484

SOUND TRANSIT
1100 2nd Avenue, #500
Seattle, WA 98101-3423
206-689-7437

STOLTZE DESIGN
49 Melcher Street
Boston, MA 02210
617-350-7109

TELEVISION BROADCASTS LIMITED
TV City, Clear Water Bay Road
Kowloon, Hong Kong
852-2335-7268

TIM NOONAN DESIGN
1914 North Prospect Avenue
Milwaukee, WI 53202
414-271-4841

TOM FOWLER, INC.
9 Webbs Hill Road
Stamford, CT 06903
203-329-1105

VARDIMON DESIGN
87 Shlomo Hamelech Street
Tel Aviv 64512
Israel

972-3-5239361

VAUGHN WEDEEN CREATIVE, INC.
407 Rio Grande NW
Albuquerque, NM 87104
505-243-4000

VISUAL MARKETING ASSOCIATES, INC.
322 South Patterson Boulevard
Dayton, OH 45402
937-223-7500

WATCH! GRAPHIC DESIGN
3447 N Lincoln
Chicago, IL 60657
773-665-2292

WITHERSPOON ADVERITISING
1000 West Weatherford Street
Fort Worth, TX 76102-1842
817-335-1373

WOOD DESIGN
1775 York Avenue 326
New York, NY 10128
212-490-2626

WOOD DESIGN AND ART STUDIO
15371 Locust Street
Omaha, NE 68116
402-431-0419

WORLDSTAR DESIGN
4401 Shallowford Road, #192
Roswell, GA 30075
404-330-7827
X DESIGN COMPANY
2525 West Main Street, #201
Littleton, CO 80120
303-797-6311

Z GRAPHICS LTD.
322 North River Street
East Dundee, IL 60118
847-836-6022

ZYLSTRA DESIGN
5075 W 220th Street
Fairview Park, OH 44126
440-734-1704